KT-117-216

Contents

Introduction

Starting Photography is a practical book for absolute beginners – amateurs with average 35 mm or APS cameras who take their films to the local lab for commercial processing. It is also for young people at school using photography as part of arts courses, and adults working on the units required for schemes such as the City & Guilds Certificate in Photography. Information and advice is mostly presented visually through discussion of colour and black and white photographs, many making direct comparisons or relating to pictures on other pages. They are virtually all within the technical capabilities of beginners with modest gear such as compact or single lens reflex cameras (preferably with manual controls).

Taking photographs is enjoyable and challenging in all sorts of ways. After all, it's a method of creating pictures which does not demand that you have drawing skills. It's a powerful means of storing memories, showing situations, or expressing views which does not insist that you be good at words. But don't fall into the trap of thinking you must have the latest, expensive 'gee whiz' camera to get the most telling shots. What photography demands of you most is the ability to observe – sharpen up your 'seeing' of surroundings, people and simple everyday objects in the world around you. Avoid taking these things for granted just because they are familiar. Develop your awareness of the way lighting and viewpoint can transform appearances, and be quick-thinking enough to capture an expression or sum up a fast changing situation by selecting the right moment to shoot.

The opening part of *Starting Photography* therefore concentrates on seeing, plus basic aspects of picture making – common ground no matter what your subject or what equipment you use. Every camera has some form of viewfinder and the challenge is to decide what is for you the most effective way to compose subjects in this picture area – emphasizing important things, suppressing others. In a given situation where should your camera be to create an interesting structured picture having directness, simplicity and strength ... rather than a conventional oh-so-boring 'snap'?

Part Two introduces the main types of amateur cameras, including digital cameras. (If you are about to buy a camera this helps you identify features needed for the kind of subjects you expect to tackle.) Part Three explains how the use of each camera control expands your creative options. Shutter speed, focus, zoom setting, use of flash, etc. become additional aids for turning that scene in the viewfinder into a successful picture on paper. In fact, as you become more practised, gaining confidence and control, it becomes increasingly possible to 'previsualize' the result you need.

The next part, on tackling particular subject types, covers photographing people (individuals or groups, formal or informal), animals, landscapes, close-up objects, etc. Here, and at other points in the book, groups of practical projects are included to further develop your visual and technical ability. Part Five reproduces a variety of unexpected faulty results, explaining how to identify their

Starting Photography
Third edition

Michael Langford
FRPS, FBIPP

Focal Press

OXFORD AMSTERDAM BOSTON LONDON NEW YORK PARIS
SAN DIEGO SAN FRANCISCO SINGAPORE SYDNEY TOKYO

Focal Press
An imprint of Elsevier Science
Linacre House, Jordan Hill, Oxford OX2 8DP
225 Wildwood Avenue, Woburn, MA 01801-2041

First published 1976
Second edition 1993
Reprinted 1994, 1997, 1998
Third edition 1999
Reprinted 2000, 2001, 2002

British Library Cataloguing in Publication Data
A catalogue record of this book is available from the British Library

Library of Congress Cataloguing in Publication Data
A catalogue record for this book is available from the Library of Congress

ISBN 0 240 51484 X

For information on all Focal Press publications
visit our website at www.focalpress.com

Typeset by Avocet Typeset, Brill, Aylesbury, Bucks
Printed and Bound in Italy

cause and avoid them in future. Then, for the adventurous, Part Six covers the making of unusual pictures – still without needing costly equipment. Parts Seven and Eight show what is involved in setting up an indoor studio, and step-by-step darkroom processing and printing of your own (black and white) pictures. A final part suggests ways of presenting and assessing your results, whether lab or self-produced.

Although not primarily a school-book *Starting Photography* introduces Art (Photography) GCE students to variety of visual work using modern photographic techniques. It is also planned for the entry stages of new post-millenium vocational courses in art and design, to develop necessary skills in the use of equipment, materials and processes. Above all the book is planned to help every beginner expand their photography, and increase their enjoyment of picture making with today's cameras.

All photographs by the author except:
Fig. 3.7 Doris Thomas; Fig. 6.4 David Bradfield; Fig. 11.1 Courtesy Fowey School; Fig. 16.2 Patricia Pruden; Fig. 16.5 Celia Ridley; Fig. 22.5 Frank Thurston; Fig. 25.9 Amanda Currey; Fig. 26.3 Sue Wilkes; Fig. 26.4 Graham Smith. Also Figs 2.4, 3.2 and 23.1 by past students at the Royal College of Art.

Part One Picture Making

This first part is mainly about observation – and how to select from what you see around you. It is concerned with picture composing devices such as framing up your shot in the camera viewfinder; choice of viewpoint and moment to shoot; and picking appropriate lighting. It also discusses how to recognize pattern, line, colour and tone in the subject you intend to photograph and how to use such features to good effect. These are visual rather than technical aspects of photography and most stem from drawing and painting. They apply no matter what camera you own – cheap or expensive, auto-everything or covered in dials and controls.

1 Seeing and photographing

All the world's cameras, films, enlargers and other photographic paraphernalia are no more than tools for making pictures. They may be very sophisticated technically, but cannot see or think for themselves. Of course it's quite enjoyable playing around with the machinery, and testing it out; but this is like polishing up your bicycle and only ever riding it around the block to see how well it goes. Bicycles enable you to get out and explore the world; cameras challenge you to make successful pictures out of what you see around you, in perceptive and interesting ways.

Anyone who starts photography seriously quickly discovers how it develops their ability to *see*. In other words not just taking familiar scenes for granted but noticing with much greater intensity all the visual elements – shapes, textures, colours, and human situations – they contain. This is exciting and rewarding in itself. The second challenge is how to put that mindless machine (the camera) in the right place at the right time, to make a really effective photographic image out of any of these subjects. Seeing and organizing your picture making is just as important as technical knowhow, and it comes with practice.

To begin with it is helpful to consider the ways *seeing* differs from *photographing*. You don't necessarily have to regard differences as a barrier. The point is that by understanding how the scene in front of you will appear on a final photo-

Figure 1.1 Framing up horizontally stresses the linear flow of this Scottish landscape.

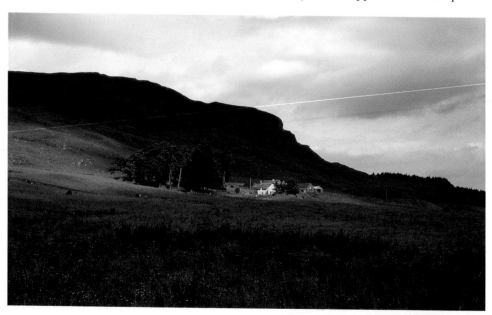

Starting Photography

graphic print you will start to 'pre-visualize' your results. This makes it much easier to work through your camera.

1 Pictures have edges

Our eyes look out on the world without being conscious of any 'frame' hemming in what we see. Stop a moment and check – your nose, eyebrows, glasses (if you wear them) do form a sort of frame, but this is so out of focus and vague that you are not really aware of any definite 'edge' to your vision. However, immediately you look through a camera viewfinder the world is cut down into a small rectangle with sharply defined edges and corners. Instead of freely scanning your surroundings you have to compose their essence within this artificial boundary.

The hard edges and their height-to-width proportions have a strong effect on a photograph. Look how the same scene in Figure 1.1 and Figure 1.2 is changed by format. Long, low pictures tend to emphasize the flow of horizontal lines and space left-to-right. Turning the camera to form an upright picture of the same scene tends to make more of its depth and distance as the scale between foreground and furthest detail is greater and more interactive.

Framing up pictures is a powerful way to include or exclude – for example deciding whether the horizon in a landscape should appear high or low, or how much of an expanse of colour to leave in or crop out. The edge of the frame can crop into the outline of something and effectively present it as a new shape too. Remember, though, that nothing you leave outside the viewfinder can be added later!

2 The camera does not select

When we look at something we have an extraordinary ability to concentrate on the main item of interest, despite cluttered surroundings. Our natural 'homing device' includes turning the head, focusing the eyes and generally disregarding any part of the scene considered unimportant. Talking to a friend outside their house you hardly register details of the building behind, but the camera has no brain to tell it what is important and unimportant. It cannot discriminate and usually records too much – the unwanted detail along with the wanted. This becomes all too apparent when you study the resulting photograph. Drainpipes and brickwork in the background may appear just as strongly as your friend's face ... and how did that dustbin appear in the foreground?

You therefore have to help the camera along, perhaps by changing your viewpoint or filling up the frame (if your camera will focus close enough). Perhaps you should wait for lighting to pick out your main item from the rest by making it the brightest or the most contrasting colour in the picture, as in Figure 1.1. Or you might control your zone of sharp focus (a device called depth of field, page 48) in order to limit detail to one chosen spot. Page 11 suggests other forms of emphasis.

Above all always take a quick look at *everything* you find in that

Figure 1.2 Making an upright picture instead emphasizes depth and distance.

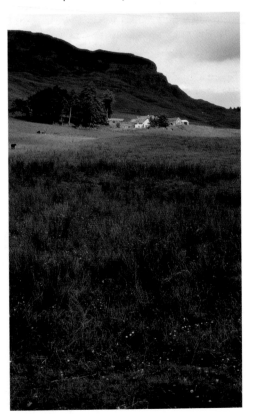

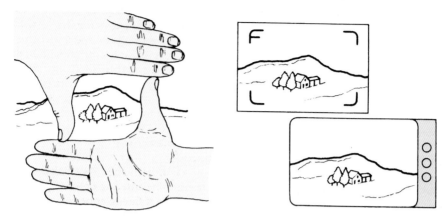

Figure 1.3 Practise framing up pictures with your hands, or through a compact camera viewfinder (top right) or a single lens reflex focusing screen. With APS film size cameras you can set picture proportions squarer or more panoramic. See page 42.

viewfinder before pressing the button.

3 Film cannot cope with the same contrast as the eye

We can make out details in dark shadows and brightly lit parts of a scene (provided they are not right next to each other) which are beyond the capabilities of a photograph. Photography generally makes darkest areas record darker and lightest areas lighter than they appeared to the eye, so that the whole image becomes more *contrasty*. This limitation can be turned to advantage, as on pages 11 or 56 for example, but if you *want* full detail throughout your picture you may have to alter or wait for changes in lighting which reduce the contrast.

4 The camera has one 'eye'

Unlike humans, the cameras we are normally using do not have binocular vision. Their pictures are not three dimensional. When we want to show depth in a scene we therefore have to *imply* it through devices such as the use of converging lines, changes in scale, or changes in tones (Figure 13.9) aided by lighting. Remember you can approximately forecast the camera's two-dimensional way of imaging by looking at the scene with one eye closed.

5 Most photographs capture just one moment in time

When things are active in front of the camera your choice of when to take the picture often 'sets' someone's momentary expression or the brief juxtaposition of one person to another or their surroundings, as in Figure 18.1. There is often a decisive moment for pressing the button which best sums up a situation or simply gives a good design. You need to be alert and able to make quick decisions if you are going for this type of picture. Once again the camera cannot think for you.

6 Colour translated into monochrome

When you are shooting or printing out results in black and white ('monochrome') the multicoloured world becomes simplified into different shades or *tones* of grey. A scarlet racing car against green bushes may reproduce as grey against nearly matching grey. Try not to shoot in monochrome pictures which rely a great deal on contrast of colours unless this will also reproduce as contrasty tones. Look at colours as 'darks' and 'lights'. Remember too that an unimportant part of your subject visually much too strong and assertive (such as an orange door in a street scene) may be ignored because it will merge with its surroundings in black and white.

Occasionally you might want to adjust the way colours translate into monochrome. This can be done with the aid of a coloured filter over the camera lens, page 118.

Starting Photography

2 Using the viewfinder – framing up

Even experienced photographers often make a rough 'frame' shape with their hands to exclude surroundings when first looking and deciding how a scene will photograph (see Figure 1.3). Similarly you can carry a slide mount to look through and practise ways of framing up your subject. When you come to buying a camera it is most important to choose one which has a viewfinding system you find clear and 'comfortable' to use, especially if you wear glasses. After all, the viewfinder is a kind of magic drawing pad on which the world moves about as you point the camera – including or cropping out something here; causing an item to appear in front of, or alongside, another item there.

If you can work easily through the viewfinder you can precisely fit a strong shape like Figure 2.1 to symmetrically fill up the frame. Or again you might frame up your main subject off-centre, perhaps to relate it to another element (Figure 3.8) or

Figure 2.1 A carefully framed close shot makes a symmetrical picture. Everything revolves around the face here.

just to add a sense of space. Notice how moving the camera viewpoint a few feet left or right, or raising or lowering it, can make a big difference to the way near and distant elements in, say, a landscape appear to relate to one another in the frame. This is even more critical shooting close-ups, where tiny alterations of a few centimetres often make huge changes.

The way you frame up something which is on the move across your picture also has interesting effects. You can make it seem to be entering or leaving a scene by positioning it facing either close towards or away from one side of your picture. A camera with a user-friendly viewfinder zoom lens will encourage you to creatively explore all these aspects of viewpoint and framing before every shot, instead of just crudely acting as an aiming device 'to get it all in'.

Using foregrounds and backgrounds

Foreground and background details cause problems when you are a beginner, for in the heat of the moment they are easily overlooked – especially when you are concentrating on an animated subject. And yet far from being distracting, what lies in front of or behind your main subject can often be

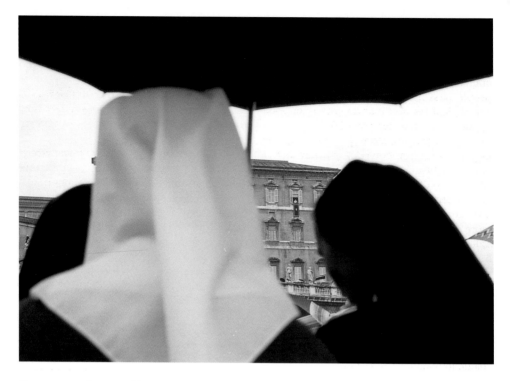

Figure 2.2 The Pope blesses from a Vatican window. Filling foreground with relevant shapes helps when the main subject is tiny.

Figure 2.3 Greek soldiers outside their barracks. Background detail forms a key link to foreground figures.

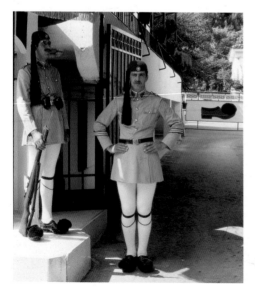

used to make a positive contribution to your picture.

Sometimes for example you are forced to shoot from somewhere so distant that even with the lens zoomed to its longest setting your key element occupies only a tiny area in the frame. It then pays to seek out a viewpoint where other, much closer items will fill in the foreground and help to create a 'frame within a frame', see Figure 2.2 above. They may even make the small size of the main element an asset which adds a sense of depth and distance. With landscape subject matter you can often use nearby foliage, rock or other appropriate elements to frame a distant subject.

Even simply photographing from a low viewpoint so that the background shows only sky and very distant detail (Figure 2.1) often eliminates unwanted assertive material. Equally, by picking a high viewpoint you can fill up your background with grass or similar plain ground – or you may find an angle from which the background is seen shrouded in shadow. On the other hand always try to make use of background details when these will add

Starting Photography

interesting information to a shot (Figure 2.3). This is also a way of making some visual comment through comparisons between like objects, perhaps parodying one element against another – for example people passing by giant figures on a billboard. Statues and monuments offer good opportunities too, see page 78.

In framing always try to fill up the picture area, but don't let your camera's fixed height-to-width picture proportions restrict you (2:3 ratio is standard for 35 mm film cameras). Some subjects will look better framed up in square format; others need a more extreme oblong shape. You may be able to get around this by again using frames within frames. Remember too that you can always trim your final print, using L-shaped cards (page 164) to help discover where best to prune its shape. If you have an APS film size camera it will allow you to choose between three format ratios before

Figure 2.4 Back-lighting here localises colour, forming the centre of interest.

each shot. The setting you make alters frame lines in the viewfinder and also informs the processing lab to print your picture the required shape. See page 42.

3 Creating a point of emphasis

Most photographs are strengthened and simplified by having one main subject or

> **Tips and Reminders**
>
> ▪ Develop viewfinder confidence – spend time getting really familiar with framing up pictures from a range of different subjects (you don't always need to shoot film).
> ▪ Remember to check out the background, and fill up the frame.
> ▪ Be adventurous with your camera viewpoint. Stand on a chair, crouch near the floor, move to one side or further back. Come in closer or zoom the lens to fill up the frame.
> ▪ For most accurate viewfinding use a single lens reflex or a digital camera with LCD screen, page 43. These will show you the actual image formed by the camera lens.

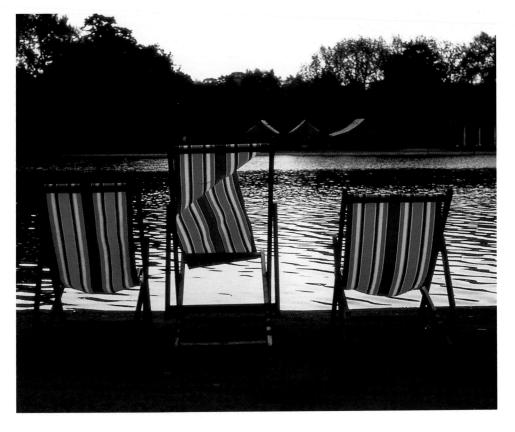

colour or tone, or by the way the subject is shown within some eye-catching shape either in front or behind it. To achieve these results it is once again important to learn to seek out the right camera viewpoint and compose your pictures in the viewfinder with thought and care.

Using lines

Lines are formed in a picture wherever lengthy, distinct boundaries occur between tones or colours. A line need not be the actual outline of an object but a whole chain of shapes – clouds, roads and hedges, shadows, movement, blur – which together form a strong linear element through a picture. Clear-cut lines steeply radiating from, or converging to, a particular spot (as in Figure 3.1 for instance) achieve the most dramatic lead-in effects. At the same time their shape (curved, straight) and general pattern (short and

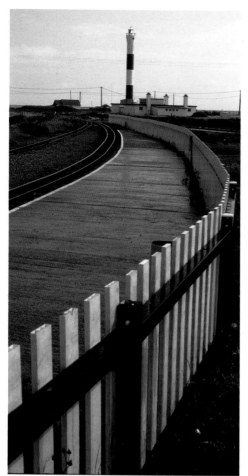

Figure 3.1 Strong lead-in lines from a curved railway platform. Patterns in the fencing and lighthouse relate too.

Figure 3.2 Picked out by colour and tone the lone bather appears to be about to perform some great feat, watched by figures on the distant promenade.

'centre of interest'. In a picture of a crowd, for example, this might be one figure waving a flag; a landscape might centre on a cottage or a group of trees. Having first decided your main element you can help to bring it into prominence and at the same time improve the structure of your shot by calling on a range of long-established visual devices used in picture composition.

In some situations you will be able to create emphasis through making the chosen item stand out relative to its surroundings because it appears to break the horizon, or perhaps is placed where lines within your picture converge. You can also give it prominence through its contrasting

Starting Photography

Figure 3.3 The building is given emphasis within this landscape by its strong, dominant positioning in the frame.

Figure 3.4 Where lines intersect gives so-called 'Golden Mean' strong positions for the main picture element.

jagged, long and parallel, etc.) can strongly influence the mood of your shot too. Compare the lively, radiating lines and curves of Figure 25.9 or the discord of Figure 25.6 with the calming effect of horizontal lines in Figure 1.1.

You can best control the appearance of lines in your picture by where you position the camera – high, low, near, far, square-on or oblique to them. As you try each of these different viewpoints observe carefully in the viewfinder how objects overlap or appear to join up with others in front or behind them to create useful shapes and lines. Then change focal length (zoom in or out, page 58) if necessary to frame up exactly the area you need.

Positioning within the picture format

Most beginners position the main subject they want to emphasize centrally in the picture. This may work well for a strictly symmetrical composition like Figure 2.1 with the child's face centred in whirling concentric circles, but it easily becomes repetitive and boring. There is however a viewer-researched classical guide to placing the principal element called the 'golden mean' which artists have favoured in composition over the centuries. The concept is that the strongest, most 'pleasing' position is at one of the intersection lines dividing vertical and horizontal zones in an 8:5 ratio. Figure 3.4 shows the four so-called 'strong' positions this gives within a 35 mm camera's picture format ratio.

The golden mean is an interesting guide in photography but, as with other

forms of picture making, it is something which should never be slavishly adopted. Figure 3.3 uses this classical sort of placing; and Figure 3.8, although very different in subject matter, does the same. Figure 3.6 and Figure 6.1 are both examples of a centralized main point of interest, but again it forms part of a carefully considered composition. Lines and tones elsewhere in these pictures all contribute to a unified, symmetrical structure. Pictures with their main element placed very off-centre against plain surroundings tend to look unstable; but they can be lively and have a spacious, open-air feel. Off-centring can work very well where another but secondary element (typically on the opposite side of the frame) relates to it and gives your picture balance. This is discussed on page 16.

Contrasting with surroundings

Making your main element the lightest or darkest tone, or the only item of a particular colour included in the picture will pick it out strongly. This is also a good way to emphasize an interesting shape and help set mood. For maximum emphasis pick a camera position which shows your chosen item against, or surrounded by, the most contrasting background. Bear in mind that the eye is most attracted to where strong darks and lights are adjacent, so make sure the emphasis really is where you want it to be. Often you can use the fact that the background has much less, or more, lighting than your main subject and then expose correctly for what is the important part (make sure your camera's exposure settings are not over-influenced by the darker or brighter areas around it. This is explained on page 55).

Remembering how photographs step up the appearance of contrast in a scene preview roughly how it will record by half-closing your eyes and looking through your eyelashes. Shadows now look much darker and contain less detail. In a really high contrast situation – like the two figures in the pedestrian underpass in Figure 3.6 – you can expect a silhouette effect

Figure 3.5 The shape of the tyre frames the man and also 'holds together' the group as a whole.

Starting Photography

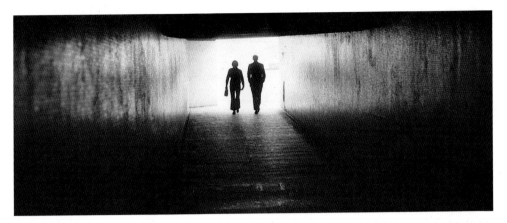

Figure 3.6 Pedestrian underpass.
Backlighting here strongly defines shapes.

when exposure is correct for most of the surrounding tunnel walls. Having dark figures against the lightest part of the environment, and helped by lead-in lines, gives their shapes great emphasis.

The same device, known as *tonal interchange*, is used for the Alice-in-Wonderland cat in Figure 3.7. Here however lighting is soft and even, and plays a minor role. Tonal differences between objects in the picture (the animal being the only white item amongst almost uniformly dark foliage) create their own tonal interchange. Contrast of tone is an especially important emphasizing device when you are shooting something in black and white. Photographed in colour this picture for example would have lost much of its effect due to the variety of colours in the shrubs drawing away attention from the cat.

Tonal interchange is a device worth remembering when you are taking a portrait, where you have some control over arrangement of the lighting. Showing the *lightest* side of a face against the *darkest* part of the background and vice versa, as in Figure 16.1, picks out the shape of the head. Often this lighting is achievable by just part closing a curtain or having someone shade the background with a card from one side.

Don't forget the value of seeking out a handy frame within a frame as the

means of isolating your main subject by colour or tone from otherwise confusing surroundings. Windows and doors are particularly useful – a figure photographed outside a building can be isolated by picking a viewpoint from where they appear framed in front of the dark shape of an open entrance behind them (preferably some way back, and out of focus). Similarly a closed door may give a patch of coloured background. Take care however – this local surround should never contain colour or patterning in such a strong manner that it overwhelms or camouflages your main subject. Other instances of 'frames' range from the clear-cut (but subject-relevant) shape of the tyre

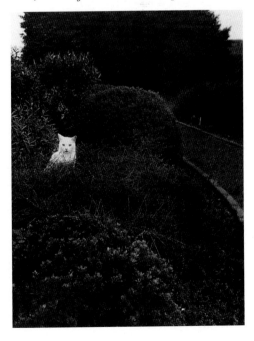

Figure 3.7 (Right) Tone difference in the subject matter itself picks out the cat from its surroundings.

Picture Making

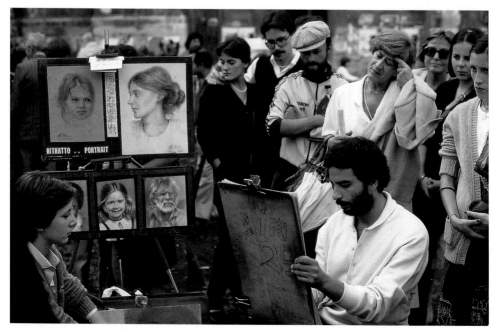

Figure 3.8 Street artist, Montmartre. Having framed up a potentially fruitful situation like this pick your moment from the various changing expressions.

in Figure 3.5, to the less obvious lines of cloud and foliage forming a triangular space around the building in Figure 3.3.

Choice of moment

Of course, if you are photographing someone you know, or a largely 'still life' subject or landscape you often have sufficient time to pick some means of emphasis such as the use of line, or tone, or positioning in the frame. But in a fast-changing, active situation often the best you can do is choose the most promising viewpoint and wait for the right moment. Sometimes this will mean first framing up a background shape or foreground lead-in, and then waiting patiently for someone to enter the picture space. On the other hand your picture may be full of people surrounding some relatively static element, like the painter in Figure 3.8. Having framed up the scene – artist, model and display of work – the moment to shoot is dependent on the expression of bystanders reacting to his drawing (not shown and so only imagined).

Always be on the lookout for fleeting comparisons which support and draw attention to one element – your main subject. Perhaps you can do this by showing two different 'compartments' in your picture. For example, comparing people framed in adjacent windows of a crowded bus or row of telephone booths. A mirror on the wall or some other reflective surface (Figure 23.3) is another useful way of bringing two quite separate components together into your picture.

4 Picking lighting conditions

Most photographs (especially when you begin) are taken under 'existing light' con-

Tips and Reminders

■ A subject on the move across your picture can be isolated from surrounding (static) clutter by means of blur. Like turning your head to follow the action you need to shoot while panning your camera. See page 112.
■ Contrasting the colour between main subject and surroundings is often the most productive emphasizing device on dull days when lighting is flat and there is a lack of helpful lines and shapes.
■ When your main subject is at a distance different from everything else try to pick it out as the only item sharply focused, see Figure 12.4 and Figure 12.7. (This calls for really accurate focusing and use of minimum depth of field, page 51.)

ditions. This term means natural or artificial lighting as it exists for your subject at the time, rather than flash or lamps in the studio which are used to provide a fully controlled lighting set up, see pages 64 and 135. It's easy to regard the lighting by which you see the world around you simply as illumination – something taken for granted. But as well as giving the eye the basic ability to *see*, it can be responsible for communicating strong emotional, subjective responses too. In fact the effect of lighting on a subject is often the reason for taking a picture as much as the subject itself.

We have all experienced the way the appearance of something is transformed under different weather conditions or at different times of the day, due to changes in the direction, colour, quality (e.g. overcast or direct sunlight) and contrast-producing effect of the light. You may not be able to exert control over these existing light conditions, but excellent pictures often result from your recognizing the right time and best camera position, choices which greatly influence the whole mood of a picture.

Quality and direction

The so-called quality of the light ranges from 'hard' to 'soft'. Hardest natural light comes direct from the sun in a clear sky; objects then cast well-defined, hard-edged shadow shapes and these may contribute strong lines and patterns to a picture as well as stark, dramatic contrast. Figure 3.2 is an example where well-defined shadow shapes on a sunny day become a key part of the picture, bringing together figures in front of, and behind, the camera. In Figure 4.1 sunlight from one side, 90° to the subject, gives a strongly three-dimensional effect. Lit parts are well defined, forming a strong pattern especially where picked out against an area of solid black shadow in the background. Colour is strong. However, you must be careful when photographing very contrasty pictures like this. It is important to expose acurately because

Figure 4.1 Wild poppy plants, side-lit against deeply shadowed distant foliage and shot from ground level. The complex delicate pattern resembles musical notes.

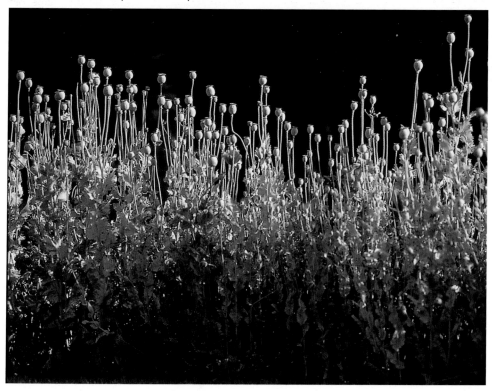

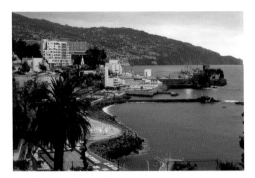

Figure 4.2 Funchal harbour, Madeira. 7pm.

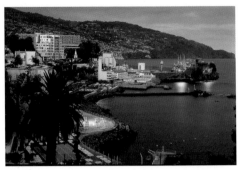

Figure 4.3 Same viewpoint, 20 mins later.

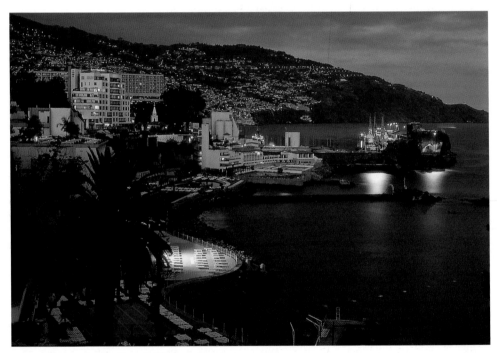

Figure 4.4 7.30 pm, best lighting balance.

Figure 4.5 Minutes later, deeper shadows.

Figure 4.6 By 8.00 pm all natural light gone.

Starting Photography

even a slight error either 'burns out' lightest detail or turns wanted shadow detail impenetrably dark. See page 55. Beware too of shadows being cast by one plant onto another, as this may give confusing results.

Softest quality light comes from a totally overcast sky. Shadows are ill-defined or more often non-existent, so that lines and shapes in your picture are created by the forms of the subject itself. A picture like Figure 3.8, full of varied shapes and colours, is best shot in soft, even lighting to reveal maximum overall information without complications of shadow. Even on a clear, sunlit day you can still find soft lighting by having your subject totally in shadow – for instance in the shade of a large building where it only receives light scattered from sky alone. Results in colour may show a blue cast however, unless carefully corrected in printing. Notice how hazy sunlight gives an intermediate, semi-diffused lighting effect. Shadows are discernible but have ill-defined, well-graduated edges and there is less contrast than given by sunlight direct, see Figure 16.2. Intermediate lighting conditions like this are excellent for many photographic subjects, and are especially 'kind' to portraits.

Time of day

Throughout the day the sun moves its *position* around the sky; the *colour* of its light reaching us also changes at dawn and dusk. Combined with the effects of weather and other atmospheric conditions like haze or smoke you have a tremendously wide range of lighting opportunities. If possible forward plan to ensure that you are in the right place at a time when a fixed subject such as a landscape receives lighting which brings out the features and creates the mood you want to show.

Photography at dusk is often very rewarding because daylight then alters appearances minute by minute. In the coastal scene opposite at first early evening sunlight diffused by hazy cloud gives soft, overall lighting. A short while later as the sun sets this soft light turns pink and is directed from a lower level. Darkness is growing, making the orangey light within the town become more apparent. This change of intensity balance continues in the remaining series until land merges with sky and the scene consists only of contrasty pools and spots of light. Often a landscape like this is best shot during the brief period when there is enough daylight in the sky to still just make out the horizon, yet most of the buildings have switched on their lighting – not difficult to judge by eye. (A firmly mounted camera with automatic exposure measurement can adjust settings as daylight dims, here 1/8 second for the first picture and up to 70 seconds for the last).

Mixed lighting

Pictures lit with, or containing, a mixture of sources – daylight, domestic lamps, fluorescent tubes, street lighting etc. – will not photograph all the same colour. Most colour films are designed to be accurate in daylight. Looking at a distant scene with mixed lighting like Figure 4.4 you notice and accept differences of colour, even though they are exaggerated when photographed. But it would be a mistake to shoot a portrait lit by the pink light of dusk, or by the floodlighting on the foreground terrace. Skin rendered pink by one and yellow by the other looks odd in isolation, and is probably beyond the ability of your processing lab to normalize in printing. Keep to lighting to which your film is 'colour balanced', page 136.

Problems can occur too when photographing people, food, flowers and similar 'colour-sensitive' subjects in surroundings

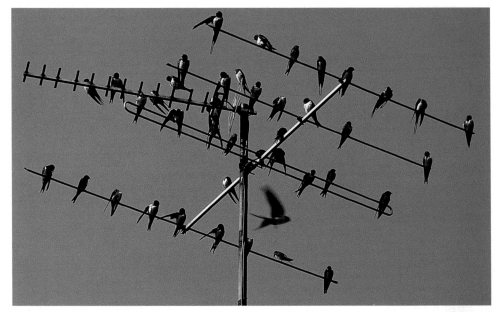

Figure 5.1 The varied pattern of swallows resting on a TV aerial. (See also version on page 125.)

which strongly tint daylight. The greenery of sunlit grass and foliage in an enclosed garden or woods may do this, or just a nearby strongly coloured wall or vehicle – particularly with subject close-ups. (Oddly enough wrong colour becomes much more acceptable if your picture actually shows the environment which was its cause.)

5 Pattern, texture and shape

Most photographs are 'subject orientated', meaning that who, or what, is featured in the shot is of the greatest interest. Others are more 'structure orientated' – enjoyed not necessarily so much for the subject as for the way the picture has been seen and constructed. In practice both aspects should ideally be present, if you want a unified picture rather than a random snap.

Pattern and shapes used in photographs are like notes and phrases used to structure music. But in visual image form they are linked with texture too – each one of the three often contributing to the others. Pattern, for example, may be formed by the position of multiple three-dimensional shapes, like the birds above. Or it might be no more than marks of differing tones on an otherwise smooth, flat surface. Then again pattern can be revealed on an even-toned *textured* surface through the effect of light – as with the weatherboard in Figure 5.2 opposite. Pattern, texture and shape, should be sought out and used as basic elements of composition provided they support and strengthen rather than confuse your picture.

Pattern

Be wary of filling up your picture with pattern alone – the result is usually monotonous like wallpaper, and without any core of interest. You can help matters by breaking the pattern in some way, perhaps having one or two elements a different shape or colour. In Figure 5.1 the birds have spaced themselves out evenly but monotony is broken by differences in the way some are perched, and a camera viewpoint from which aerials of different design overlap. So in effect three patterns are at work. Another way to create variety in a regular pattern is to photograph it from a steeply oblique viewpoint, in order to get a difference in size.

Shadows frequently form interesting patterns, especially when the surface receiving the shadow is undulating rather than flat. You can see this for instance when the shadow of a window frame falls on pleated white curtaining.

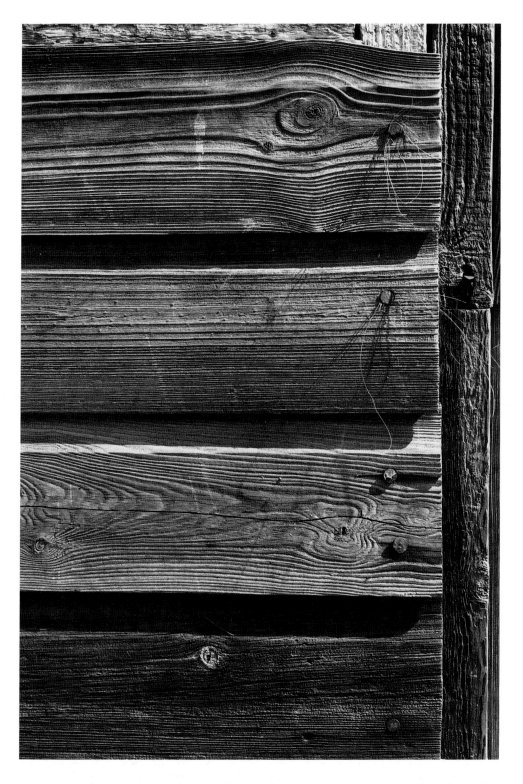

Figure 5.2 Oblique, direct sunlight emphasizes the texture and pattern of weathered wood.

Picture Making 21

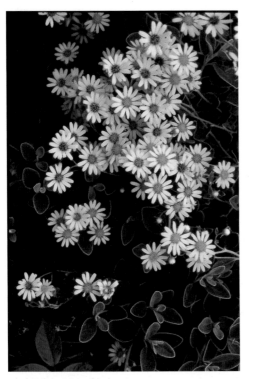

Texture

Revealing the texture in the surface or surfaces of your subject helps to make a two-dimensional photograph look three dimensional. Texture also adds character to what might otherwise just be flat-looking slabs of tone and colour, helping to give your subject form and substance. All sorts of types and sizes of interesting textures exist around us. Rough wood or stone comes immediately to mind, but look also at the texture of ploughed earth, plants, ageing people's faces, even the (ephemeral) texture of windblown water. In rugged landscapes distant hills and mountains present texture on a giant scale.

There are two essentials for emphasizing texture. One is appropriate lighting, the other is the ability to resolve fine detail (e.g. accuracy of focusing, no camera shake, or a light recording material without a pattern of its own). Where the subject's textured surface is all on one plane, as in Figure 5.2, direct sunlight from one side will separate out the raised

Figure 5.3 Near-identical shapes forming a random pattern picked out by their colour contrast. Overcast daylight.

Figure 5.4 (Below) Shape created by a simple natural situation, and helped by a careful camera viewpoint.

Starting Photography

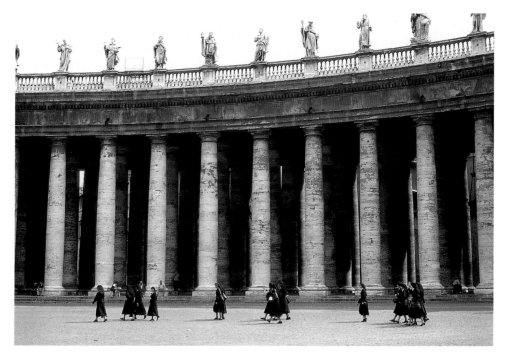

Figure 5.5 Rome. Regular stone shapes related to a scattering of nuns.

and hollowed parts. The more the angled light just grazes the surface the greater the exaggeration of texture.

Such extreme lighting also tends to leave empty black shadows – if these are large and unacceptable pick a time when white cloud is present in other parts of the sky, and so able to add some soft 'fill-in' light. When your subject contains several textured surfaces shown at different angles the use of harsh lighting from one direction may suit one surface but lights others flat-on or puts them totally in shadow. More diffused, hazy sunlight (but still steeply directed from above or one side) will then give best results. What you can learn from sunlight can also be applied on a smaller scale, working with a lamp or camera flash, in the studio (see page 138).

Shape
A strong shape is a bold attraction to the eye, something that you can use to structure your whole picture. It might consist of one object, or several items seen together in a way that forms a combined shape, like

Figure 5.4. Shape is also a good means of relating two otherwise dissimilar elements in your picture, one shape echoing another, perhaps in a humorous way. Bear in mind too that shapes are often made stronger when repeated into a pattern – like the formal row of regular chimney shapes in Figure 17.5 or (very differently) the irregular pattern of identically shaped yellow flowers in Figure 5.3.

The best way to emphasize shape is by careful choice of viewpoint and the use of contrast. Check through the viewfinder that you are in the exact position to see the best shape. Small camera shifts can make big changes in edge junctures, especially when several things at different distances need to align and combine. See false attachment, page 75. If this position then leaves your subject too big or small in the frame remain where you are but zoom the lens until it fits your picture.

Shape will also gain strength and emphasis through contrast with its surroundings – difference in tone or colour of background and lighting. An extreme instance here is a shape seen against the light as a silhouette. Sometimes you will find it possible to fill up a shape with pattern. Figure

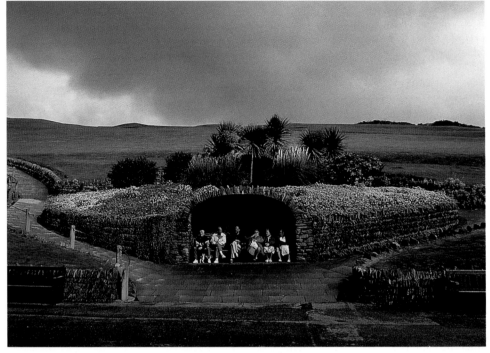

Figure 6.1 Seaside gardens. The garish colours of a man-made landscape. Symmetrical framing strengthens its artificial feel.

13.13 does this using a cast shadow and making the camera set exposure for darkest detail only, so 'burning out' the surround.

6 Using colour

Like shape and pattern it may be the *colour*

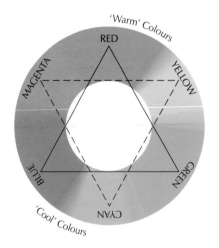

Figure 6.2 Spectrum colours. Hues shown most opposite on this wheel are termed 'complementary' to one another.

in a scene which first attracts your eye and becomes a dominant feature in your picture. (Just switch your TV or computer screen between colour and black and white settings to prove how much colour contributes to an image). Colour can help create harmony or discord. It may pick out and emphasize one important element against all others, or link things together as in Figure 6.3, by containing pale hues close to one another in the spectrum. A more varied pair of colours will interact and gain contrast from one another, especially if they are strong hues well separated and 'complementary' in the spectrum. The resulting effect may then shout for attention – lively and exciting or perhaps just garish.

Notice too from pictures combining contrasty colours how reds often seem to advance or 'come forward' while greens and blues 'stand back'. Even black or white is influential. Areas of black surrounding small areas of colour can make them seem luminous and bright, as in Figure 6.4. Adjacent white makes colours look darker.

Once again the key to practical suc-

cess is *selection* – mainly through tightly controlled framing and viewpoint. Rigorously exclude from your picture any elements which confuse or work against its colour scheme. Where possible select lighting conditions which help to present colours in the way you need. For example, under overcast weather conditions have you noticed how a car which looked brilliant red in hard sunlight reflects light from the white sky in its polished surface and appears a diluted colour? Similarly atmospheric haze or mist in a landscape scatters and mixes white light in with the coloured light reaching you from distant objects, so that they appear less rich and saturated. Then, if dull overcast conditions change to direct sunlight (especially immediately after rain), clear visibility enriches and transforms all the colours present.

Colour of the light

The actual colour of the light on your subject at different times of the day and from different light sources – domestic lamps or

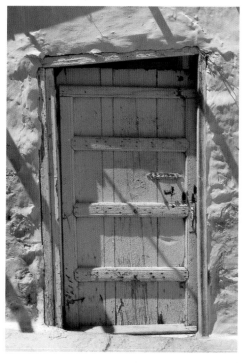

Figure 6.4 Water on a new road surface. Colour, pattern and shape appear in unexpected places. Camera viewpoint is critical here – colours alter with change of angle.

Figure 6.3 A simple sun-bleached door, reminder of Greece. Adjacent pastel colours work harmoniously together.

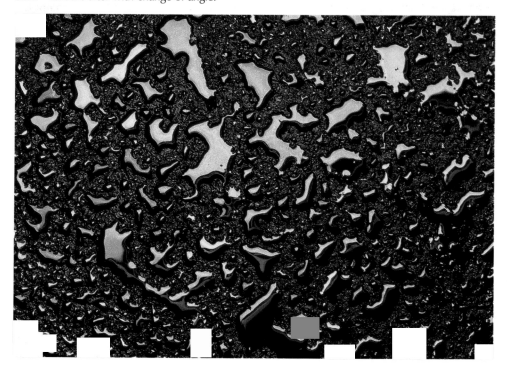

candles for instance – can make big differences to the emotional effect of your picture. The comfortable mood of a cottage interior may be intensified by a warm colour cast from domestic lights and firelight. Bare tree branches in winter can appear cold and bleak in light from a clear blue sky, or be transformed in the orangey light of sunset (see Figure 13.12).

So subject colour is never completely constant and need not always be strictly accurate when atmosphere and mood are your main priorities. An empty ruined building can seem more mysterious in a photograph with a dominant colour scheme of blues and grey-greens, especially when the *overall* tone of the picture is dark (low key) too. A 'cold' colour filter over the lens, page 118, may help to achieve this effect. Other macabre results – inhuman-looking portraits for example – are possible using off-beat but easily found light sources such as sodium street lighting, at night. You can judge by eye when lighting of this kind makes familiar colours such as red look just

Figure 6.5 A spooky portrait taken on colour film at night under a sodium street lamp.

dark grey, and skin seem an unholy greenish yellow. The distortion is even stronger when recorded on regular daylight type colour film.

Finally, don't overlook the value of blurred and 'stretched out' semi-abstract shapes and streaks of colour for making pictures depicting action and movement in dynamic ways. At night, fairgrounds or just roads with busy traffic lanes will provide you with fruitful subject matter. See page 111.

Figure 6.6 The crispness of winter with its sparkling, back-lit frost. The cold colour cast here is due to the presence of blue sky.

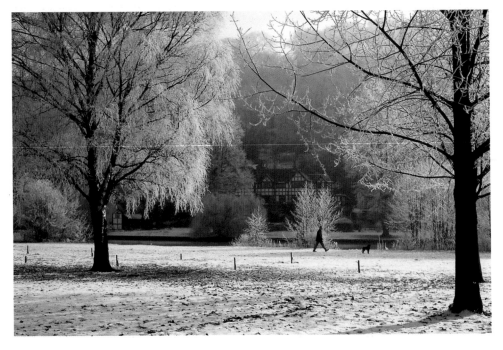

Projects: Developing a personal approach

This first part has been concerned with 'seeing' – with not taking simple everyday objects for granted but observing them as mixtures of shapes and forms, with various colour and pattern characteristics and set against a background. Over-familiarization as to what things are actually *for* (or who people *are*) easily blunts your visual sense. Looking and photographing in a completely unfamiliar environment like a strange town or country is often more productive because newly seen things trigger perception strongly. The more you begin to see objects as potential picture subjects the less your photography will be limited to clichés like postcard-type views or the conventional family group.

At the same time the various structures of picture making itself allow plenty of scope for personal approach. For convenience, ways of composing pictures have been discussed here under framing, lighting, colour, etc, but in practice almost all photographs (including most of the ones reproduced here) use a *mixture* of devices. One may be more effectively used for a particular set of circumstances then another, but rarely to the exclusion of all others. You have to decide your priorities and seize opportunities on the spot.

A good way to develop awareness of picture possibilities is to set yourself projects. These can be applied to subjects which interest you – family, locations, sport, etc. The example projects which follow are similar to assignments and tests in photography course programmes. You will probably be able to find subjects in your locality for most of them, even though they differ somewhat from the suggestions made. Don't slavishly copy pictures in this and other books. Approach each project as a chance to make your own discoveries – sometimes these come from producing unexpected images (including mistakes!) worth following up later.

'Developing your eye' in this way will also provide a powerful incentive for learning technical aspects of photography in order to get what you want into final picture form. The way cameras work and how their controls can contribute to results are the themes of the next two parts.

Project 1 Most cameras are used at eye level, so most photographs show the world from this height. Take six pictures of familiar subjects using your camera only below waist height or above normal head height.

Project 2 Making appropriate use of colour, lighting, composition and expression take two portraits of the same person. One should show your subject as gentle and friendly, the other as sinister and frightening. Keep clothing and setting the same in each picture.

Project 3 Make a series of three pictures of one of the following subjects: wheels; doorsteps; or trees. One photograph should emphasize shape, another pattern, and the third colour.

Project 4 Shoot three *transiently* textured surfaces. Suggestions: rippled water; clouds; billowing fabric; smoke. Remember choice of moment here, as well as lighting.

Project 5 Find yourself a static subject in a landscape – an interesting building, a statue, even a telephone box or tree – and see in how many ways you can vary your viewpoint and still make it the centre of interest. Utilize line, tone and colour.

Project 6 Take four pictures which each include a cast shadow. Use your own shadow, or one cast by a variety of objects shown or unshown.

Project 7 Using your camera as a notebook, analyse shapes found in your local architecture. Do not show buildings as they appear to the casual eye but select areas strong in design.

Project 8 Produce three interesting pictures of people in surroundings which can be made to provide strong lead-in lines, e.g. road and roof lines, steps, corridors, areas of sunshine and shadow. Make sure your subject is well placed to achieve maximum emphasis.

Project 9 Machinery often has a regularity of form. Produce a set of four differing images which make this point, either through four separate mechanical subjects *or* using only one of them but photographed in a variety of ways.

There are further projects on pages 68, 100 and 133.

Part Two Camera and Film

7 Camera principles

The word *photography* means *drawing* (or *writing*) with *light*. It's a good description because every time you take a photograph you are really allowing light from the subject to draw its own picture on film. But just how does this 'automatic drawing' take place? Have you ever been lying in bed in the morning watching patterns formed on walls or ceiling by sunlight coming through gaps in the curtains? Sometimes the shadowy shapes of trees and buildings can be made out, especially if the curtains are dark with only one narrow space between them. If you can use a room with a window small enough, cover the window completely with black paper or opaque kitchen foil. Pierce a small clean hole through the black-out with a ball-point pen. Provided the daylight is bright and sunny you should be able to see the dim outlines of the scene outside projected on a piece of thin paper held about 30 cm (1 ft) from the hole (Figure 7.1). Various shapes should be visible although everything will be upside down.

This arrangement for making images is called a *camera obscura* meaning 'darkened chamber'. It has been known for centuries, and all sorts of portable camera obscuras about the size of boxes were made which also allowed people to trace over the image, and so help them draw scenes. Figure 7.2 shows a camera obscura you can make yourself out of an old cardboard cylinder and tracing paper. The image is upside down because light always travels in straight lines. Light from the *top* of the window here passing through the small hole reaches the *bottom* of the image on the paper viewing screen.

Enlarging the hole makes the image brighter but much more blurred. However, you can greatly improve clarity *and* brightness by using a magnifying glass instead of just an empty hole. A magnifier is a piece of glass polished so that its edges are thinner than its centre. This forms a converging *lens*, which is able to give a brighter and more detailed image of the scene, provided it is the correct distance from the screen. Try fitting a lens of this kind to the hole in your camera obscura. You will find that you now need some way of altering the distance between lens and screen ('focusing') until the best position is found to give a clearly defined image. All properly made camera lenses are made up of several lenses together in a single housing. In this way the faults, or 'aberrations', of individual lens elements cancel out to give clearer, 'sharper' images.

Figure 7.1 A small hole in a window blackout forms a dim image of the sunlit garden onto tracing paper.

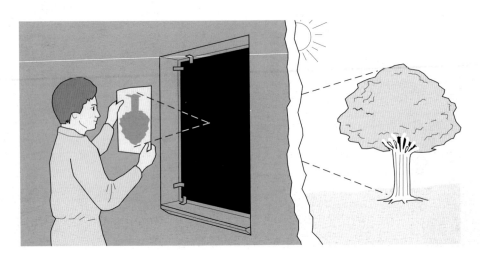

Starting Photography

Figure 7.2 Home-made camera obscura.
(Paint its inside surface matt black.)

Light-sensitive film

We have now almost invented the photographic camera, but need some way of recording the image without actually having to trace it by hand. There are many materials which are sensitive to light. Curtains and carpets and paintwork of all kinds gradually fade under strong illumination. Newspaper yellows if left out in the sun. The trouble with these sorts of materials is that they are much too slow in their reaction – exposure times measured in years would be needed to record a visible picture in the camera. So instead most cameras use film coated with chemical compounds of silver called silver halides, which are extremely light sensitive and change from creamy colour to black. The silver halides are mixed with gelatine and coated onto plastic film, giving it a pale yellowish/orange appearance called a 'light-sensitive emulsion'.

Scientists discovered too that it is not even necessary to wait until the silver halides darken in the camera. You can just

Figure 7.3 Camera – basic principle. A simple lens forming an image on 35 mm film.

let the image light act on it for a fraction of a second, keep the film in the dark, and then later place it in a solution of chemicals which develops the silver until the recorded image is strong enough to be visible.

With most films processing gives us a *negative* picture on film. Subjects which were white appear as black metallic silver, and dark subjects as clear film. Parts of the subjects which were neither light nor dark are represented as intermediate grey density. The negative is then printed in the darkroom onto paper coated with a similar emulsion containing silver halides. After development the image on the paper is 'a negative of the negative', i.e. the paper appears white where the original subject was light, black where it was dark and (assuming you are using monochrome materials) a suitable grey tone where it was in between. We have a *positive* print. The advantage of using negative and positive stages is that many prints can be run off one camera exposure. And by putting the negative in an enlarger (which is rather like a slide projector) enlarged prints can be made. So you don't have to have a big camera to make big photographs.

Figure 7.4 shows in basic form the optical and chemical steps in making a black and white photograph. Most pictures of course are shot in colour, but the same principles apply. Colour films are coated with several emulsion layers, sensitive to blue, green and red. After appropriate processing colour negative film carries images which are reversed in colour (blues appear yellow, greens magenta etc.) as well as in tone. When such a negative is enlarged onto multi-coated colour paper the paper responds in a similar way to give a positive print with colours brought back to their original subject hues.

8 The 35 mm film camera

There are so many film cameras you can buy that to begin with it is quite confusing.

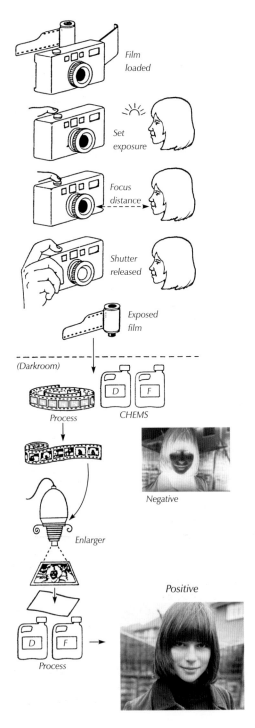

Figure 7.4 Basic stages in making a photograph – from loading and using the camera (top) to processing and printing the film, in this instance black and white.

Starting Photography

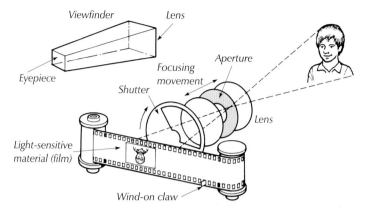

Figure 8.1 The basic elements of a simple 35 mm film camera.

Remember though, every camera is basically just a light-tight box with a lens at one end and a light-sensitive surface (e.g. film) at the other. Figure 7.3 (page 29) showed what taking a picture would be like if the camera body was missing. Cameras using film in rolls vary a great deal in detail but they all possess the basic features shown in Figure 8.1 in some form. These are first and foremost a lens positioned the correct focusing distance from the film; a shutter; a lens aperture; a viewfinder; a means of winding on the film; and an indicator to show how many pictures you have taken.

The *lens* is the most important part of the whole camera. It must be protected from fingermarks and scratches, otherwise images resemble what you see when your eyes are watering. The spacing of the lens from the film has to change for subjects at different distances. Cheapest cameras have the lens 'focus-free', meaning it is fixed for what the makers regard as the subject distance for average snaps. Some have a ring or lever with a scale of distances (or symbols for 'groups', 'portraits' etc.). Operating this focusing control moves the lens slightly further from the film the nearer your subject distance setting. Many modern cameras have lenses with an autofocusing mechanism able to alter focusing to suit the distance of whatever the camera is pointing at in the central area of your picture. In all cases though anything nearer

than the closest subject setting the camera allows will not appear sharp, unless you fit an extra close-up lens or extension ring (see page 95).

The *shutter* prevents light from the lens reaching the film until you press the release button, so it allows you to decide exactly when the picture will be taken. On simplest beginners' cameras it may function at one speed only, typically opening for about 1/25 second, although this may not be marked. But shutters on more advanced cameras offer a range of ten or so speed settings, from several whole seconds down to 1/1000 second or less. Having a choice allows you to 'freeze' or 'blur' moving subjects, and also compensate for dim or bright lighting. On fully automatic cameras such as modern compacts the shutter speed is selected by the camera mechanism itself, mostly

Figure 8.2 Aperture adjustment set (left) for bright sun and (right) cloudy weather. Top: Simple camera uses symbols. Bottom: Camera using *f*-numbers.

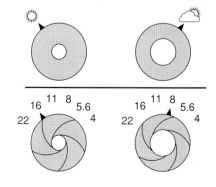

according to the brightness of the image and light-sensitivity of your film.

The *aperture* (also known as the *diaphragm* or *stop*) is a circular hole positioned within or just behind the lens. It is usually adjustable in size like the iris of the eye – changing to a smaller or larger diameter makes the image dimmer or brighter, so again this is a means of compensating for strong or weak lighting conditions. The shutter therefore controls the time the image is allowed to act on the film, and the aperture controls the brightness of the image. Together they allow you to control the total exposure to light the film receives. The aperture also has a very important effect on whether parts of scenes closer and further away than the subject for which the lens is focused also appear sharp. The smaller the aperture the greater this foreground-to-background sharpness or '*depth of field*' (see page 50).

Very basic cameras have one fixed aperture, or 2–3 settings simply marked in weather symbols. Most single lens reflex cameras offer half a dozen aperture settings which are given '*f*-numbers'. Each change of *f*-number lets in half, or double the light, this is explained further on page 48. Automatic cameras have an aperture setting selected by the camera mechanism in response to the brightness of your subject lighting, and often display no settings at all.

The *viewfinder* allows you to aim the camera and preview how much of your subject will be included in the picture.

Some cameras (non reflex types) have a direct viewfinder which you can recognize by its own separate window above the lens, Figure 8.4 and Figure 8.5. Others (single lens reflex cameras) allow you to look inside the camera itself and view the actual image formed by the lens, page 35. Direct viewfinders are bright and clear, but less accurate than reflex systems for composing pictures, particularly close-ups. You have to follow correction lines denoting the true top edge of your picture at the camera's closest focusable distance, Figure 8.3.

Film wind on. Cameras accept 35 mm wide film in cassettes and use a roller with teeth to engage in the film's two rows of perforations. Winding-on after each picture

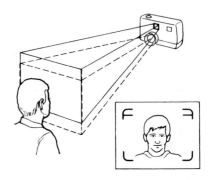

Figure 8.3 A direct viewfinder shows the limits of your picture with lines or corners. Short lines redefine the top of the picture (correcting 'parallax error') for the closest subjects the lens is able to focus.

is taken (by hand or motorized) moves the film onto a built-in take-up spool. At the same time a frame number, displayed in a window on the camera body, shows how many shots you have taken.

Although all the features above are found in every camera the way they are presented to you to use (or arranged to function automatically) varies from one brand to another. Cameras fall into two main 'families':

1 Compact cameras, which have a direct viewfinder and tend to be all-in-one, with no add-on extras.
2 Single lens reflex cameras which are slightly larger and heavier, and allow you to see through the taking lens. These are often the nucleus of a kit comprising a whole range of interchangeable lenses and other attachments. Both are made in manual and automated forms.

Beginners' cameras

Young photographers often start with a low-cost compact 35 mm camera – maybe a disposable type or one which you can reload with film.

Disposable or 'single use' basic cameras come with film already loaded and sealed in. After shooting the last picture you hand the camera in to the lab, where it is broken open and the film processed. The cost of a disposable camera is only about

Starting Photography

twice the cost of a film, so it can be treated as a fun camera on the beach or even in the rain.

Compacts. Simplest reloadable compact cameras are the next step up and, like disposables, have a viewfinder window (with eyepiece at the back of the camera) which gives you a direct view of the subject. You see your subject clear and bright, and apparently with everything always in focus. Most settings are 'fixed', so all you have to do after loading the film is to point the camera, press the shutter, and wind on. This sounds ideal but the lens has a fixed setting to focus subjects from infinity (the far horizon) through to about 2.5 m (8 ft) away. You cannot get sharp images any closer, nor can you take shots with foreground detail sharp and background unsharp.

The fixed shutter speed of about 1/125 second avoids camera shake effects when you shoot hand-held, but is too slow to freeze fast subject movement. The fixed (or very limited range) aperture means that you cannot adjust for correct exposure for varying lighting conditions, nor choose between deep or limited depth of field to suit your picture. The viewfinder, being an inch or so from the taking lens 'sees' your subject from

a slightly different position. This difference of viewpoint or *parallax error* becomes greater the nearer your subject. Remember to use the correction lines, Figure 8.3.

Nevertheless, with care reasonable photographs can be taken with a simple compact (Figure 5.4 and Figure 16.7 are both examples) provided you understand and work within its limitations. (Otherwise, you may start with a simple camera, expect too much of it and end up disheartened.) Load fast (ISO 400) film for correct exposure in cloudy conditions, and slow (ISO 100) film for bright sunshine, and use flash indoors.

Advanced compacts. Top-of-the-range compact cameras are much more expensive. They are fitted with lenses giving higher resolution images (noticeable when you make bigger enlargements) and wider apertures (to cope with dimmer light). Advanced compacts still present you with little or nothing to adjust but give technically good results over a wide range of lighting conditions and subject distances. They do this by electronic automation. For example, a camera as shown in Figure 8.5 will sense whether the film you have loaded is fast or slow in sensitivity, together with its length. A sensor behind a small window near the lens measures the brightness of your subject. The camera uses this film and subject information to set an appropriate aperture and shutter speed – ranging from smallest aperture and fastest speed in brilliant lighting, to widest aperture and slowest holdable speed in dim light.

Figure 8.4 Low cost cameras. Left: Single-use disposable type. Right: Reloadable compact. Viewfinder close to lens minimizes differences in viewpoint.
Flash is at a distance, reducing 'red eye' (page 62).

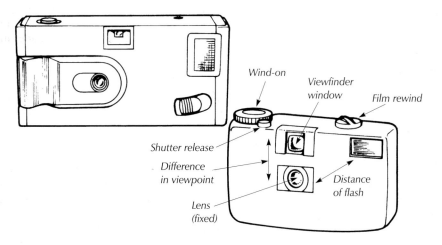

Wind-on
Viewfinder window
Film rewind
Shutter release
Difference in viewpoint
Distance of flash
Lens (fixed)

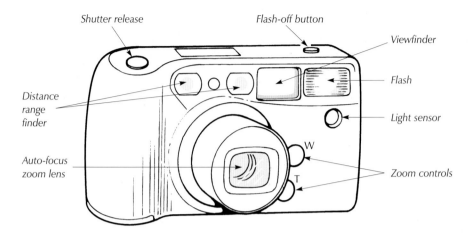

Shutter release Flash-off button

Viewfinder

Flash

Distance range finder

Light sensor

Auto-focus zoom lens

W

T

Zoom controls

Figure 8.5 A fully automatic compact camera with zoom lens.

Two further windows near the camera top sense the distance to whatever you have composed centrally in the viewfinder. As you press the release button the lens adjusts its focusing position to suit this distance. If the subject is too close the camera signals a warning in the viewfinder eyepiece; if lighting is too dim another signal warns you and may automatically switch on the camera's built-in flash. When the flash is in use it will automatically sense how much light to give out, according to subject distance, and whether other lighting is present. After each shot a motor winds on one frame, and after the last picture on the film it winds it all back into the cassette ready to unload.

Often the only control offered, apart from shutter release, is a focal length changing 'zoom' button which makes the image bigger or smaller. In this way you get more (or less) of a scene to fill your picture without having to move further back (or closer) see page 58. The camera's viewfinder automatically zooms too, adjusting to match these focal length changes. It may also tilt slightly according to the distance of your autofocused subject, to help to compensate for parallax error and so more accurately show what you are getting in.

Between completely 'fixed' and completely automatic models you will find a whole range of compact cameras at intermediate prices. Some are cheaper because they omit completely one of the features described. They may lack a zoom lens, or the range of shutter speeds and apertures automatically set may be curtailed, limiting your shooting conditions. Bear in mind that having a camera with settable controls is often an advantage, as you will see in Part Three.

Single lens reflex (SLR) cameras

All SLR cameras have a clever optical system (as shown in Figure 8.6) which allows you to view an image of the subject formed by the lens until just before exposing your picture. Unlike a compact camera the shutter is not in the lens but in the back of the camera just in front of the film. Looking into an eyepiece at the back of an SLR you observe a small, ground-glass focusing screen, onto which the lens image is reflected by a mirror. So you see what the lens sees, and as the focusing control is turned it is easy to examine which parts of the subject are in focus. When you are satisfied that the picture is correctly composed you press the shutter release button. The mirror then rises out of the way, blocking out the focusing screen briefly and allowing the image to reach the back of the camera where the shutter opens to expose the film. As the distance from lens to film is the same as lens to screen (via the mirror) what was focused on visually will also be in focus on the film and there is no viewfinder parallax error, however close the subject.

Since the shutter is at the back of the camera body you can remove the lens and fit others of different focal length, even

mid-film. In fact single lens reflexes are 'system cameras' meaning that the makers offer a wide variety of lenses, and accessories ranging from close-up rings (page 37) to data imprinting backs. So starting off with a camera body and regular lens you can gradually build up quite an elaborate camera outfit bit-by-bit as you become more experienced.

Cameras of SLR design include manual types, which expect you to set most of the controls, up to much more automatic models working to built-in programs. These take many technical decisions out of your hands. Both have their advantages and limitations.

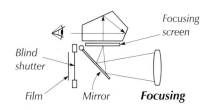

Focusing screen
Blind shutter
Film Mirror **Focusing**

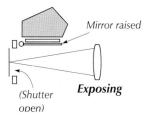

Mirror raised
(Shutter open) **Exposing**

Manual SLRs

A typical manual-only camera (Figure 8.7) has setting dials for shutter; aperture and focus; also a film wind-on lever and a rewind knob. Having loaded and set the speed of your film, you look through the eyepiece and turn the lens focusing ring until the most important part of your picture appears sharp. Typically you then set a shutter speed such as 1/125 second if you are hand-holding the camera (see page 45). Look through the eyepiece, half depress the shutter release and turn the aperture control until a signal light or needle next to the focusing screen indicates that the exposure set is correct.

Figure 8.6 How you view and focus your subject using a manual SLR camera. Top: Visually composing and focusing on the film size screen. Bottom: Pressing the release raises the mirror and opens the shutter just in front of the film.

Alternatively you can first make an aperture setting because depth of field is important (see page 50) and then alter the shutter setting until correct exposure is signalled. Pressing fully on the release then takes your picture, and you must use the wind-on to advance the film by one frame ready for the next shot.

So a manual SLR camera requires you to know something about choice of tech-

Figure 8.7 A manual 35 mm SLR camera offers a full range of controls.

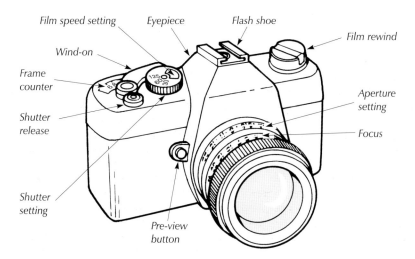

Film speed setting Eyepiece Flash shoe
Wind-on Film rewind
Frame counter
Shutter release Aperture setting
Focus
Shutter setting
Pre-view button

nical settings, but it will tackle a wider range of lighting conditions and subject distances than all but the most advanced compacts. Since it only uses electronics for its exposure meter the camera will still take photographs with its (tiny internal) batteries flat. To use a flash you attach a separate flashgun.

Advanced SLRs

A technologically advanced SLR (Figure 8.8) has features such as autofocusing; film speed sensing; built-in flash; motorized film transport with exposure/wind-on rates of five pictures per second; and what is known as 'multi-mode' functioning. Multi-mode means that by selecting one mode you can have the camera function as if it were manual, or by selecting another have it totally autoprogrammed (just point and shoot). Yet another mode will allow you to choose and set shutter speed but makes every other setting automatically, whilst a fourth mode allows you to make the aperture your priority choice instead.

An SLR camera like this may also offer you five or six modes covering different ways of exposure reading and making settings, plus an almost overwhelming range of other options. You can even programme the camera to take a rapid 'burst' of three pic-

Figure 8.8 Advanced multi-mode 35 mm SLR camera. (For hinge-up flash see page 62.)

tures when you press the button, each one giving a slightly different exposure. Virtually all the camera actions are battery powered – from its internal focus sensor and motor-drive for the lens, to the electronically timed shutter providing a much wider setting range (l/8000–30 seconds for example) than a manual camera.

Typically, all the information concerning the chosen mode, shutter and aperture settings made, number of pictures left, etc., appears on a display panel on top of the camera body. Some of this data is also shown alongside the focusing screen when you look through the eyepiece.

Accessories

A great range of accessories are available for cameras – although almost all are designed for SLR types. Figure 8.9 shows the most useful items.

Extra lenses Provided your camera body accepts interchangeable lenses you can fit a wide angle or telephoto type in place of its standard focal length or zoom lens (the advantages of doing this are explained on page 57).

Extension tubes Fitted between the lens and body these allow you to work very close-up to your subject, see page 95.

Tripod with tilting top A firm support when you want to give exposure times which don't allow the camera to be steadily

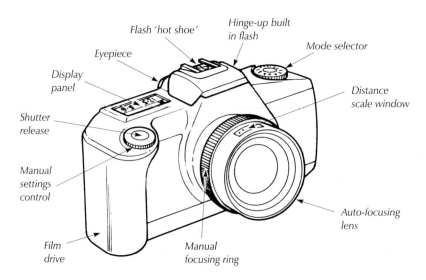

Flash 'hot shoe'

Hinge-up built in flash

Mode selector

Eyepiece

Display panel

Distance scale window

Shutter release

Manual settings control

Auto-focusing lens

Film drive

Manual focusing ring

Starting Photography

held by hand (longer than 1/60 second for instance). Most compact cameras as well as SLRs have a threaded baseplate to accept a tripod.

Shutter release extension As long as your camera is either threaded for a cable release or has connections for a cable switch this accessory minimizes risk of camera shake when you give a long exposure. For cameras not accepting either form of release it may be possible to fit an adaptor.

Flashgun Even if your camera has a built-in flash, a separate, more powerful, unit which can be attached and used instead will allow far more interesting lighting opportunities, see page 64.

Lens hood Shades the lens from flare from strong back or side-light, and also helps protect it from knocks.

Filters A push-on colour filter can be helpful in black and white photography, see pages 90 and 118. Colour correcting filters help colour shots under unusual lighting, and there is a whole range of attachments for special effects.

Eyepiece corrector Some SLR viewfinder eyepieces will accept an eyesight corrector lens. This is of great value if you wear glasses which otherwise prevent your eye being close enough to comfortably see the entire picture format.

So which camera is best?

There is no ideal camera, which is why so many variations exist even within the two mainstream types discussed here. (For cameras using film other than 35 mm wide see pages 42 and 172). Even if money is no object and you buy the most expensive multi-mode SLR, just having so many options available can be confusing, overwhelming your picture making. And yet keeping it set to 'auto-program' is wasteful if you then never use its other possibilities.

Figure 8.9 Useful camera accessories.
A: Extra lenses. B: SLR eye-piece corrector.
C: Extension tube (close-up ring) between SLR body and lens. D: Tripod, and camera clamp. E: Cable release. F: Flashgun, fits SLR 'hot shoe'. G: Lens hood. H: Lens filters.

A modern, automatic-only compact camera is easy to carry and quick to bring into use. It is a truly pocketable camera, lightweight and small (even more so if it is made for APS size film rather than 35 mm, page 42). You don't have to carry accessories either, which encourages you to take the camera everywhere. Without delays making settings you can concentrate on composition, viewpoint and people's expressions when taking pictures, knowing that technicalities like focus and exposure are taken care of.

If you want a bit more image control, without having to understand any technicalities, a compact with zoom lens gives you helpful image size adjustment. The wider the zoom range though the more a camera increases in size and price. If you buy a low cost compact camera remember that poorly lit or fast moving subjects (Figure 9.6, for example) will be beyond its capabilities, as well as accurate and sharp close-ups. SLR cameras

are unrivalled for framing accuracy and close working, but they are heavier and more bulky.

Automatic-only cameras of either kind work on programs which ensure a high level of technical success (e.g. sharp focus, correct exposure) under most conditions. The trouble is that when you are unable to make individual settings – such as distance, shutter speed and aperture – you deprive yourself of many of the creative visual possibilities, as shown here in Parts Three, Four and Six. For someone who wants to understand photography and is prepared to learn to set the controls it is still difficult to beat a manual SLR. Such a camera accepts a great range of accessories, often including the same high quality lenses used on the makers' most expensive model SLR. Again, if you buy an SLR with a choice of modes make sure one of these is 'manual'. Then, having really learnt the controls, you are in an informed position to know whether changing to a semi-automatic or fully programmed mode offers a short cut for particular subject conditions, but will still give the result you want.

9 Films

Film records the image exposed onto it in your camera, using light-sensitive chemicals (silver halide crystals) coated as a gelatine emulsion on a plastic base. The size, shape and how tightly packed these silver halides are basically determines the speed of a film – from fine-grained and relatively 'slow' in reaction to light, to coarser grained and 'fast' in sensitivity.

Colour negative films

These are the most popular and are made in the widest range of types and speeds, particularly in 35 mm size. From colour negatives it is possible to have enlargements made cheaply in colour or (in some labs) in black and white. Labs can also convert negatives and slides onto a photo-CD ready for input into a home computer system.

Black and white films

Black and white films make a refreshing change. Pictures are simplified into monochrome without the realism (and sometimes

distraction) of colour. However, few labs offer a black and white processing service. One solution is to use the type of monochrome negative film – Ilford XP2 for example – which labs can process in their regular colour chemicals and produce black and white results. Black and white is also your best choice to start your own processing and printing, see Part Eight.

Colour slide films

Colour slide films are designed to be 'reversal' processed so that positive colour images are formed in the film instead of negatives. You can then project them as slides. It is possible to have colour prints made off 35 mm slides, but (as with the purchase and processing of the film itself) this is more expensive than off colour negatives. You must be more accurate with exposure when shooting slides and, where necessary, have a filter to correct the lighting (see page 136).

Film information

The film box gives you all the important information. Apart from type, brand, and size it shows the number of pictures, film speed, type, and the 'use by' date.

Film speed

Light sensitivity is shown by your film's ISO (International Standards Organisation) speed rating. Every doubling of the ISO number means that a film is twice as fast. Regard films of about ISO 100 or less as slow in speed, ISO 200 and 400 as medium, and ISO 800 upwards fast.

Choose a fast film if all your pictures will be shot under dim lighting conditions with a simple camera, or when you don't want to have to use a slow shutter speed or wide lens aperture. However, expect resulting prints – especially big enlargements – to show a more visible granular pattern. Sometimes 'graininess' suits a subject, like Figure 9.6. But since it destroys fine detail

Figure 9.1 A range of film types. From the top: (1) 35 mm colour neg. (2) colour slide (3) black and white neg. (4) black and white slide (5) APS colour neg. All actual size.

DX pattern

Figure 9.2 APS cartridge and (right) 35 mm cassette. The DX pattern informs cameras of the film's speed.

and coarsens tones it would not be the best choice for the fine pattern and texture in Figure 9.4. Fast film is also more expensive.

Figure 9.3 Inserting a 35 mm film into a manual or an autoloading camera.

A slow film suits bright light conditions where you don't want to be forced into using a fast shutter speed or small lens aperture. It's clearly the best choice if you want prints with highest image resolution. For most situations though a medium speed film offers the best compromise. Always check that your camera is properly set for the ISO rating of the film it contains.

Expiry date

The expiry date is the 'use before' date on the film box. It assumes average storage conditions away from fumes, heat and humidity. Outdated film becomes less light sensitive, and colours may suffer. To extend shelf life store your films (sealed) in the main compartment of your refrigerator.

35 mm film

The biggest range of film is made for 35 mm cameras. Double perforated 35 mm wide film comes in a light-tight cassette you load

MANUAL FILM LOADING

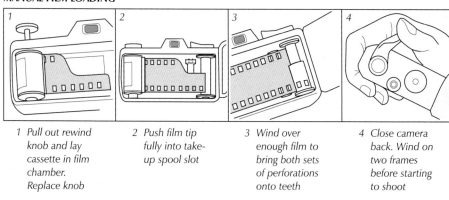

1 Pull out rewind knob and lay cassette in film chamber. Replace knob

2 Push film tip fully into take-up spool slot

3 Wind over enough film to bring both sets of perforations onto teeth

4 Close camera back. Wind on two frames before starting to shoot

AUTOLOAD

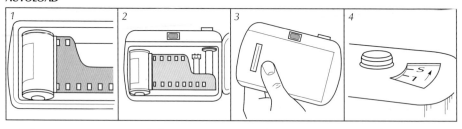

1 Insert cassette (motor-driven camera has no rewind knob)

2 Pull out just enough film to lay across and touch far end

3 Close camera back. Window allows you to read film data off cassette

4 Closing triggers film advance. Counter moves from S to 1

Starting Photography

Figure 9.4 Slow film records finest detail. 125 ISO material was used here.

into your camera's empty film compartment with its paler, light-sensitive surface facing the back of the lens (Figure 9.3). As you take pictures the film winds onto an open take-up spool within the camera. It therefore has to be rewound back safely into the cassette before you open the camera and remove your exposed film. Never load or remove film in bright light – especially direct sunlight. (The slot in the cassette through which the film protrudes has a velvet lining, but intense light may still penetrate.) Always find a shady area or at least turn away from the sun. Speed, length and type are also encoded in a chequer-

Figure 9.5 Typical (ISO) speeds available.

Col. neg.	B&W	Col. slide
Slow fine grain		
25–100	25–125	25–160
Medium		
200–400	400–800	200–400
Fast, coarse grain		
1000–1600	1600–3200	640–1600

Camera and Film

Figure 9.6 Fast 1600 ISO colour negative film. Exposure 1/60 sec at *f* 3.5, at night.

board pattern on the side of the cassette (Figure 9.2). Electrical contacts inside the film compartment press against this pattern and so read and program the camera's exposure measuring circuit for film speed, etc.

Number of pictures

The standard picture format given by a 35 mm camera is 24 x 36 mm, and you can buy cassettes containing sufficient length of film for either twenty-four or thirty-six pictures. A few come in twelve exposure lengths.

APS films and cameras

The Advanced Photo System (APS) is a film format introduced in 1996. APS films are only 24 mm wide, giving negatives slightly over half the area of pictures on 35 mm film. See page 39. They do not fit 35 mm cameras, and so a whole range of scaled down cameras from compacts to single lens reflex designs have been introduced for APS photography. They are similar in price to 35 mm equipment.

APS film comes in an oval shaped cartridge (Figure 9.2) which, when inside the camera opens and pushes out the leading edge of the film to automatically load it. After the last shot is taken the film rewinds automatically and you hand in the cassette for processing. APS film carries a transparent magnetic coating used to record information from your camera to instruct the processing laboratory machinery. For example, a picture shape setting on your camera allows selection of either full 'H' format (9:16 ratio), 'classic' format (2:3, the same height-to-width ratio as 35 mm) or a longer, narrower 'panoramic' 1:3 ratio. This causes the lab printer to crop the particular picture to the shape you selected when framing up your shot.

Other information passed from an APS camera via the film to the lab can also cover the lighting used for each individual shot, and time and date of shooting (ink printed on the back of your photo). APS films and equipment therefore offer many conveniences, but for large prints they do not match 35 mm in final image quality. There is a much wider choice of film types available in 35 mm size, and this larger format is also less costly to have processed than APS.

10 Digital cameras

Digital cameras don't use film of any kind. Camera 'front end' principles (lens, focusing, aperture, flash, etc.) still apply, but in place of removable film there is a fixed grid of microscopic light-sensitive 'picture elements' (pixels) known as a CCD or charge-coupled device. This typically has an equivalent film speed of ISO 100.

Immediately after you have fired the shutter the CCD turns the picture into a stream of digital electronic signals which can be fed into a computer system. The more pixels present the more detailed your recorded image. For example a grid having 640 × 480 pixels gives a just acceptable image viewed on a small computer monitor, but to get 6 × 4 in photo-quality colour pictures out of your computer printer the camera must have several million pixels.

Figure 10.1 Digital camera designs. Each has a LCD viewing screen on back or top.

Since unlike film you can't change the CCD, pixel count has to be considered when you buy the camera and is very much linked to price.

Most digital cameras look like compacts, with a direct viewfinder and/or a small flat display screen on the back. Since this screen is wired direct from the CCD it shows your picture when you are framing up your subject, offering the same parallax-free accuracy as an SLR film camera. After shooting it displays the picture you have just taken. If you dislike your result it can be erased immediately; otherwise it is held in the camera's digital memory or a tiny memory card which slots into the camera back and stores thirty or more pictures in digital form.

Other digital designs (Figure 10.1) include flat-cased cameras with a flip-up

Figure 10.2 Camera's small memory cards can plug into your computer via adaptors.

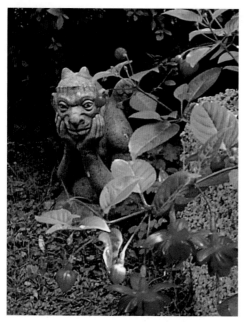

LCD screen and models with a lens and CCD unit which pivots and rotates, or can be unclipped from the camera on a one-metre lead.

After shooting you down-load digital images into a home computer, either direct from the camera or from its removed memory card. Then, having brought up each picture on your computer monitor you can use a manipulation software program to adjust colour, tone down assertive background, etc. See page 125. When the result on the screen is what you want this is printed out as an image on paper through an inkjet or thermal computer printer, Figure 10.4.

Advantages of digital cameras include:
• no film or processing costs;
• shots viewable immediately;
• deleting unwanted shots and reusing file storage means no material wastage;
• pictures can be improved in your computer, and transmitted by e-mail, as well as printed out.

Disadvantages include:
• cameras are much more expensive than their film camera equivalents;
• professional equipment aside, image detail is presently poorer than from 35 mm film, especially when you enlarge;
• heavy drain on batteries, particularly with cameras having LCD screens;
• hard copy materials (paper, ink) more expensive than silver halide colour prints.

Figure 10.3 Picture taken with a Kodak digital compact camera with 1152 x 864 pixel resolution (cropped here by 50 per cent).

Figure 10.4 Images from a digital camera can be downloaded (direct or via its memory card) into your PC. A software program such as *PhotoSuite* then allows you to enhance results on screen, before printing out through an inkjet printer.

Starting Photography

Part Three Creative Use of Camera Controls

Each of the camera's technical features introduced in the previous part – lens focusing, shutter, aperture, etc. – is there for two purposes. Firstly it helps you to get clear, accurately framed and properly exposed pictures of subjects – distant or close, under dim or bright lighting conditions. But each control also has its own creative effect on the image too. This allows you interesting options – in other words you can choose a particular setting for its creative influence, and then adjust the other controls if necessary to still maintain correct exposure. Clearly the more controls your camera offers and the wider their range the more choices you will be able to make. Fully automatic-only cameras work from set programs based on choices set by the manufacturer, but as you will see even here a measure of control is possible – for example by loading fast or slow film.

11 Shutter speeds and movement

A shutter set for 1/125 second should safely avoid overall blur due to camera movement when you are trying to hold it stationary in the hand. This setting will also overcome any blurring of slower moving subjects, particularly if some distance away.

If you want to 'freeze' action subjects you will need a camera offering faster shutter speeds. The athlete in Figure 11.1 was photographed at 1/250 second. Cycle races and autocar events will probably need 1/1000 or 1/2000 second to lose all blur, but much depends on the direction of movement and how big the moving subject appears in your picture as well as its actual speed. Someone running across your picture will record more blurred than the same runner moving directly towards you. Filling up your picture with just part of the figure – by shooting close or using a telephoto lens – again exaggerates movement and needs a shorter shutter speed to freeze detail.

With a manually set camera select a fast shutter setting, then alter lens aperture until the meter signals that exposure is correct. On a semi-automatic or multi-

Figure 11.1 High jump (courtesy Fowey School).

Figure 11.2 Ice-rink, 1/8 sec. Dark subjects blur well against plain white, or the reverse.

mode camera choose 'shutter priority' ('Tv'), pick a fast shutter speed and the camera will do the aperture setting for you. An auto-only camera loaded with fast film will set its briefest shutter speed, in strong light. In fact shooting on film of ISO 400 or 1000 is advisable with all cameras using briefest shutter settings, to avoid underexposing. If you have a simple, one fixed shutter speed camera try instead to swing ('pan') the camera in the same direction as the moving subject (see page 112). This can give you a reasonably sharp picture of your subject against a blurred background. See also flash, page 62.

Slow shutter speeds, say 1/30 second or as long as several whole seconds, may be necessary just to get a correctly exposed result in dim light, especially with slow film. These longer times also allow you to show moving objects abstracted by different degrees of blur. Look at the way faster skaters in Figure 11.2 are 'thinned down' more than others barely on the move, and how different limbs vary in their degree of movement blur. Often action can be suggested more strongly this way than by recording everything in frozen detail.

Working with these longer expo-

Figure 11.3 Camera steadying. Methods include tucking your elbows in (centre) and using forehead and knee (right).

sures however means taking extra care to steady the camera, or camera shake will blur everything instead of just those parts of your subject on the move. Figure 11.3 suggests ways of improving steadiness when using your camera hand-held. Learn to squeeze the shutter release button gently – don't jab it. Even then, if you use settings of 1/30 second or longer, find a table, doorway or post and press the camera firmly against this. Your camera may display a 'shake' warning when it automatically selects a slow shutter speed. Be careful too when using a telephoto lens, because the larger image it gives magnifies camera movement, like looking through binoculars. A tripod, or even a clamp which will secure your camera to the back of a chair, etc., will allow steady exposures of unlimited length. Make sure though it has a pivoting head so you can angle the camera freely before locking it in place. See page 37.

The range of slow shutter speeds

offered on many compacts and manually set SLR cameras only goes down to about one or two seconds. For exposures longer than this SLRs (and a few compacts) offer a 'B' setting. The shutter then stays open for as long as the release button remains pressed, and you time your exposure with a watch. In practice it is best to use an extension shutter release, Figure 8.9, to avoid camera shake. Advanced SLR cameras may set timed exposures of 30 seconds or longer.

Exposure times of several seconds open up a whole range of blur effects that you can first experiment with and then increasingly control – although results always have an element of the unexpected. Pick something light and sparkling against a dark background. At night fairgrounds, fireworks, or simply street lights and moving traffic make good subjects. Pick slow film and use a small lens aperture so that you can give a long exposure time without overexposing. (Some manual SLR camera meters will not measure exposure for B settings, in which case 'cheat' the meter as described on page 110.)

Figure 11.4 1/30 sec. Panning to follow these figures blurs background, not subject.

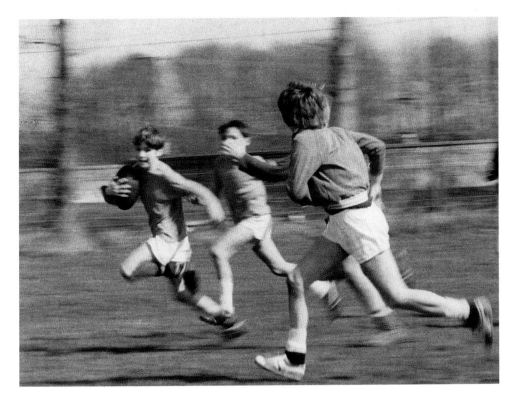

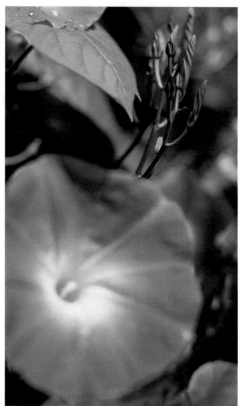

Figure 12.1 Precise focusing emphasizes one chosen element – the flower petals.

Figure 12.2 Here altered lens focus shifts attention to the buds.

12 Focus and aperture

Selectively focusing your camera lens for a chosen part of the subject is a powerful way of drawing attention to it, subduing unwanted details at other distances, and helping to give your picture a sense of depth. In Figure 12.1 and Figure 12.2, for example, emphasis has been switched from the flower to the buds simply by changing focus setting. Think carefully about where your location of greatest sharpness should be. In portraits it is best to focus on the eyes; with sports events you might pre-focus on the cross bar of the high jump or just the sports track line a runner will use.

A manually focused SLR camera allows most scope to actually observe how a particular point of focus makes the whole picture look. With an autofocusing (AF) camera you will probably need your point of focus filling the tiny autofocus frame line in the centre of your viewfinder (see Figure 12.3). Then if you want to compose this point off-centre operate the camera's AF lock (after half pressure on the release) to maintain the same focus while you reframe the picture before shooting.

The degree of autofocusing accuracy your camera will give depends upon the number of 'steps' (settings) it moves through between nearest and furthest focusing positions. Fewer than ten is relatively crude; some have over 100. Where a good AF scores most is when faced with a moving target. Here it will adjust continually to maintain your subject in focus as subject distance changes. However, most autofocusing SLR cameras allow you to change to manual focusing if you prefer to work this way.

Aperture and depth of field

The adjustable size aperture in your lens has an effect on how much of your picture will

Starting Photography

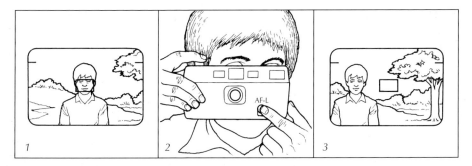

Figure 12.3 An autofocus camera with AF lock allows you to sharply focus a main subject you compose off-centre. 1: First centre the subject in the autofocus rectangle. 2: Half depress the shutter release to make the lens focus, then operate the AF-L control. 3: Now you can compose the subject anywhere within the frame before shooting.

appear in focus. The smaller the diameter of the hole the greater the range of items, at nearer or greater distances, appear sharply focused along with what you actually focused on. A photograph with objects over a wide range of distances clearly focused is said to have considerable depth of field.

Aperture size is described by an 'f-number', and if your camera lens has manual control this will carry a scale of (internationally agreed) f-numbers as set out in Figure 12.5. Notice how the wider the aperture the lower the f-number. To see this in action look at the picture of the girl with apples, Figure 12.4. In both shots the lens was focused for the girl's hands. But whereas one picture was taken at a wide aperture (an f-number of f4) the other was taken at a small aperture (f16). The f4 result has a very shallow depth of field. Only where the lens was focused is really sharp – apples in the foreground and trees in the back-

Figure 12.4 The effect of aperture. In both pictures the lens focus setting remained the same, but changing from f4 to f16 greatly increases depth of field.

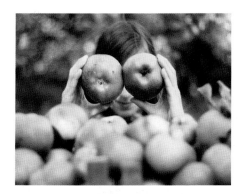

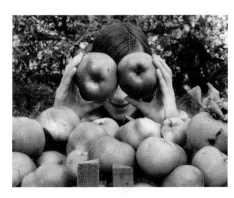

ground are very fuzzy. The other version shows much greater depth of field. Almost everything nearer and further away than the point of focus, the hands, now appears sharp.

Of the two versions the one on the left works best for this subject because it concentrates your attention on the two apple 'eyes'. The same applies to the horse's whiskers shown in Figure 12.7, opposite. But on other occasions – the cornfield shown in Figure 12.6, for example – you may want to show all the pattern and detail clearly from just in front of the camera to the far horizon. So controlling depth of field in a picture by means of the lens aperture setting is a useful creative tool.

As Figure 12.5 shows, each *f*-number also doubles, or halves, the brightness of the image. The wider the aperture offered too, the more expensive and bulky the lens becomes. A simple fixed-aperture camera may only offer *f*5.6; many non-zoom compacts have lenses which 'open up' to *f*4.5 and 'stop down' to *f*16. SLR standard lenses may offer a longer part of the scale – from *f*1.7 or *f*1.4, through to *f*16 or *f*22.

SLR cameras are designed so that you always see the image on the focusing screen with the lens held open at widest aperture, which is brightest to view and most sensitive to focus. This situation is deceptive though if you have set a small aperture – just as you release the shutter the aperture changes to the size you set, so the picture comes out with far more depth of field than you saw on the screen. Some single lens reflex cameras have a depth of field preview or 'stop-down lever'. Pressing this while you are looking through the viewfinder reduces the aperture size to whatever you have set, so you can visually check exactly which parts of a scene will be sharply recorded. (Although at the same time the smaller aperture makes the image on the screen become darker.)

Another way of working, if you have time, is to use the depth of field scale shown on many SLR camera lenses, Figure 12.8. First, sharply focus the nearest important detail – in the example shown this reads as 3 m on the focusing scale. Next, refocus for the furthest part you also want sharp, which might be 10 m. Then, refer to the depth of field scale to see where to set focus between the two, and what *f*-number to use in order to embrace both 3 and 10 metres – in this case *f*8.

Maximum depth of field

Using an automatic-only camera pictures show greater depth of field the brighter the light and/or when fast film is loaded. This is because the camera then automatically sets a small aperture (along with brief shutter speed) to avoid overexposure. A simple fixed-focus compact camera is likely to have its lens set for about 4 m with a fixed aperture of about *f*8. In this way you get depth of field from about 2 m to the far horizon. But remember that it remains unchangeable in every shot.

Using a manually focused lens you should first set the lens for the key element in your picture or, if there is not one, for a distance about one third into the scene. So if nearest important details are about 2 m (7 ft) and furthest detail 7.5 m (25 ft) from the camera, a difference of 5.5 m (18 ft), focus for about 4 m (13 ft). Select your smallest lens aperture (such as *f*16 or *f*22) then alter the shutter speed until the meter reads correct exposure.

Using a semi-automatic or multi-

Figure 12.5 *f*-number aperture settings.

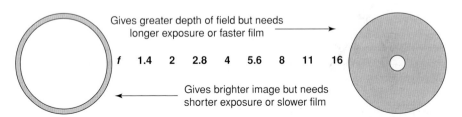

Gives greater depth of field but needs longer exposure or faster film

f 1.4 2 2.8 4 5.6 8 11 16

Gives brighter image but needs shorter exposure or slower film

Starting Photography

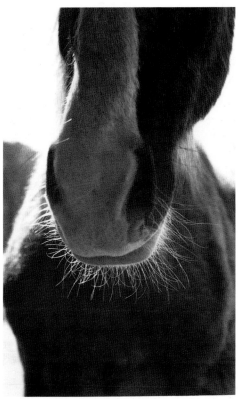

Figure 12.6 Deep depth of field, using an aperture of *f*16.

Figure 12.7 Shallow depth of field ('differential focus'). Aperture *f*2.

mode camera choose 'aperture priority' ('Av'), set the smallest aperture your lens offers, and the camera does the rest. In poor light, unless you are using fast film, this may lead you to a slow shutter speed – so be prepared to use a tripod or some other means to steady the camera.

Minimum depth of field

To get minimum depth of field you need a camera with wide aperture lens (and therefore a really accurate method of focusing too). But remember, using apertures such as *f*2 means that a fast shutter speed will probably have to be set, to avoid overexposure. In bright lighting it will be helpful to load slow film.

A further way of reducing depth of field is to use a longer focal length lens, or come closer to your subject. Changing to a telephoto lens (or setting your zoom control to T) gives less depth of field even though you keep to the same *f*-number. Remember,

Figure 12.8 Depth of field scale on SLR lens. Top: Lens focus at 3 m, lower scale shows that *f*8 gives sharpness from 2 m to nearly 6 m. Bottom: Focus 5.5 m, depth 3 m–10 m at *f*8.

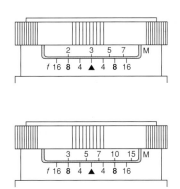

however, that this use of shallow, selective focus means there is no margin for error in setting the lens for your chosen subject distance, especially with close-ups.

13 Choice of exposure

Essentially, giving 'correct' exposure means letting the image formed by the camera lens act sufficiently on your light-sensitive film to give a good quality picture after processing: neither too much nor too little. The black and white negative shown in the panel below (top centre) has been correctly exposed. You can see from the print from this negative, shown directly under it, that plenty of detail has recorded in both the darkest shadows and the brightest parts of

Figures 13.1–6 (L to R) Under-, correct and overexposure of negatives, and the resulting prints.

the picture. The same would apply to a colour negative film.

The negative on the left (Figure 13.1), however, has been seriously underexposed. Dark parts of the picture such as the boy's shadowed face and his pullover have recorded as detail-free clear film – and appear heavy and featureless when printed (Figure 13.4). Only the very lightest parts such as the puppy's white fur and the boy's hair could be said to show slightly more detail than the correctly exposed version. The negative on the right (Figure 13.3) has been overexposed. So much light has recorded in the highlight (lightest) parts of the subject they appear black and solid on the negative, white and 'burnt out' on the print. Only the pullover and face show more detail than in the correctly exposed shot.

When you are shooting slides the same final differences apply, although there

are no negatives involved. (See also colour faults, page 105.)

The exposure controls

Most cameras make settings which will give correctly exposed results by:

1 sensing the ISO speed rating of the film you have loaded;
2 measuring the brightness of the subject you are photographing;
3 setting a suitable combination of shutter speed and aperture, either directly or by signalling when you have manually made the right settings.

Simplest cameras having no exposure adjustments expect you to load an appropriately fast or slow film for your lighting conditions (page 41) then rely on the ability of modern films to give prints of fair quality even when slightly over- or underexposed.

If you are using a manual SLR you point the camera at your subject and alter either the shutter speed or lens aperture until a 'correct exposure' signal is shown in the viewfinder. This freedom of choice is like filling a bowl of water either by using a fully open tap (aperture) for a short time (shutter) or a dribbling tap for a long time. Figure 13.7 and Figure 13.8, for example, are both correctly exposed although one had 1/30 second at ƒ2.8 and the other 1 second at ƒ16. Each change to a higher ƒ-number halves the light, so ƒ16 lets in only one thirtieth of the light let in by ƒ2.8, five settings up the scale. The pictures differ greatly though in other ways. Figure 13.7 has very little depth of field but frozen hand movements; Figure 13.8 shows nearly all the keys in focus but the moving hands have blurred during the slow exposure.

A fully automatic camera makes settings according to a built-in program. This might start at 1/1000 second at ƒ16 for a very brightly lit scene then, if the light progressively dims changes to 1/500 second at ƒ16, and 1/500 second at ƒ11, 1/250 second at ƒ11 ... and so on, alternating shutter speed and aperture changes. Such an automatic programme would never give results like either Figure 13.7 or Figure 13.8. It is more likely to set 1/8 second at ƒ5.6.

If your camera, like most compacts,

Figures 13.7–8 Metering will tell you how the f-numbers and shutter speeds line up. You must then decide which to use. Top picture: 1/30 second at f2.8. Bottom picture: 1 second at f16. Both are correctly exposed but very different in appearance.

Creative Controls

Figure 13.9 Measuring exposure from the sunlit city buildings makes this shadowed foreground record as a sinister silhouette.

Figure 13.10 Exposure measured off nearby lit stonework ensures these distant stone figures expose correctly.

is fully automatic only you will always get maximum depth of field (combined with freezing of movement) in brightest light, especially if fast film is loaded. This is why multi-mode cameras, mainly advanced SLRs, also offer aperture priority mode allowing you to set the *f*-number and so control depth of field. Alternatively by selecting shutter priority mode you can choose and set shutter speed to control blur.

Advanced SLR cameras may contain more than one fully automatic program designed to make intelligent exposure setting decisions for you. For example, when you change to a telephoto lens the program alters to one using the aperture mostly to adjust exposure, leaving the shutter working at its faster speed to counteract the extra camera shake risk from a long focal length.

Automatic exposure programs are remarkably successful in giving correctly exposed results from many different subjects and lighting conditions (see also flash exposure, page 67), but of course make their own assumptions about 'what settings are best'. So when you *want* blur in a sports picture or minimal depth of field in a landscape you must change to another mode, or switch to manual, if these options are provided. A manually set camera may be slower to use but in knowledgeable hands offers the widest range of creative results from exposure.

Measuring the light

Most compact cameras have a small, separate window behind which a sensor responds to light reaching it from the whole of the scene you can see in the camera viewfinder. This so-called 'general' light reading it makes is accurate enough for subjects such as the wheat field, Figure 12.6. Here, considered overall, the areas taken up by dark parts are roughly equal to the areas occupied by brightest parts, with the rest of the scene in tones approximately half way between the two. A general reading of the whole lot averages out all these differences, and the camera settings made have produced an exposure which is a good compromise for everything in the picture.

Starting Photography

Contrasty subjects

Simply averaging the whole subject area in this way lets you down occasionally though, if you want to shoot a picture such as Figure 13.11. Here the dog and wheelbarrow occupies less than half the whole picture area – the rest is much brighter sky. A general reading here would have been over-influenced by the (unimportant) sky, averaging out the scene as quite bright, and so make settings which underexpose the dog. The result might even be a black, featureless silhouette for the camera does not know that detail in dog and wheelbarrow is vital. Much the same thing can happen if you are photographing a room interior by existing light, and include a bright window. (You will probably need fill-flash, page 67.)

In pictures like Figure 13.9 you meet the opposite problem. A general reading here would be influenced by the large area of shadowy stone figure and foreground. It would cause settings to be made which render sunlit parts of the landscape overexposed and bleached out, whereas the picture works better keeping these correctly exposed and the shadows dark. (The same problem applies to Figure 13.12 and Figure 3.2.) If your automatic camera has an exposure lock you can first tilt the camera downwards and towards the right for the Parisian view (or move closer for the wheelbarrow shot) so that the entire frame is filled with the area you want correctly exposed. Then, by pressing the exposure lock, the light reading made here is memorized and does not change when you compose the shot as you originally intended. With a manual SLR you should use the same frame-filling procedure, adjust aperture or shutter speed to get a 'correct exposure' signal, and keep to these settings (even though over- or underexposure may be indicated when you recompose). Cameras with an 'exposure override' control allow you to change the film speed setting the camera would otherwise make. Here you might first set '+1' to double exposure for the dog and '−1' to halve exposure for the Paris shot, then measure light by a general reading.

Almost all SLR cameras use socalled 'centre-weighted' light measurement, designed to take more account of the broad

Figure 13.11 The large area of sky included here would make a general reading overexpose the (darker) main subject.

central part of the picture where the majority of main subjects are deemed to be placed. A few SLRs offer a 'spot' reading mode, whereby just a tiny area shown centrally in the focusing screen measures the light. You can position this over any key part, such as a face, even when some way off. A spot reading is very accurate and convenient, provided you don't let it stray to a completely wrong part of the scene. Modern advanced SLRs offer a 'multi-pattern' form of metering light. Measurements are taken from several parts of the picture format, and it then calculates which segments should most influence the exposure set.

Deciding priorities

Learn to recognize situations where special care over the way the light is read will greatly improve a shot. In Figure 13.10 for instance the stone sculptures on the parapet were chosen as the key element. By temporarily filling the viewfinder with some similar sunlit stone close at hand exposure was measured correctly for the sculptures further away.

Creative Controls

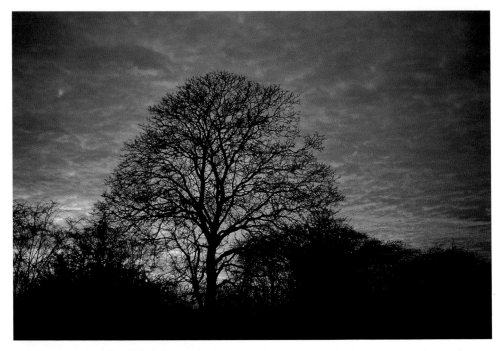

Figure 13.12 Reading off sky alone here avoids overexposure bleaching its colour.

Figure 13.13 A picture created by setting exposure for this deep cast shadow alone.

(Equally you can measure exposure for people's faces by reading off the back of your own hand in the same lighting.)

Sunsets against tree shapes are often disappointingly colourless when exposure is measured by a general reading. For Figure 13.12 the camera was first angled so only sky filled the frame to make the exposure reading. The brickwork girl, Figure 13.13, was a dark shadow cast onto a sunlit cream-painted wall by a figure just outside the picture. Exposure was measured close to the shadow and settings made purely for this area. So brick details were recorded only within the figure, leaving the rest of the wall burnt out. For yet another example look at the colourful deckchairs in Figure 2.4. With all contrasty lighting situations it is best to take several shots, 'bracketing' your exposure settings, i.e. use exposure override or aperture or shutter settings to give twice and/or one half the exposure as well as the exposure you expect to give the result you need.

Pictures like these also need to be followed up with sympathetic printing by your processing lab. Otherwise the lab could

strain to 'correct' the very effect you wanted to produce. If necessary ask for a reprint, explaining what you were aiming for.

14 Changing focal length

The creative controls your camera lens offers include focus (allowing a sharp image of things at your main subject distance, and so giving them emphasis), and aperture (allowing changes in depth of field as well as helping to control the amount of exposure). But your camera offers a third possibility, which is to alter its lens focal length. When you change focal length you alter image size. This makes a difference to how much of your subject the camera now 'gets in'. Two practical advantages stem from the change:

1 you can fill up the frame without having to move closer or further away;
2 the perspective of your picture can be altered, by changing your subject distance and altering focal length.

'Normal' focal length

A normal (or 'standard') lens for a 35 mm SLR camera is 50 mm focal length. On a 35 mm compact a lens of 35 mm focal length or less is often fitted as standard, mainly for space-saving reasons. These lenses give an angle of view of 46° or 60° respectively. A 50 mm lens is accepted as making the images of objects at different distances in a scene appear in about the same proportions one to another as seen in real life. (Judged from a typical size final print held at reading distance.)

Changing to a lens of longer focal length (also described as a *telephoto* lens) makes the image bigger. So you have a narrower angle of view and fill up your picture with only part of the scene (see Figure 14.2 and also Figure 5.1). A change to a shorter focal length (a wider angle lens) has the opposite effects. But beware, the more extreme these changes are from normal focal length the more unnatural the sizes and shapes of objects at different distances in your picture begin to appear.

How changes are made

Compact cameras have non-removable lenses, so changes of focal length have to take place internally. A few older types come

Figure 14.1 Angle of view alters when you change lens focal length. The shorter the focal length the wider the angle.

with a dual focal length lens – pressing a switch changes components inside the lens so it alters from, say, 35 mm to 50 mm. Most compacts though have a zoom lens, meaning it will change focal length, in steps or by smooth continuous movement, which are usually powered by a motor. Pressing a 'T' (telephoto) button progressively increases focal length and narrows angle of view. Pressing 'W' (wide angle) has the opposite effect. The zoom power range, as written on the lens rim, might be 35–70 mm. This lens makes image details twice as large at 70 mm than at 35 mm and is described as a 2 × zoom. The compact's viewfinder optics zoom at the same time, to show how much your picture now includes.

Single lens reflex cameras have detachable lenses. You might start off with a normal 50 mm (offering a large, ƒ1.7 aperture, and very reasonably priced because of the large numbers made). This can be interchanged with any of a very wide range of wide angle or telephoto fixed focal length lenses. They could include anything from an extreme 8 mm fisheye through to an extreme 1000 mm super telephoto. Alternatively buy your SLR with a continuously variable zoom lens controlled by a ring on the lens mount. This might be a middle range (35–70 mm) or a tele zoom (70–210 mm, for example) or

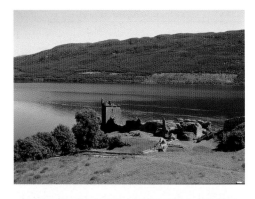

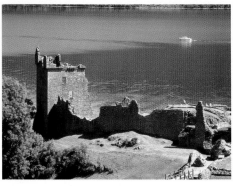

Figure 14.2 Pictures taken from the same spot using a zoom lens set to 35 mm (top version) and 70 mm (bottom version).

wide angle range (24–50mm). Bear in mind though that these lenses – zooms, wide-angles or telephotos – tend to offer a maximum aperture of only ƒ3.5 or ƒ4 at best. Zooms and telephotos are also bigger and heavier than a normal fixed focal length type. The effects of each lens change – on depth of field as well as image size – are accurately seen in the viewfinder, thanks to the SLR camera's optical system.

Using a longer focal length
A very useful reason for changing to a longer focal length telephoto lens is that you can keep your distance from the subject and yet still make it fill your picture. In portraiture changing to 70 or 100 mm allows you to take a head-and-shoulders shot without being so overbearingly close that you make the person self-conscious, or also creating steepened perspective which distorts the face. Candid shots of children or animals are more easily shot with a 135 mm or 150 mm

focal length lens from a greater distance where you can keep out of their way. At sports events too you are seldom permitted to approach close enough to capture action details with a normal lens. Both here, and when photographing animals or birds in the wild, a lens of 210 mm or longer is worthwhile.

Long focal length lenses are also useful for picking out high up inaccessible details in monuments (Figure 14.4) or architecture, or to shoot landscape from a distance so that mountains on the horizon look relatively large and more dominant.

Remember, however, that longer focal length means less depth of field, so you must be very exact with your focusing. The more magnified image also calls for greater care to avoid camera shake than when using the normal focal length.

Using a shorter focal length
Zooming or changing to a shorter, wider angle focal length (28 mm for example) is especially useful when you are photographing in a tight space – perhaps showing a

Starting Photography

building or the interior of a room – without being able to move back far enough to get it all in with a normal lens. It will also allow you to include sweeping foregrounds in shots of architecture or landscape (Figure 14.5 or Figure 3.1 for example). The differences in scale between things close to you and furthest away are exaggerated. People seem more grotesque, even menacing. But lenses of 24 mm or shorter themselves begin to distort shapes, particularly near the corners of your picture. Another change you will notice using a short focal length lens is the extra depth of field it gives, relative to a normal or a telephoto lens used at the same *f*-number setting.

Controlling perspective

It used to be said that the camera cannot lie, but using different focal length lenses you have almost as much freedom to control perspective in a photograph as an artist has when drawing by hand. Perspective is an important way of implying depth, as well as height and width, in a two-dimensional picture. A photograph of a scene such as a landscape shows elements smaller and

Figure 14.3 Whether drawing or photographing, a close viewpoint gives steepest perspective (change of apparent size between nearest and furthest elements). Moving back reduces this ratio of nearest and furthest distances, flattening perspective.

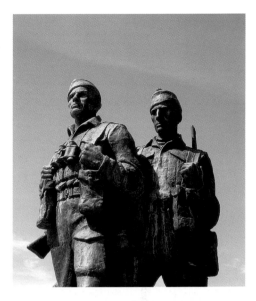

Figure 14.4 Long focal length lenses are useful for picking out details of items otherwise too far away and inaccessible to fill the frame. This Scottish memorial was shot with a 135 mm lens from ground level.

closer together towards the far distance, and parallel lines imaged obliquely seem to taper towards the background. The more steeply such lines appear to converge (the greater the difference in scale), the deeper a picture seems to the eye.

As Figure 14.3 shows, it's all a matter of relative distances. Suppose you photograph (or just look) at someone from a

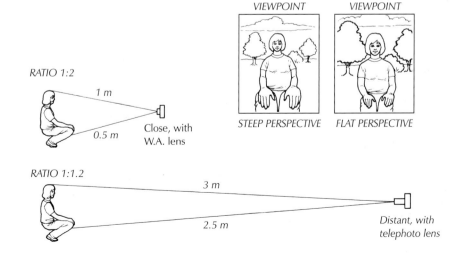

RATIO 1:2

1 m

0.5 m Close, with W.A. lens

RATIO 1:1.2

3 m

2.5 m Distant, with telephoto lens

CLOSE VIEWPOINT DISTANT VIEWPOINT

STEEP PERSPECTIVE FLAT PERSPECTIVE

Creative Controls

Figure 14.5 (Above) A 28 mm lens gets in more interior, but beware of distortion.

close viewpoint so that their hands are only half as far from you as their face. Instead of hands and face being about equal in size, normal human proportions, the hands look *twice* as big. Perspective is steep. But if you move much further back, your distance from both hands and face becomes more equal. Hands are only 1.2 times as big as the face. Perspective is flattened. Of course, being further away too, everything is imaged smaller – but by changing to a longer focal length lens you can fill up your picture again.

So to *steepen perspective* the rule is to move closer and then get everything in by either zooming to wide or changing to a wide angle lens. A shot like Figure 14.6(a) makes you feel close to the person with the hat and distant from the cottage across the river. It was shot using a 35 mm lens with the camera some 10 m from the fenced tree. In Figure 14.6(b) the camera was moved to three times this distance and then the lens changed to a 100 mm to restore the tree to about its previous image size. But look what

Figure 14.6 Changing both distance and focal length. See text. Compare with page 58.

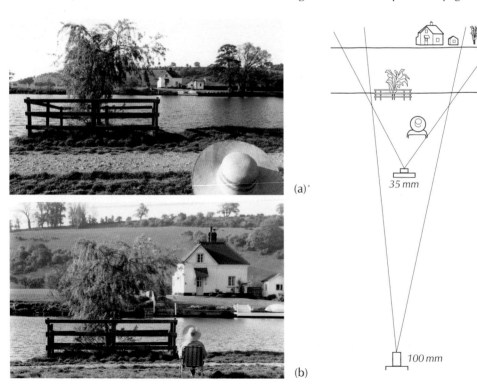

(a)

(b)

Starting Photography

Figure 14.7 'Toothy' horror fish-eye portrait.

has happened to the cottage and the seated figure! There is now much less scale difference between foreground and background elements. With the camera further away perspective has been flattened (painters would call this 'foreshortening') and the photograph has a cramped-up feel. Figure 16.8 and Figure 17.11 also make use of this foreshortening technique to 'bring up' a distant part, and flatten or merge foreground and background details more closely into one another.

Extremely short or long focal length lenses give results so unlike human vision they are really special effects devices. Figure 14.7, shot with an 8 mm fisheye lens on an SLR, demonstrates its extreme depth of field as well as distortion (the building behind was one long straight wall). Lenses of this kind are very expensive, but lower cost 'fish-eye attachments' fit over the front of a normal SLR lens.

Creative Controls

15 Flash and its control

Flash is a very convenient way of providing enough light for photography. After all, you carry it around built into the camera, its pulse of light is brief enough to prevent camera shake and freeze most subject movement, and it matches the colour of daylight. Unfortunately, this compact, handy light source has its shortcomings too. As explained below, in portraiture it is easy to get an effect called 'red-eye' with every shot. Small, built-in flash units give harsh illumination slammed 'flat-on' to your subject, resulting in ugly and very unnatural looking lighting effects. Subjects often show a dark, sharp-edged shadow line cast to one side of them onto background detail (Figure 15.2). Anything reflective like gloss paint or glass, square-on to the camera, records a flare spot, see page 106. Nearest parts of a scene receive more light than furthest parts, often destroying the normal sense of depth and distance. Finally, flash pictures have a *uniformity* of lighting – which tends to make one shot look much like every other.

Don't, however, let this put you off flash photography. Most of these defects can be avoided or minimized (particularly if you can use a separate, clip-on flash unit). Flash is really useful when natural light is excessively contrasty or from the wrong direction, or impossibly dim for active subjects indoors. Just don't allow it to become the answer for all your indoor photography – especially if having a camera with wide aperture lens and loaded with fast film allows you to work using existing light.

Cameras with built-in flash

With the exception of some single-use types, virtually all compact 35 mm and APS film cameras today are designed with a small flash unit built in. The vast majority of SLR autofocusing cameras are similarly equipped. Manual single lens reflexes more often have a flash shoe with electrical contacts ('hot shoe') on top of the camera body. This will accept one of a range of more powerful slip-on flashguns.

In both instances the flash unit takes a few seconds to charge up when switched on, and after each flash. Wiring synchronizes the flash of light to the camera shutter's open period when you take the picture. Some cameras automatically switch on the flash when the metering system detects dim lighting conditions; it is important though to be able to switch it off when you *want* to shoot by existing light.

'Red-eye'

When you look at someone's face the pupil in the centre of each eye appears naturally black. In actual fact the light-sensitive retina at the back of the eye is pink, but is too recessed and shaded to appear coloured

Figure 15.1 35 mm and APS cameras with built-in flash. The flash tube itself often pulls out or rises, offsetting itself further from the lens to reduce red-eye. Each flash has a subject-facing light sensor (shown black) controlling output.

Figure 15.2 A picture having most of the worst features of flash direct from camera – such as red-eye, ugly edge shadows and background glare spot.

under normal lighting conditions. However, flash built into a small camera body is only displaced an inch or so to one side of the lens. Like an optician's lamp used to closely examine eyes, this easily lights up that part of the retina normally seen by the camera lens as dark. The result is portraits showing 'red-eye'. Camera designers go to great lengths to minimize the defect – the flash source often slides out or hinges up (Figure 15.1) to locate it further from the lens. Another approach is to make the flash programmed to give one or more flickering 'pre-flashes' just before flashing at full power with the shutter. This is done to make the eyes of whoever you are photographing react by narrowing their pupil size.

To help minimize red-eye (and other lighting defects shown in Figure 15.2) angle the camera to avoid straight-on portraits. This may also avoid glare from any reflective surfaces square-on in the background. You

may even be able to diffuse and so spread the light with a loop of tracing paper over the flash window. But best of all, if your camera accepts an add-on flashgun, you will be able to 'bounce' the light and avoid red-eye altogether.

Figure 15.3 The camera used for the shot, right, had a much more offset flash which was diffused with tracing paper.

Creative Controls

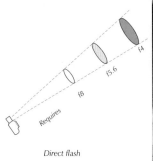

Direct flash

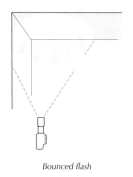

Bounced flash

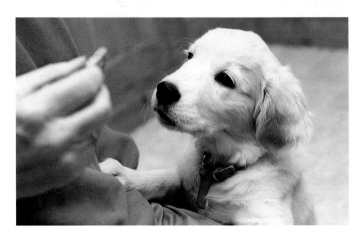

Figure 15.4 (Top pair) Direct flash noticeably dims with distance. Foreground tends to overexpose, background appears dark.

Figure 15.5 (Lower pair) Bouncing your flash off the ceiling spreads and softens lighting. The effect is even and natural.

Using bounce flash

Instead of pointing the flash direct from the camera you will get far more natural, less problematic results by bouncing the light off some nearby white surface (Figure 15.6). This might be a ceiling or wall indoors, or even white card or plastic in a camera-attachable support, which is usable outside too. Most accessory flashguns, Figure 15.7, can be tilted or swivelled so that you can point them upwards or sideways. The bounce surface you have lit then effectively becomes the light source – soft and even like overcast daylight. As comparing Figure 15.4 and Figure 15.5 shows, you avoid the worst aspects of direct flash even when red-eye did not occur. The less flat-on lighting gives you much better subject modelling and sense of

form. And instead of light intensity falling away from front-to-back, most of the room is lit in an even and natural looking way – from above. Be careful though not to bounce the flash off a tinted ceiling or when surrounded by strongly coloured walls. The overall colour cast this gives is much less acceptable in a photograph than in real life. Also, ceiling-bounced flash should be directed at an area *above the camera* rather than above the subject. Otherwise, the subject receives too much top lighting resulting in over-shadowed eyes, chin etc.

Accessory flash units

Provided your camera has some form of electrical contacts for flash (e.g. an SLR hot shoe) you can mount a separate flashgun on

64

top of the body. Here the flashhead itself is sufficiently spaced from the lens to avoid red-eye and it still fires when appropriately triggered by the shutter. There are three main types of small add-on flashgun, Figure 15.7.

The simplest type does not tilt, has one fixed light output, and a table on the back shows the aperture to set for different flash-to-subject distances and film speeds.

The second kind is self-contained and semi-automatic. The film speed and camera lens aperture you have set are also set on the flashgun. When the picture is taken a sensor on the front of the unit measures how much light is reflected off your subject and cuts ('quenches') the duration of flash. The head tilts for bouncing light, but you must always have the sensor facing your subject, not the ceiling.

Then there are 'dedicated' flash units which connect into an SLR's metering circuits, picking up information on the ISO speed of the film it carries, to measure and

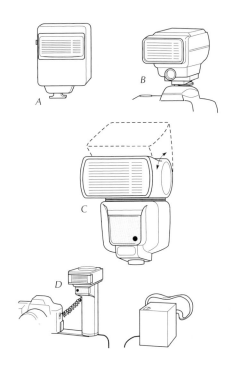

Figure 15.6 (Below) Pale toned bathrooms are ideal for bounced flash technique, provided ceilings are not coloured.

Figure 15.7 Add-on flashguns which connect via the camera's 'hot shoe' or cable. A: Low cost basic unit. B: Semi-automatic with tilting head. C and D: More powerful dedicated types.

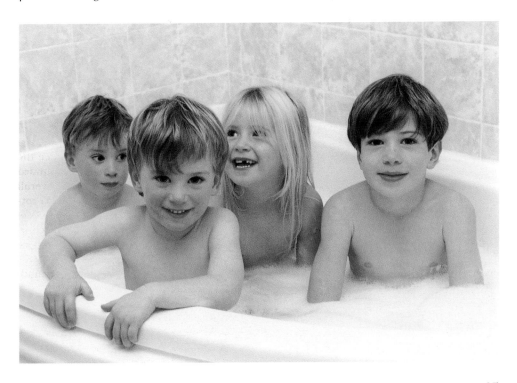

Figures 15.8–10 Left: daylight alone. Centre: with fill flash. Right: exposed for flash alone.

control flash duration by using the camera's own internal metering system.

These flash add-ons tend to be of little use if you have a compact camera. However, it is worth experimenting with a self-contained 'slave' unit which someone can hold for you, perhaps pointed at the ceiling. The slave has a light detecting trigger which responds to your camera's built-in flash and instantaneously flashes too.

Figures 15.11–12 Left: Existing light only. Below: With the addition of flash bounced off the ceiling and wall behind the camera. Requires a powerful flashgun.

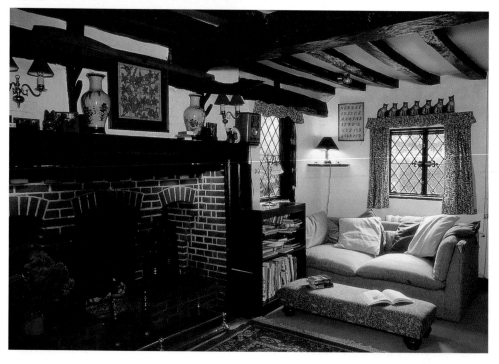

Starting Photography

Exposure and flash

On a simple compact camera with no adjust-ments its built-in flash gives sufficient light for correct exposure at the fixed aperture (typically $f5.6$ for ISO 100 film) at one set distance (typically 2.1 m or 7 ft). A flash of this power is said to have a 'Guide Number' of 12 ($f5.6 \times 2.1$ m) see page 68. Anything in your picture much closer or further away is over- or underexposed respectively. The same applies to the simplest add-on flash unit with its fixed light output.

Most flash built into compacts (like self-contained automatic flash units) contain a small light sensor pointing at your subject. The closer and lighter your main subject, and the faster the film speed set, the briefer the duration of your flash. So for a really micro-second flash, able to show spraying water droplets as 'lumps of ice', work close and load fast film. All self-regulating flash units, whether built-in or add-on, only maintain correct exposure over a *range* of flash-to-subject distances. At basic level this is often 1.5–3.5 m. The more advanced the system (e.g. dedicated units) the wider the range of distances over which it will adjust to maintain correct exposure. But don't expect to light a cathedral interior with amateur flash equipment. An auto-flash camera in the audience at a pop concert will probably just record people a few yards ahead, all the others disappearing into a sea of black.

Switching on the flash on a camera with built-in flash automatically sets the shutter to a speed (typically 1/60 second) short enough to hand-hold the camera, but not too short to 'clip' the flash. (When you add a flash unit to a manual SLR you may have to set your shutter speed to 'X' or *any slower setting* to synchronize properly for flash.)

Fill-in flash

An excellent way of using flash on the camera is as auxiliary or 'fill-in' illumination for the existing lighting present. When you shoot towards the light, as in Figure 15.13 or Figure 15.14, a low-powered flash on the camera (built-in or clip-on) illuminates what would otherwise be dark shadows. Provided the flash is not overwhelming like Figure 15.10 results look entirely natural – you

Figure 15.13 Compact camera set to 'fill flash' just lightened shadows here.

Figure 15.14 Direct fill-in flash balanced daylight outside. Beware of glare off windows.

Creative Controls

have simply reduced excessive lighting contrast. An auto-focus compact or SLR camera which offers 'fill-flash' mode will make the necessary settings for you.

Fill-in flash from the camera is also useful for room interiors which may include a window and where the existing light alone leaves heavy black shadows (Figure 15.11). If possible use a powerful flashgun here which allows you to bounce its light off a suitable wall or surface not included in the picture, to produce the most even fill-in effect.

'Open flash'

An interesting way to use a separate flashgun, without needing any extra equipment, is called *open flash* technique. This means working in a blacked-out room, or outdoors at night. You set the camera up on a firm support and lock the shutter open on 'B'. Then holding the flash unit freely detached from the camera but pointed at your subject you press its flash test firing button. Having fired the flash once and allowed it to recharge you can fire it several more times each from different positions around the subject before closing the shutter again. The result looks as though you have used several lights from different directions.

Open flash allows you to photograph the garden or part of your house as if floodlit. Calculate exposure from the guide number given for your flash. This is flash-to-subject distance times the lens *f*-number needed. If the guide number is 30 (metres) with the film you are using then set the lens to *f*8 and fire each flash from about 3.75 m (12 ft) away from its part of the subject. Plan out roughly where you should be for every flash, to light a different area. The total time the shutter remains open is not important provided there is little or no other lighting present.

Projects

Project 10 Experiment with blur. With a camera offering settable shutter speeds expose a whole ISO 100 film at 1/8 second setting. Include people and traffic on the move, preferably close. Use your camera hand held; on a support; and panning (in various directions). Compare results.

Project 11 Advance a sunset. Take a quick sequence of four colour pictures of a landscape at late dusk. Give the first one correct exposure, progressively halved as you continue. Which print gives the most atmospheric result?

Project 12 Using a cardboard frame sliding on a transparent ruler (see below) simulate the use of different focal length lenses. (A 24 × 36 mm slide mount positioned 50 mm from your eye matches the angle of view of a 35 mm SLR normal lens.)

Project 13 With a separate flashgun create a 'stroboscopic' action picture. Have the camera on a tripod with shutter locked open on 'B'. Shoot a light-coloured moving figure (dancer) against dark background in a darkened room. Using a separate flashgun set in a position to one side. Make 4–5 test button flashes, the figure altering position after each one. Follow the guide number for one flash when setting *f*-number.

Figure 15.15 With a home-made adjustable viewing device like this you can practise the framing up effect of a range of different focal length lenses.

Part Four Tackling Subjects

Many aspects of picture composition apply to all photography, as Part One showed. Technical controls too, such as the camera settings you make, choice of lenses and uses of flash play an influential role. But then again, the kind of subject you choose to pho- tograph presents its own possibilities and problems. Part Four looks therefore at a range of subject situations with these points in mind. Potentially interesting subjects include people, places, animals, landscapes, small objects in close-up ... the list is almost endless. It is probably true to say though that all of us sometime will want to photograph *people*.

Figure 16.1 Babies often make great unselfconscious expressions.

16 People

Subjects here may be individuals or groups, posed or unposed, ranging from family and friends you know and can control, to candid shots of strangers. In all instances it pays to pre-plan your shot as far as you can – which means concern for background and setting, direction of the light, and how 'tight' to frame the person (full length; half length; head and shoulders; head shot). At the same time you must always remain able to respond fast to any fleeting expression or unexpected moment of action or reaction, as it may occur. For example, the mixture of uncertainty and achievement briefly shown by the little boy on the log, Figure 16.2, could be lost a moment later; similarly, the baby's raised head and open mouth in Figure 16.1.

Babies are the least self-conscious people. The main problem is to manoeuvre or support a young baby so they are not just shown lying down. Try photographing over the shoulder of the supporting adult, or have the baby looking over the back of an armchair. Avoid direct, harsh sunlight. If your camera offers a zoom lens set this to its longest focal length (T) or change to a long focal length type. A lens of 85 mm or 100 mm is ideal for a 35 mm camera; even used at its closest focus setting such a lens will give you a large but undistorted image.

As children begin to grow up they quickly become conscious of the camera. It

Figure 16.2 Expression of triumph. This little boy has just reached that instant of balance when anxiety turns to success.

Figure 16.3 Give youngsters things to do, but don't overdirect.

Figure 16.4 Clothes, pose and plain background help to give the picture of this pair an overall cohesive shape.

is often better then to give them something to do – set up simple situations which are typical for the child, then wait for something to happen without over-directing the occasion. The girl looking through the letter box in Figure 16.3 was just such a 'can you see me?' activity for the individual concerned, improvised on the spot for the photograph.

Remember the importance of lighting. Sunlight reflected from the far side of the white-painted door illuminated the child's eyes in Figure 16.3. For the baby shot Figure 16.1, taken at floor level, a white towel was used held vertically on the left to reflect some daylight back into the shadow side of the face. (See also studio lighting for portraits, page 139.)

Pairs

Portraying people in pairs allows you to relate them to each other in various ways. The relationship may be simply to do with comparative shapes (Figure 5.4) and the individuals themselves remaining anony-

mous. Or it may be the highly personalized warmth and friendliness of the two brothers, above, both to each other and the person behind the camera. In this semi-posed shot the boy in black stole into what was planned as a single portrait. The pale background helps to create a strong combined shape, and plain garments avoid distraction from faces. Lighting here was flash bounced off a white ceiling.

In other instances expressions can have quite different connotations. The candid shot of the two elderly Italians, Figure 16.9, has a rather sinister air. The hats, the shades, and the gesticulating hand seem to suggest some plot or business deal. A whole story can be dreamt up around such a picture – when in fact it was probably just a couple of old pals on a day out.

Your shot may be a largely constructed situation or taken incognito, but picking exactly the right moment can be quite difficult when *two* facial expressions have to be considered. Expect to take a number of exposures; you may find out anyway that a short series of two or three prints in an album forms an interesting 'animated'–type sequence.

Groups

Organizing people in groups is rather different to photographing them as individuals or in pairs. For one thing each person is less likely to be self-conscious – there is a sense of safety in numbers, and a touch of collective purpose and fun. This is a good feature to preserve in your picture rather than have everyone wooden-looking and bored. For similar reasons don't take too long to set up and shoot.

Groups of large numbers of people tend to call for a formal approach, and here it helps to prepare some form of structure, perhaps one or two rows of chairs. This guides people to where to sit or stand, and your camera position can also be prepared in advance. Smaller groups can be much more informally organized, participants jostling together naturally and given freedom to relate to one another, although still under your direction.

Most groups are linked to *occasions*

Figure 16.5 Showing surroundings can usefully add a sense of place – it would be wrong to tightly crop this informal group.

and it is always helpful to build your group around a centre of common interest – which might be the football and cup for a winning team, or a new puppy with its family of proud owners (Figure 16.6). Begin by picking an appropriate setting. Often this means avoiding distracting and irrelevant strong shapes or colours in the background. With close, small groups you can help matters by having everyone at about the same distance from you but keeping background detail much further away and out of focus. (See depth of field, page 50.) Sometimes though, showing the environment contributes greatly to your shot. Leaving space around the casual group in Figure 16.5, below, helps to convey the idea of an adventurous gang of youngsters.

If at all possible avoid harsh direct sunlight which will cast dark shadows from one person onto another or, if the sun is behind your camera, causes everyone to screw up their eyes. Aim to use soft, even light from a hazy or overcast sky. Alternatively try to find a location where there is some large white surface (the white-painted wall of a house for example) behind the camera. This will reflect back diffused

Starting Photography

Figure 16.6 Using a centre of attention. The gate-top offers a ledge for the puppy, and gives the group shape a base.

light into the shadows to dilute and soften them. For small groups fill-in flash may be possible.

 Always try to locate the camera far enough back from the group to allow you to include everyone using a normal focal length lens. Working closer with a wide-angle or zoom lens at shortest focal length setting can make faces at the edges of a group appear distorted.

 Every group shot calls for your direction to some degree. Consider its overall structure – gaps may need closing by making people move closer together. With large formal groups you can aim for a strictly

Figure 16.7 Choir group. Hazy daylight avoids confusing shadows. The pattern of faces and clothing works best against a simple unassertive background.

regular pattern of faces and clothing. Ask if everyone has unobstructed sight of the camera lens. Always shoot several exposures because of the practical difficulty of getting *everyone* with the right expression, eyes open, etc. (Having several versions also gives you the opportunity to digitally mix heads into one composite, see page 125.)

Candids

To take portraits of friends and strangers without them being aware calls for delicate handling. But results can be rewarding in warmth and gentle humour. Candid shots of strangers are easier if you begin in crowded places like a market or station where most people are concentrating on doing other things. Observe situations carefully, especially relationships (real or apparent). These may occur between people and pets, or notices, or other people; or just the way people fit within a patterned environment, Figures 5.5 and 16.8.

An autofocus, auto-exposure camera is helpful for candids, but working manually you can often prefocus on something the same distance away in another direction, and read exposure off the back of

Figure 16.8 A candid shot simply based on how someone fits into a patterned beach.

Figure 16.9 (Below) Expressions and garb give this passing pair a conspiratorial air.

Starting Photography

Figure 17.1 Tower of Belem, Lisbon. A shot timed for the lighting to strongly reveal form.

your hand. Avoid autowind cameras with noisy motors. Remember not to obstruct people when photographing in the street, and always ask permission to shoot on private property.

17 Places

Unlike people, places of habitation – towns, cities, buildings, etc. – are obviously fixed in position relative to their surroundings. This does not mean however that picture possibilities are fixed too, and you cannot produce your own personal portrait of a place. It is just that good, interpretive shots of permanent structures require more careful organization of viewpoint and patience over lighting than most people imagine. The best picture is seldom the first quick snap.

Decide what you feel strongly about a place – this might be easiest to do when

Figure 17.2 A viewpoint chosen to produce false attachment of foreground to background gives a caged-in feeling to this building.

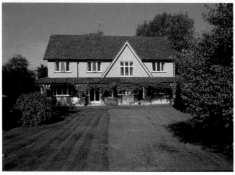

Figures 17.3–4 A building's texture, pattern and form changes appearance as the sun moves direction during the day.

you visit the area freshly for the first time, or it may come from a longer stay giving greater insight into what the environment is really like. Compare Figure 17.1 and Figure 17.2 which both show architecture. The Portuguese Tower of Belem, photographed from a tourist boat, is an attractive pictorial record. (It is also a somewhat conventional postcard type view.) The concrete tower block, in London, has received a totally different and much more personal treatment. It takes a *stance* about buildings – interpreting the block as some sort of prison, cut off from the rest of the world. To help achieve this a distant viewpoint flat-on to the wall was carefully selected by eye – aligning wall, tower and shadow, so that they seem connected. The effect is one of shallow space, with wall and railings 'attached' to the tower and caging it in. Then the lens focal length was changed to 80 mm to fill up the frame from this spot. Printing the shot in black and white helps to merge the different elements as well as increase its sombre feel.

Choosing the lighting

Lighting has a big part to play in both Figure 17.1 and Figure 17.2. Direct sun side-lighting the Lisbon structure picks out its Moorish architecture and fairy-tale embellishments. The softer lighting on the tower block contributes a flattening, downbeat effect. Whenever possible think out the sun's position moving from east to west throughout the day and come back at the time when its direction will best suit what you need to

Figure 17.5 Edinburgh chimney-pots, simplified by flat lighting and perspective.

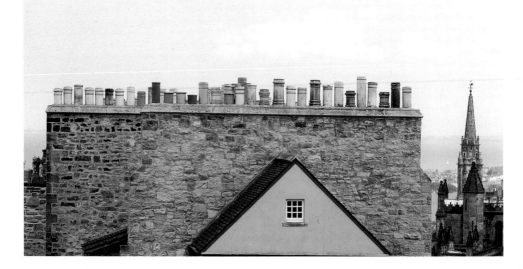

Starting Photography

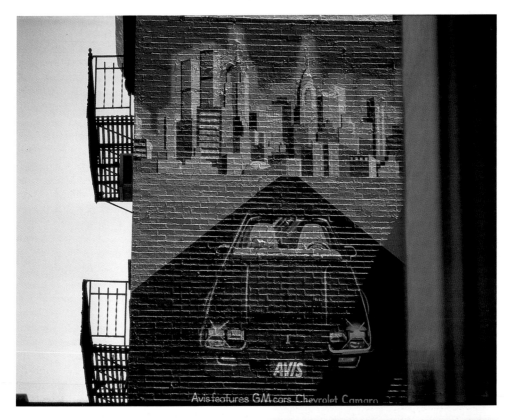

Figure 17.6 Wall-painting, East Side New York.

show. Comparing morning and late afternoon sunlight on the same house (Figures 17.3–4) shows how changing parts of its structure are given emphasis or suppressed by the alteration in lighting direction.

The same applies to choosing a day when weather conditions give direct sunlight, or soft diffused light. Harsh, glancing light was essential to show the surface texture of bricks and mortar across the wall painting shown in Figure 17.6. On the other hand the pattern of varied chimney pot designs in Figure 17.5, opposite, would be over-complicated by their shadows in hard light. Overcast conditions here, together with choice of viewpoint, help keep the picture on one flat plane. The result is a sense of the eccentric or surreal.

Remember that the best times for interesting, fast-changing lighting effects are either in the early morning or late afternoon. But be prepared to work quickly when sun-cast shadows are an important feature –

Figure 17.7 Shadow pattern under the Eiffel Tower, Paris. Exposure was read for shadowed areas, then halved to darken them.

they change position minute by minute (or may disappear altogether) while you are adjusting the camera. Again, don't overlook the transformation of building exteriors at dusk, when internal lighting brightens the windows but you can still separate building shapes from the sky. See Figure 4.4.

You can often sum up a whole city or village by just showing part of one build-

Subjects 77

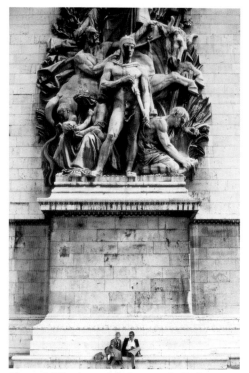

Figure 17.8 Imperial stonework, Paris.
Figures contrast warlords and provide scale.

Figure 17.9 Arab quarter, Jerusalem.
Exposure was measured for the central area,
to preserve the darkness of foreground.

ing, Figures 5.5 and 17.10 for instance.
Signs and logos can form titles.

Sometimes, to avoid hackneyed shots, try just suggesting the famous bits, through a reflection or shadow, Figure 17.7. Or you may want to bring together a 'collection' of shots of selected details such as mailboxes, house names, etc. All these 'sketches' of what strikes you as special and most characteristic about a place will build up a highly personalized set of photographs. Leave the general views of famous sites to the excellent work of professionals shooting under optimum conditions – on sale at tourist centres.

People and places

Several other visual devices are worth remembering to help strengthen things you want to say through your pictures. For example, the size of a structure can usefully be shown by the inclusion of figures, as in Figure 17.8. But here they also contrast the quieter and foot-weary lower part of the picture with the all-action, nationalist upper half. In Figure 17.9 the silhouettes of local children out shopping add atmosphere as well as scale to this early morning shot of a souk. Provided the figures you include relate to a place they can be used as symbols – for example showing the solitary outline of a person at a window in a vast, impersonal office block.

On the other hand the complete absence of inhabitants may be important, as in Figures 17.10 and 17.11. The newsagents shop in an English Cotswold village (Figure 17.10) is definitely closed for lunch, but within this small and trusting community people are left to take papers and pop the money through the letterbox. Even when somewhere is cold, bleak and empty instead of sunny and colourful as anticipated it can be worth shooting some pictures. Try to make them express this paradox in your glum impression of the day, perhaps by combining the sun and sea as depicted on painted signboards with awful reality.

Whatever your personal reaction to a new place – perhaps good, maybe bad – aim to communicate it through your photography. New York City is impressive with its soaring architecture; but perhaps you notice too its features of public neglect (holes in the road, garbage) contrasting with corporate

Starting Photography

Figure 17.10 Newsagents in a quiet English village, at lunchtime.

Figure 17.11 Bad day at the seaside – all the cold and gloom of a resort at end-of-season.

splendour (marble-faced commercial buildings).

Pictures of places don't always have to be linked to vacations and travel. You can practise your skills locally – encapsulating a street, or an industrial park ... even your own school or workplace. See page 100. Longer term, pictures taken once or twice every year from the same spot could create a series documenting the development of a garden. By always including the family they show how children grow and develop too.

Tips and Reminders

■ When you include figures make them relevant but subsidiary in your pictures. People easily dominate over places.

■ If the direction and type of lighting are not ideal take one picture anyway – then plan the best time and weather conditions for a re-shoot later.

■ Pick your camera position from where false attachments (page 76) will *help* your picture, not be destructive.

■ Watch out if you tilt your camera upwards – vertical lines appear to converge. If this distortion is unwelcome move much further back and then change to a longer focal length lens (zoom in).

■ If a place is best shown in one long, continuous vista consider shooting a series of overlaps and construct a panorama, see page 130.

Interiors of buildings

Making pictures of the interiors of buildings may sound difficult if you are a beginner, but technically modern camera equipment has made this easier than ever before. A wide angle (or at least a shorter-than normal focal length) lens is usually necessary. This is because there seldom seems to be enough space to get back far enough to include what the eye sees when looking at an interior. A compact camera with its 30 or 35 mm lens fitted as standard has an advantage here. A 28 mm lens on an SLR is probably ideal – still shorter focal lengths start to create distortion of shapes near the corners of your picture, see Figure 14.5.

Be cautious about tilting the camera. Whereas the convergence of verticals this gives is acceptable to the eye when the shot is clearly looking up (Figure 17.14) or down (Figure 17.15), *slightly* non-parallel vertical lines in a straight-on view are a distracting distortion. As Figure 17.13 shows, you should *keep the back of the camera vertical* and either move back or crop off the unwanted extra foreground from your final print. You will also find that a long focal length lens, such as 100 or 135 mm, is useful for out-of-the-way details within a large interior. Picking out features can suggest the whole.

Lighting

The main problem here is *contrast*, and to a lesser extent the *dimness* and *colour* of the light. The lighting range between, say, the most shadowy corner of an interior and outside detail shown through a window, is often beyond the exposure capabilities of your film. To avoid this problem you could exclude windows, keeping them behind you or to one side out of frame. But where windows need including as an important architectural feature:

1 Shoot when the sky is overcast.
2 Pick a viewpoint where windows in other walls help illuminate interior detail.
3 Give a series of bracketed exposures (some degree of window 'burn out', as in Figure 17.14, may prove atmospheric and acceptable provided you have retained important detail in shadow areas).
4 With smaller domestic size interiors fill-in flash from the camera can reduce contrast, as in Figure 15.12. But don't expect success in a cathedral, especially using a camera with tiny built-in flash!

Figures 17.12–13 Top: Parallel vertical lines appear to converge when you tilt your camera upwards. Bottom: Keeping the camera back vertical and later cropping off excessive foreground is one solution.

Figure 17.14 Dome of St Peters, Rome. Wide angle lens. Exposed for 1/8 sec at ƒ5.6, pressing the camera firmly to a handrail.

Figure 17.15 Mass in St Peters. Mixed artificial light and daylight. The altar area records orange on daylight film.

Dimness of light need be no problem provided your camera offers long exposure times and you have some firm kind of camera support – improvised or, preferably, a tripod. Some SLR cameras offer timed exposures of up to 30 seconds. By selecting aperture priority mode and setting an ƒ-number chosen for depth of field the camera's metering system will automatically hold the shutter open for a calculated period. If you time this with a watch you can next change to manual mode and take shots at half and double this exposure time to get a range of results.

Even during daytime the interiors of large public buildings are often lit by artificial light mixed with light through windows and entrances. As Figure 17.15 shows, often the interior light is a warmer colour than daylight – a difference barely noticed by the eyes of someone there at the time but exaggerated in a photographic colour print. In such a mixture it is still often best to keep to the normal daylight type film, without filtering, as correcting for the orangey artificial light turns daylit areas unacceptably bluish.

Cities at night

At night floodlit monuments and city vistas have a special magic – transformed from the mundane into a theatre-like spectacle. As with interiors, contrast is your main problem. Shooting at dusk (page 19) is helpful, but sometimes the sparkle and pattern of lights against a solid black sky make your picture. Wet streets after rain, reflecting illumination from shop windows and street lamps will help reduce contrast; similarly fountains spread the lighting. But even so dark objects still just showing detail to the eye will become silhouettes in photographs when you expose correctly for lit areas. So pick a viewpoint which best places interesting and relevant black shapes in the foreground where they can add depth.

Advanced compacts and all SLRs can expose correctly for floodlit subjects (typically 1 second at *f*5.6 on ISO 200 film). Just ensure that you measure illumination from close enough to fill up the frame with lit surfaces. Note too that film behaves as if less sensitive when given a long exposure in dim light. If 10 seconds or longer is needed most colour films halve in speed – so set the lens aperture one *f*-number wider, or the exposure override control to +1 (×2 in some cameras). See also fairgrounds, page 111.

Figure 17.16 Paris fountains. Exposure was read from the central, lit water area.

Figure 17.17 Athens. An SLR set to Av mode gave 12 secs at f8. Mixed lighting – domestic lamps in foreground café.

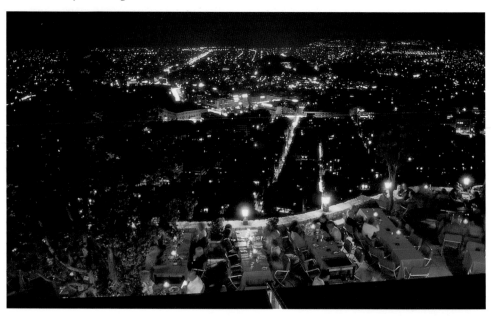

Starting Photography

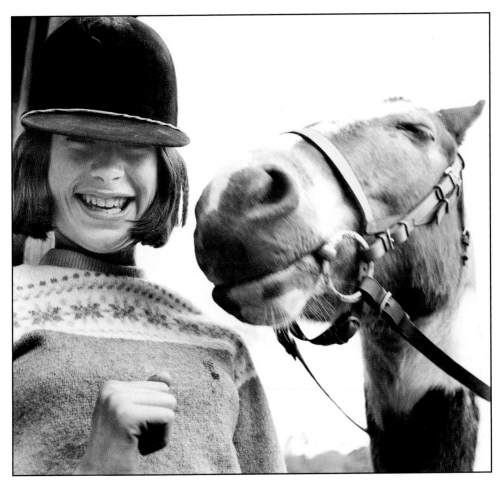

Figure 18.1 A self-satisfied animal with its owner. The low angle here gives strong shapes, and a final line around the print edges holds things together.

18 Animal portraits

Photographing family pets and rural animals is rather like photographing young children. You need a lot of patience because they cannot be told what to do; they are unself-conscious (although capable of showing off); and their relationships with people are a great source of situation pictures.

Always take the camera to the animal rather than the reverse. In other words, don't put the animal in a false or unfamiliar environment just because this is more convenient for your photo-graphy. Animals do not really belong in studios.

Showing character

As much as possible try to convey the indi-vidual character of the animal you are pho-tographing. Often you can do this by show-ing the bonds between a pet and its owners, particularly children. It is also possible to show relationships between animals (Figure 18.3 for instance) although you may have to keep your distance and so avoid disturbing them by your presence.

Decide what is a typical activity and environment for your particular animal. Large pets like ponies and big dogs are often more placid than small dogs and kittens. Even so it is not helpful to over-excite them by making the photography a 'big event'. You can suggest size by including other things in the picture to give scale. Also make good use of camera viewpoint. A looming great horse can be shown close from a low angle (but use

Figure 18.2 Cradling in a helper's arms provides scale and also keeps this lively young animal under control.

this is valid as part of your pet's character it should be shown. Maybe it is good at leaping for balls, rolling on its back, or just lapping up milk? Try setting up simple attractions – a ball on a string or a throwable stick – and then await natural developments patiently ... But don't over-manage and degrade your pet by, say, dressing it up or putting it into ridiculous situations. An animal rushing around might be portrayed via a short *series* of shots, like a sequence of stills from a movie. Try to keep your viewpoint for this consistent, so that the action appears rather as if on a stage. Another approach is to pan your camera to follow the action (easiest with the lens zoomed or changed to tele) and shooting at 1/30 or 1/15 second. The blurred surroundings and moving limbs then become a feature, although you will need to take plenty of shots on a hit-or-miss basis.

Have a helper – preferably the owner – to control the animal and if necessary attract its attention just at the key moment. But make sure you brief the helper where to stand near you behind the camera, and not to call the animal until requested. Another approach is to give the animal time to lose interest in you and your camera and return to its normal activities, even if this is just dozing in the sun.

a normal or long focal length lens – coming in close with a wider angle gives ugly, steep perspective (page 108 for instance). Again, a small cat or puppy looks tiny cradled in someone's arms, or photographed from a high viewpoint perhaps in front of a pile of crates and casks. Work from across the street with your zoom lens on telephoto setting.

Small active animals are often by nature excitable and difficult to control. If

Figure 18.3 On a hot day horses behave a bit like humans.

Lighting and exposure

As in human portraiture, soft, even daylight is usually 'kinder' and easier to expose for than contrasty direct light. Try to avoid flash indoors, or if you do use it bounce the light

Starting Photography

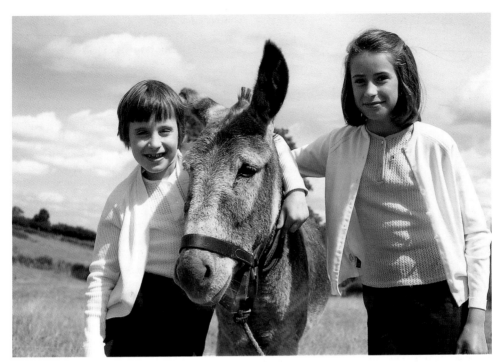

Figure 18.4 Donkeys cheerfully join in family groups.

Figure 18.5 One scared kitten sees a dizzy world through its front door.

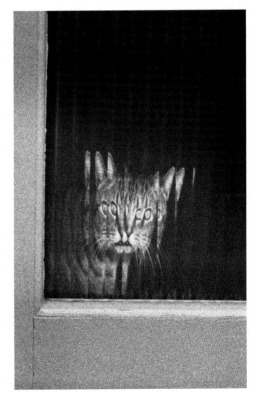

off the ceiling. 'Red-eye' from flash on the camera is just as prevalent with animals as human beings. Load medium/fast film, say ISO 400, so that you can still use a fast shutter speed in existing light yet not introduce grain pattern.

If you have a multi-mode exposure system camera select shutter priority (Tv) and set the shutter to 1/250 outdoors unless you want subject movement blur, see above. With a manual camera set this same shutter speed, then change the aperture setting until a reading off the animal's coat signals correct exposure. Having all your camera controls set in advance will avoid loss of pictures due to fiddling with adjustments at the last minute. You need to combine patience with quick reactions, watching your animal through the viewfinder all the time, to be ready to shoot the most fleeting situation. A rapidly autofocusing camera is helpful when an animal is liable to move about unexpectedly, especially if it is also close.

Backgrounds

Think carefully about the surroundings and

changes to something worse as you follow your subject into a different setting. The safest background to pick is a relatively large area of grass, camera viewpoint being high enough to make this fill the frame like Figure 18.6 or Figure 18.8. Or by bending your knees and coming low you can use the sky (Figure 18.1 or Figure 18.4). Better still, pick surroundings showing something of your particular animal's habitat, adding character and enriching the portrait. A scared kitten neurotically observing a confusing world through its reeded glass front door is one case in point; the pair of horses gently dozing under the shade of a tree is another.

Not all animal portraits are set up of course. Always look out for opportunist pictures (for which a compact camera is the quickest to bring into operation). Just like candid shots of people, you will discover a rich source of animal relationship pictures at gatherings – pet shows, livestock markets, pony races, farmyards, even dogs' homes – where plenty is going on.

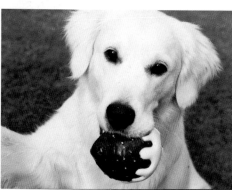

Figures 18.6–8 Puppies and kittens change interests from one moment to the next. With a helper you can set up an active game. But include the quieter moment when your pet is intent on studying something new (top). Keep well back and zoom to 'tele'.

background against which your subject will be shown. Many animal pictures are ruined because assertive and irrelevant details clutter up your shot. Animals cannot be directed in the same way as people, and what may start out as a good background easily

Tips and Reminders

■ If you have to shoot through wire mesh (as with a rabbit or hamster box) place the camera with its lens close up to the wire. The mesh then records so out of focus it effectively vanishes.

■ Experiment photographing domestic animals while lying on the ground, showing them at or below their own height.

■ Use a familiar toy, or favourite food scrap, to hold your pet's attention. Tugging a rope pull (Figure 18.7) or playing with something suspended in one spot shows the animal active but not moving about uncontrollably.

■ Young animals often have eyes which are dark and impenetrable. Where possible shoot from a viewpoint where a bright part of the sky will reflect as catchlights. Figure 18.8.

■ To make an animal look alert click your fingers or make an unusual noise. But leave this until you and the camera are fully prepared and ready to react – the animal typically looks up, but then moves towards you.

■ A motordrive camera will allow you to shoot a quick picture series, keeping your eye at the viewfinder. But a noisy drive can be self-defeating because the animal is attracted by its sound *after* each picture has been taken.

19 Landscapes

Successful photography of landscapes (meaning here natural scenes, principally in rural locations) goes beyond just accurate physical description. The challenge is to capture the atmosphere and *essence* of somewhere, perhaps in a romanticized or dramatized way. The colours, pattern of shapes, sense of depth and distance, changes of mood which go along with variations in weather conditions all contribute here. In fact a landscape is rather like a stage set. Yet photographs often fail to capture what it felt like to actually be there. Of course, elements such as sounds and smell, the wind in your face, the three-dimensional feeling of open space are lost in a two-dimensional picture. But there is still plenty you can retain by careful selection of when and from where your shot is taken.

Paramount in all this is *lighting*, and since we are dealing here with natural light the time of day, the weather, even time of year all have a strong influence on results. You can argue that not much of this is under your control, and certainly there is always an element of seizing an opportunity when by luck you find yourself in the right place at the right time.

But you can also help yourself by anticipation. Don't shoot second best – notice when conditions are not quite right and aim to return again earlier or later in the day when the weather is different or perhaps when you can bring a different item of photographic equipment with you (lens, film type, tripod, etc).

A landscape is basically immobile but it is certainly not unchanging, and there is often a decisive moment in its appearance which will not re-appear for another week ... or another year. Good landscape photographers therefore have to be good planners. They aim to get themselves into the right location *before* the right time – set up and patiently awaiting a scene to 'unfold'.

Lighting

If you look through the viewfinder at a landscape as if it were a stage, your framing up

Figure 19.1 Lighting dramatically transforms mountainous landscapes. This deep valley in Madeira kept changing as patches of sunlight drifted through.

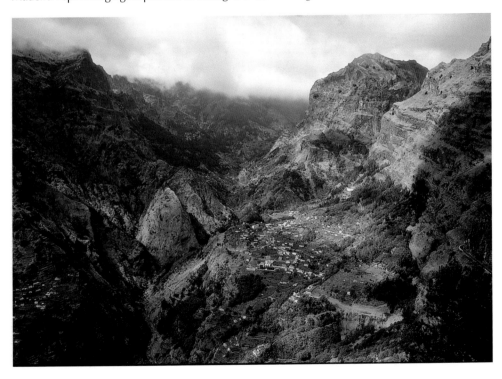

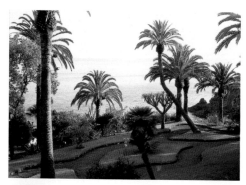

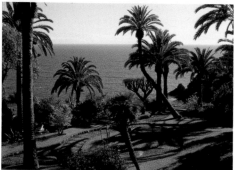

Figures 19.2–3 Intensity of colours can change within minutes. Sea mist creates softened colours and tones (top). A short time later sun has burnt through the haze.

mist can have a softening effect (Figure 19.2). Notice the influence of clear direct light on the visual intensity of colours. Hazier conditions give them a more pastel appearance, and the sea no longer reflects blue sky.

The combination of lighting, weather and season of the year has a powerful influence on a landscape's appearance, particularly noticeable in temperate parts of the world such as England. Figures 19.4–8, each taken in a different month of the year, were all shot from the same window. Differing elements in the rural scene become emphasized in each picture, and the more diffused the lighting conditions the more monochrome appearances become.

Remember that visually the most rapidly changing, interesting seasons for landscapes are Spring and Autumn. Snow-covered scenes in winter (Figure 6.6 for instance) need direct sunlight in order to 'sparkle', unless you want a moody sombre effect. Very hazy conditions are good for atmosphere but easily become dull. It may be best then to shoot *against* the light and base your picture on silhouetted foreground shapes linked to greyer shapes further away.

and composing is a kind of stage-setting. But then comes the all-important lighting of this space. Time of day affects mainly the *direction* of the light; weather conditions affect its quality (hard; semi-diffused; soft) as well as its distribution across the scene. In Figure 19.1 for example gaps in the wind-blown cloud cover give dappled patches of direct sunlight, moving across a high mountainous landscape. Every moment the appearance changes, which means firing the shutter just when a patch of illumination is in the right places to pick out the scattered houses. The same applies to Figure 1.1 on page 6. Here the terrain is less spectacular but sunlight through a hole in cloud cover after rain spotlights the farmhouse, emphasizing its isolation.

Cloudless sunny days, so common in the tropics, often provide monotonous lighting. Under these conditions it is more interesting to shoot early or late in the day. Shadows then are long and contribute strongly to a picture, although at times sea

Camera technique

The basic elements when framing up a landscape are its foreground, middle-ground and background. Each of these areas should contribute in some way, and relate to the others. Consider how high to place the horizon – a decision which often determines the ratio of the three parts. Beginners often position the horizon dead centre. Don't overdo this though, for unless you consciously plan a symmetrical composition (Figure 19.9 or Figure 19.16 for example) splitting the picture into equal halves can make it weaker and indecisive. Always avoid tilting the horizon, which seems to happen most easily when you use the camera on its side to shoot a vertical format picture. Keep the foreground interesting or at least filled, preferably in some way which provides a lead-in to the main elements in your picture. Even a plain foreground looks good if in shadow, contributing depth to the picture as a whole.

A zoom lens which offers a short focal length, or a wide-angle lens of about 28

Starting Photography

Figure 19.4 Spring, April.

Figure 19.5 Summer, July.

Figure 19.6 Autumn, October

Figure 19.7 Autumn, November.

Figure 19.8 Winter, January.

Subjects

Figure 19.9 Clear atmosphere and low, angled lighting give rich colours here. Exposure was measured for the sunlit foliage – a general reading would give too pale a result.

black and white photography, to darken the monochrome reproduction of blue sky and so make white clouds appear more boldly, page 118. The polarizing filter, which appears overall grey, is also useful for colour photography. It can reduce the glare or sheen of light reflected from surfaces such as glossy foliage, water or glass, as well as darkening blue sky at right angles to the direction of clear sunlight. The filter can therefore help to intensify subject colours, although colourless itself.

Finally a small, easily carried tripod greatly extends the possibilities of landscape work. It frees you from concern over slow shutter speeds when time of day, weather conditions and dark tones of the scene itself combine to form a dim (but often dramatic) image.

Colour in landscape

The intensity of colours in landscape photography is enormously influenced by atmospheric conditions, plus the colour, type and intensity of the light, and technical matters such as choice of film and use of filtration. In Figure 19.9 for example, direct, warm evening light shortly after a downpour which has cleansed the air, gives intense saturated colours. The mirror reflection off water (this picture was taken through the open window of a moored boat) helps to double the effect. Water provides a very interesting foreground for landscapes. Changes in its surface – from still to rippled by breeze – mixes both colours and shapes.

A much more formal man-made landscape, like the gardens at Versailles, Figure 19.10, already has a scheme of tightly restricted colours built in. The brilliance of red and green, with a touch of yellow, appears most strongly to the eye in hard, clear sunlight. Parts are lost in dark shadow but these are small in area, and help to intensify graphic shapes.

Choice of colour film (and the colour paper your negatives are printed on) can fine-tune results, emphasizing the richness of certain hues in a landscape or give more muted, subtle results. Experiment with different maker's brands. And if you produce your own colour prints through a computer printer (page 126) various software pro-

mm for an SLR is very useful for landscape work – particularly when the foreground is important (Figure 19.10) or when you just want to 'open up' the whole of a scenic view like Figure 19.1. Secondly, a lens of moderately long focal length such as 135 mm is occasionally handy when you want a distant element in your picture – mountains on the horizon for example – to loom large relative to mid-distance and foreground (see also Figure 14.6).

When your lighting is uneven decide the key part of your landscape and measure exposure for this part – perhaps turning and reading off nearby ground which is receiving the same light. A worthwhile accessory here is a × 2 graduated grey filter, Figure 8.9, which can prevent overexposure bleaching important sky detail when you set the correct exposure for darker ground detail. Other filters useful for landscape work include a deep orange colour, and a polarizing filter. The former is used for

Starting Photography

Figures 19.11–12 Top: Landscape shot on false colour, infra-red 35 mm film. Results are most dramatic when the picture includes young foliage in direct sunlight. Below: The same scene taken on regular colour film in winter.

grams will allow you to 'tweak' the final colour balance in different directions. Don't overdo this manipulation though. The same restraint applies to use of a unique 35 mm film, Kodak Infra-red Ektachrome. This false colour slide film records landscapes containing foliage in psychedelic manner, Figure 19.11. Designed for professional aerial photography it is available on special order from larger camera stores. Sunlit landscapes in Spring (when foliage is rich in chlorophyll) record with living green vegetation reproduced as bright magenta. Infra-red Ektachrome must be used with a deep yellow filter; exposure is critical and you should make a series of bracketed shots for each scene.

Figure 19.10 Gardens at Versailles. A shot which needed careful framing to exclude colours outside this restricted range.

Skies

Skies – meaning clouds, sunsets, vapour trails, rainbows, etc – form an important and ever-changing element in land and seascapes. The contents of skies can also form abstract images of their own. (American photographer Alfred Stieglitz called his photographs of clouds 'equivalents' – their shapes and tones evoking emotions such as love, foreboding, exuberance, even ageing and death.)

The best times of year for interesting skies are during Spring and Autumn. Cloud shapes appear most dramatic when back or side lit, in ways which strongly separate them from the general tone of the sky. For example, the sun may have just set, leaving a brilliant sky background and silhouetted shapes. Conversely, during unsettled weather, clouds can appear intensely bright against a dark background bank of storm clouds. Often a 'skyscape' needs a weight of tone to form a base to your picture. You might achieve this by composing darker parts of a cloud mass low in the frame (Figure 19.17) or by including a strip of land across the bottom of the shot. Where possible make elements in this lower part of

Figure 19.13 With the setting sun on or just below the horizon cloud shape becomes strong.

Figure 19.14 Centre: White cloud and steam picked out against a distant storm. Exposure was read off a sunlit hand.

Figure 19.15 Sunset in a hazy sky. By reading exposure for the sky alone its colour is retained. Land becomes a black shape, relieved by foreground reflection.

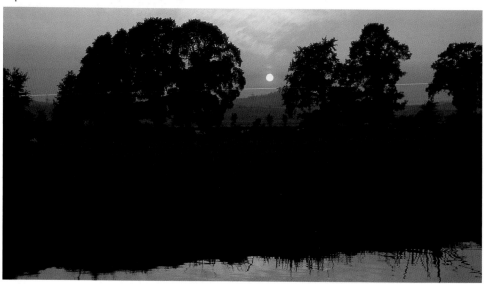

Starting Photography

Figure 19.16 This seascape in rain has become almost colourless. Grey tone values plus a rolling sea have a calming effect.

Figure 19.17 (Below) High atmospheric conditions can produce ray-like streaks across clear sky when the sun is behind cloud. Measure exposure for blue sky only.

your picture complement sky contents in some way (Figures 19.14 and 19.16). Trees here may usefully help to frame the sun when this is also shown.

Warning: The sun's bright globe loses its energy and can be harmlessly imaged late in the evening, when the light passes through miles of haze. But never point your camera direct at the sun in clear sky at other times of day. Like using binoculars under such conditions the intensity of light can damage your eyes. The camera's exposure meter too is temporarily blinded and can give rogue readings for several minutes afterwards.

Even though the sun itself is not shown decide carefully how you will measure exposure for sky pictures. It's easy to overexpose when your camera metering system becomes too influenced by a darker land mass also in the picture. The consequence is that cloud texture and sky colours burn out. Choose which part of the picture should finally appear mid-tone – midway between darkest and lightest details – then fill the entire frame with this or a visually matching area while you measure and set exposure (then set the AF lock on automatic

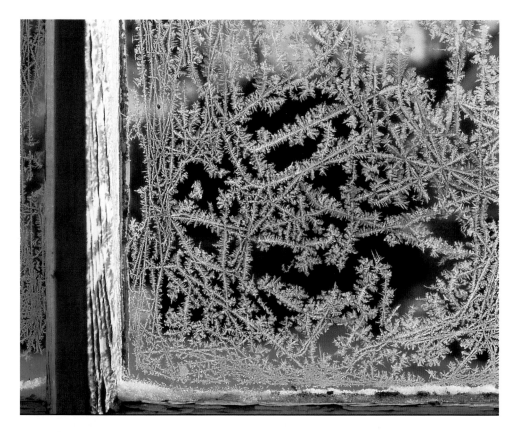

Figure 20.1 Backlit frost on a shed window. Dark garden behind shows up pattern.

exposure cameras). If possible make one or two bracketed exposures, giving *less* rather than more exposure. Make sure your final picture is printed dark enough to give exactly the feeling for shadow and light that you wanted.

20 Close-up subjects

Working close-up (within 30 cms or so of your subject) opens up a whole new spectrum of picture possibilities. You can not only record small objects so that they fill the frame, but interesting, even dramatic pictures can be made from details of relatively ordinary things which you might not otherwise consider for photography. A cabbage, or a few clothes pegs ... or just the page edges of a thick book are examples of hundreds of simple subjects that can be explored for hours in close-up. Along with plants and flowers, and weathered or corroded materials, they provide a rich source of pictures based on colour, shape, pattern and texture.

Close-up photography is also useful to record possessions for identification purposes. Items of special value to you can be logged in detail, against possible damage or theft leading to an insurance claim. If you are a collector your collection of stamps, coins, model cars, etc, can be visually catalogued this way and then scanned into a computer file. Photographing inanimate objects in close-up is also an excellent self-teaching process for control of lighting and picture composition generally, working in your own time.

Technically the main challenges in close-up work are to:

1 sharply focus and accurately frame up your subject;
2 achieve sufficient depth of field, which shrinks alarmingly with close subjects;
3 arrange suitable lighting.

Focus and framing

The closer your subject the more the camera lens must be located further forward of the film (or have its focal length shortened) to give you a sharp image. Basic, fixed focus cameras do not sharply image subjects nearer than about 1.5 m, unless you can add a supplementary close-up lens, see below. A typical 35 mm compact camera allows focus adjustment down to 0.6 m (20 in) and the more expensive models to 0.45 m (12 in). The latter means that you can fill the picture with a subject about 6.5 cm wide. Some cameras have a so-called macro setting for their closest focusing distance. It may mean there is a gap between the lens's *continuous* focusing adjustment and its positioning for one set, close distance. This is more limiting than to be able to focus 'all the way down'.

One way to adapt any camera for close subjects is to fit a close-up lens element over the main lens which shortens its focal length. These supplementary lenses, like reading glasses, are rated in different diopter power according to strength. Fitting a +1 close-up lens to a fixed focus 50 mm lens camera for example makes it focus subjects 87 cm distant. Used on a focusing compact with a camera lens set for 0.6 m it sharply focuses subjects 30 cm away.

The main difficulty using a close-up lens on a compact camera is that its separate viewfinder system becomes even more inaccurate the nearer the subject. See page 32. A close-up lens is more practical on a digital camera, where you can observe focus

Figures 20.3–5 Close focusing with an SLR. Top: 50 mm lens used at its closest setting, no ring. Centre: With a 1 cm ring added. Bottom: Using a 5 cm ring instead.

and composition accurately on an electronic display screen. Similarly any single lens reflex film camera has a viewfinding system which allows you to see what is being imaged.

However, close-up lenses – particularly the most powerful types – do reduce the overall imaging quality of your main lens. This is where an SLR camera scores heavily over a compact. For instead of adding a lens you can detach its regular high-quality lens from the camera body and fit an *extension ring* between the two. The extra spacing this gives might mean that your normal lens which focuses from infinity down to 0.45 m offers a range from 0.45 m to 0.27 m. (So the subject is imaged on film about one quarter life size.) By using extension rings of different lengths – singly or several at once – you can move in closer

Figure 20.2 A bellows unit for close work.

Figures 20.6–7 Morning glory. Left, using *f*4 and 1/250 second. Right, *f*16 and 1/15 second. The left-hand version has a less distracting background, looks more three-dimensional. Hazy daylight from above and behind helps to reveal form.

still. See Figures 20.3–5 and Figure 20.13. The degree of extension, and therefore how close a subject can still be focused, is even greater if you fit a bellows unit rather than extension rings. Autofocus lenses have to be manually focused.

Most SLR zoom lenses offer a macro setting on the focusing scale. This adjusts components inside the lens so you can sharply focus subjects an inch or so from its front surface. Often the range of subject distances is very restricted. For best quality and greatest flexibility in close-up work change your SLR camera lens to a more expensive macro lens, specially designed for close subjects. Its focusing scale allows continuous focusing down to about 0.2 m and thereafter closer still if you add rings or bellows.

If you have no macro lens you can achieve maximum magnification with your SLR camera equipment by combining your *shortest* focal length lens with your *longest* extension tube or bellows. In other words if you own a simple extension ring fitting it behind a 28 mm lens instead of a normal 50 mm type will sharply focus your subject about 30 per cent larger. However you will be working much closer, which may result in the camera casting a shadow. This close proximity also makes three-dimensional subjects record with steepened perspective, see Figure 20.9.

Depth of field

Depth of field decreases as you come closer to your subject, even though you use the same lens aperture (e.g. A lens focused on something 1.5 m away might give nearly 20 cm depth of field, but this shrinks to only 3 cm depth when the same lens is focused for 0.45 m). This means that your focusing must be very precise – there is little latitude for error. Where possible arrange your

Starting Photography

camera viewpoint so that all the parts of the subject you need to show pin sharp are about the same distance from the lens. Figure 20.8 is one such example.

On the other hand, comparing Figure 20.6 with Figure 20.7 shows the value of choosing to have shallow depth of field. Provided that every part of the subject where you must show detail *is* sharp, rendering things at other distances out of focus helps to isolate it, erasing clutter. A manual camera with depth of field preview button is very useful here – observing image appearance as you alter the lens aperture setting will give you a good idea of the extent of sharp detail (although you must get used to the screen getting darker as the aperture is reduced in size).

Garden flower close-ups

Flowers are a rich source of colour, pattern, texture and form. Lighting is therefore very important. Out in the garden shooting against diffused sunlight is a good way to show the transparency of petals and leaves, emphasized by shadowed background (Figure 20.6). Back or side lighting also

Figure 20.8 Having the main subjects all the same distance from your lens reduces focus problems. Direct sunlight from one side is needed to reveal snow texture.

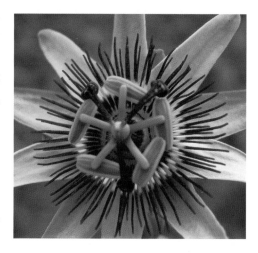

Figure 20.9 Passion Flower, actual size. Hand-held camera. Even *f*11 gives extremely shallow depth of field this close, but helps separate out component parts.

reveals the stalks and other structural detail in a three-dimensional way. Direct sunlight from the side is good for emphasizing texture (including dew or snow on plant surfaces, Figure 20.8). Even when sunlight is diffused fit a lens hood or shade your lens some other way to minimize light scatter and flare. Measure your exposure mainly from delicate petal detail – if this results in dark stalks it is still more acceptable than burnt-out flower colours.

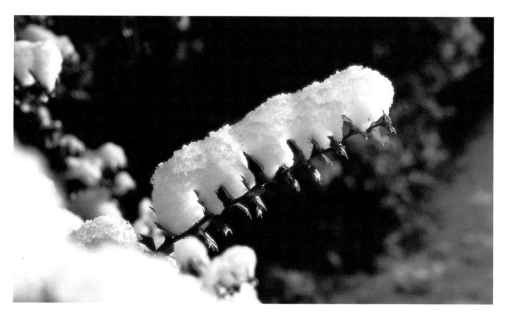

Figure 20.10 This piece was lit by a wide rear window. Shooting from a distance avoided steep perspective, hid camera reflection.

Figure 20.11 Copied on a window sill, lit by soft overcast daylight from above, and white card below the lens to fill-in.

For a strongly patterned flower like Figure 20.9 soft even light will cause least confusion. One advantage of working so close is that it is not difficult to modify natural light to suit your needs. A piece of tracing paper hung between plant and direct sunlight will bathe everything in soft, even illumination. A hand mirror can direct sunlight into a shadowed bloom. White card held close behind the camera reduces excessive contrast with back-lit shots.

Movement blur

A feature of working outdoors you will discover is that small movements of the flower caused by the slightest breeze are magnified by image size. As a result it keeps swaying out of focus, and there is a risk of movement blur.

A card shield on the windward side just outside the picture area helps here. But shooting on fast film will allow you to set a combination of brief shutter speed (perhaps 1/125 second to reduce blur and allow camera hand-holding) *plus* a really small aperture to produce sufficient depth of field. But avoid film which destroys the finer qualities of your image with grain pattern, especially if you plan a big print. It is really best to work using a tripod, or at least partly support the camera on top of a stick or 'monopod' reaching to the ground. A monopod set-up can minimize movement blur yet still allow you quick adjustments to distance.

Using a manual or semi-automatic camera on aperture priority mode, first set an aperture to achieve the depth of field you need and then shoot at the shutter speed indicated to give correct exposure. Clamping the flower in some way – perhaps holding its stem with your hand just outside the picture area – will also help.

Flash is a handy source of movement-freezing illumination in a close-up situation. If possible have a flashgun on an extended lead – so that you can position it from the best angle for the subject features you want to show, using the light either direct or diffused with tracing paper. Flash on or near the camera can be useful when working with daylight to dilute shadows, leaving sunlight from above to pick out form (page 66). Flash will also suppress unwanted background or surroundings by underlighting them, but take care that this does not give you unnatural looking results.

Close-ups indoors

Being able to work close up means that you can find all kinds of subjects indoors, either to photograph for factual record purposes or to create pictures. You might for example create a 'portrait' of someone through a still life group of related possessions and personal memorabilia. For a child this might be the contents of their schoolbag; for an aged relative pictures and objects displayed on a bureau. Much of this work can be done by

Starting Photography

Figure 20.12 Shot with a 50 mm lens and extension ring. Tracing paper diffused daylight.

Figure 20.13 Same lens and ring. f16 was used to get eye and distant window sharp.

means of daylight. Hazy sunlight through cloud (*not* blue sky) will give most accurate colour, and if you can work in a room with a large window this will help to avoid uneven illumination. Figure 20.12 was lit in this way. A tripod is practically essential – it not only gives you the freedom to give longer exposures without camera shake, but anchors viewpoint and distance in one spot while you build up your picture, bit by bit. See also studio work, page 137.

Copying flat surface subjects

The most important factors in photographing physically flat subjects such as drawings, sheets of stamps etc. are:

1 to be square-on to your subject;
2 have it evenly lit.

Unless the back of your camera is truly parallel to the surface you are copying horizontal and/or vertical lines will converge. Look very carefully around the edges of the frame to ensure that the borders of your subject line up – don't be tempted to tilt the camera a bit if the picture is not quite central (shift it sideways instead).

When using daylight through a window come close to the glass so you have the widest possible width of illumination, e.g. lay your subject flat on a bay window sill. Evenness is further improved if you place white card vertically facing the window on the room side of your subject just outside the picture area. Be careful about measuring exposure when your subject is on a background sheet of a very different tone, as in

Figure 20.11. Stamps displayed on a black, or white, page will be over- or underexposed respectively by a general light reading. It is best to cover the whole page with a mid-grey card and measure off this.

Reflective subjects

Reflective surfaces such as glass or shiny metal need special lighting care, otherwise shadowy reflections of the camera will confuse detail. Sometimes you can help matters by shooting from further away, using a longer focal length lens on an extension tube.

Figure 20.10 was photographed in this way, with a 135 mm lens. The camera can then be far enough back to be a small, unsharp, invisible reflection. A large sheet of tracing paper used close to your subject is the best way of controlling reflection. The watch, Figure 20.12, was shot at a slight angle so that only the tracing paper surface (through which all the lighting passed) was

Tips and Reminders

■ All close-up focusing is easier if you first set your lens to its closest setting or estimated subject distance, then inch the *whole camera* towards and away from the subject until the image on the focusing screen or display screen appears sharp.

■ If you buy only one extension tube pick the shortest one for your camera (typically 10 mm). Added to a normal 50 mm lens this will be more useful than any other length.

■ If there is insufficient depth of field move the camera away and re-focus. The smaller image will have more in focus, and can later be enlarged from the centre of your negative.

Subjects

Figure 20.14　One of a series on man-made patterns – notes, graffiti and doodles near an art studio telephone.

shown as an even white reflection off the metal, picking out its engraving.

　　　Some shots stretch depth of field to its limits. In Figure 20.13 for example the aim was to get both the eye itself and the much more distant window reflection acceptably sharp. The lens was therefore set to its smallest aperture (f 16) and the dim image examined as the camera was shifted fractionally backwards and forwards until both elements were just within depth-of-field boundaries.

Projects: Tackling self-set themes

A good way to extend your photography is to work to a particular topic or theme – something chosen yourself, or set perhaps in a competition. This will challenge you to organize ideas and plan your approach, and actually having to carry out an assignment encourages you to solve technical problems, gaining experience and confidence.

　　　Themes might place greatest emphasis on the subject itself (person or thing) or on shapes or structures more than what they actually happen to be. Or again they may be concerned with underlying concepts, such as humour and emotions of various kinds.

Singles or series?

Your result might be a single picture, or a pair or a sequence of photographs. One picture can sum up a simple concept such as joy or sorrow; it might provide a glimpsed 'portrait' of a place and the people living there without actually showing them (as shown above). Taking two separate photographs offers opportunities for comparisons and contrasts when presented together. Maybe they simply make a point about man-made patterns and natural pattern, like Figure 20.14 and Figure 20.15. Sometimes it's necessary to make features such as background, positioning in the frame, etc., similar in both pictures to show up differences in your main subjects. A longer series of pictures gives scope to tell a story or explain a process, show changes of time and place, and thus *develop* a theme.

Subject-based themes

Several subject themes have been touched on in this part of the book but there are many more, such as sports activities, natural history, still life, etc. Perhaps you decide to work to a portrait theme. Think of all the ways you can show an individual – at work, at home with their possessions, with family and friends, travelling, relaxing or practising a hobby. You need patience and time to get to know your subject well, observing mannerisms, seeking out representative aspects of their life.

Another way of working is to shoot a collective portrait, say one picture of every family in a street or apartment block. Here you might show each at their own front door, keeping your viewpoint and lighting similar to provide continuity. Allow the groups to pose themselves. Even show their reactions to being photographed – some showing off, others shy.

Structural themes

Here the project might centre on movement or colour, or shapes. Build a set of pictures from 'found' subjects which all share a common colour scheme but have many variations in content, scale, etc. One might be blue sky with clouds, another a group of blue painted signs, a house with blue curtains, a close-up of blue flowers ... Make sure each shot is a satisfying image within itself though.

To begin a project on the theme 'light', you could consider qualities such as brilliance, reflection, colour, cast shadow and so on. Observe the effects of light on various surfaces under different atmospheric conditions. Next work through your list, eliminating similarities and identifying six or so characteristics you want to show. Then find suitable subjects (don't overlook the macro world) and techniques to communicate strongly each aspect.

Emotive and narrative themes

Projects based on the dominant *feelings* a viewer reads out of your picture are arguably more difficult to plan and tackle. A sense of gaiety, or stress (Figure 25.6), implied menace (Figure 16.9) or close friendship are all of this kind. Your chosen approach might be factual and objective, or implied through the shape of a shadow or plant structure, or something colourful but quite abstract.

A story-relating narrative sequence of pictures might illustrate a poem, or cover a passage of time or a journey from one place to another. Picture series like this need visual *variety* but also *continuity*. Start off with a strong general view as an establishing shot, then move in to concentrate on particular areas including close-ups and lively (but not puzzling) viewpoints. The final photograph might bring the viewer full circle,

e.g. the opening picture re-shot at dusk.

Project 14 Sum up your impressions of one of the following places in 3–4 pictures (a) a graveyard; (b) the seashore; (c) a modern industrial park.

Project 15 Make a short series of pictures of *owners* and *pets* to prove or disprove the theory that they grow to resemble one another.

Project 16 Produce two or three animal 'head and shoulders' portraits of either (a) a dog; (b) a tame rabbit or hamster; (c) a cat. Try to convey character through showing what they do. Include the owner if relevant.

Project 17 If you have some valuable items record them for insurance purposes. Include a ruler alongside for scale.

Project 18 Using hands as an expression of emotion, produce three pictures, each conveying one of the following – anger, tenderness, tension, prayer.

Project 19 Illustrate three of the following themes using a pair of pictures in each case: simple/complex; young/old; tall/short; hard/soft.

Project 20 Make a documentary series of four pictures on either 'Children at play', or 'Shopping', or 'A day off'.

Figure 20.15 Part of a set of pictures based on the theme of light and pattern. In this instance natural pattern.

Part Five Troubleshooting

21 Assessing results from the lab

Everyone makes mistakes, some time. But when you receive back unexpected results from processing it's important to identify what went wrong. Was it the film ... or the camera ... or (most likely) the way you used your equipment? Or maybe it's all due to the lab which processed and printed your results?

A fault most often experienced by beginners with 35 mm cameras happens during loading, if the leading edge of the film is not properly attached to the take-up spool

Figure 21.1 Negative film completely black.

Figure 21.2 One black frame, but the rest of the film with no pictures.

Figure 21.3 Separate frames, each black or with a vastly dense picture. B&W film.

in the camera. After closing the camera back the film remains stationary even though you wind on after each exposure. Results appear like Figure 21.2 or Figure 21.5. Another very common error is to open the camera before you have rewound your exposed film back into its light-proof cassette, Figure 21.1. Single use cameras avoid these problems by having the film ready loaded and sealed in. Cameras (including APS) with automatic loading and rewind are also unlikely to allow wind-on errors to occur.

What to look for

When you notice a fault on a print the first thing to do is to compare it very closely against the returned negative (the film exposed in the camera). If this negative looks normal and shows a lot more detail in the shadows or highlights than its print, or the print shows a blemish which cannot be seen on the negative, ask for a reprint. (If you have shot slides it is often easier to pin down faults as the chain of processing does not then include possible printing errors.)

The most disastrous sort of results are shown in Figures 21.1–7 – where an entire film either contains no pictures at all, or is a jumbled mass of images, patches and marks. The kind of prints reproduced on pages 104–8 however are more likely to occur individually than from every picture on the film. Comments alongside apply to 35 mm colour prints or slides; on this and the facing page they relate to colour negatives unless stated otherwise. See also black and white negative faults, page 145.

No usable images at all

Your film is completely black without data, numbers or lettering visible along the edges. It is most likely to have been heavily fogged to light in some way. Perhaps the camera back was open as the film was rewound? Or a child, playing, pulled the film from its cassette (and then wound it back in). Exceptionally, this can be the result of chemical fogging during processing.

The film has one frame black, near the beginning. The rest is clear film although

data can be read along its edges (see Figure 21.2). This film was correctly in place for the first picture but then failed to move on because it became detached from the camera's take-up spool. All your shots were therefore exposed on the one frame.

Each frame can be seen, but is just solid black. Every picture has been grossly overexposed. Maybe the shutter sticks, remaining open for several seconds? Or the lens aperture remains fully open despite bright conditions. Your exposure metering system may have a major fault, or you set film speed wildly wrong (e.g. ISO 32 for ISO 3200 film). The camera may leak light alongside the lens.

The film is end-to-end a mix of overlapping images and frame lines (see Figure 21.4). You have put the same film through the camera twice. Winding an exposed film completely back into its cassette, or folding over its protruding end, will avoid this happening.

Your film is clear, having no images but with edge data present. An unexposed negative film has been sent for processing.

The (slide) film is black. Edge data though is still present. The film sent for processing was unexposed.

Indeterminate shape patches of fog and perforation shape patterns along the whole length of the film, as well as images. Your film has been partially fogged to light, probably during processing. Films are spliced end-to-end to go into a processing machine. If light briefly enters the machine loosely coiled film may print its perforations onto the film surface beneath it, giving results like Figure 21.7 below.

Figure 21.7 (Below) Colour negative film with dark patches and patterns over pictures.

Figure 21.4 A continuous jumble of overlapping images and frame lines.

Figure 21.5 Negative film which is clear but shows edge numbers and data.

Figure 21.6 Slide film which is black but shows edge numbers and data.

Individual images faulty

A line of white spots and beads – Figure 21.8

Cause: 'Necklace' of flare spots caused by internal reflection within the lens when shooting towards the sun. This happens most easily when using a wide-angle or a zoom lens. (On an SLR camera you may not actually see this defect if you are viewing the image at widest aperture.) The size and shape of spots alter as you change *f*-number.

Avoid: Shade the lens with your hand or a lenshood, or shift the camera into the shadow of a building.

Black hair shape – Figure 21.9

Cause: A small hair on the actual film surface when this shot was taken (or on a slide scanned into the computer).

Avoid: Check the cleanliness of the space between lens and film plane in the (empty) camera. With an SLR lock the shutter open on 'B' to access this area. Clean slides before scanning.

White hair shape – Figure 21.10

Cause: A hair temporarily on the negative surface during printing or scanning.

Avoid: Ensure negatives are clean before they go into the enlarger. You may be able to disguise the mark by print spotting, page 166, or digital manipulation, page 126. If this was printed by a lab request a reprint.

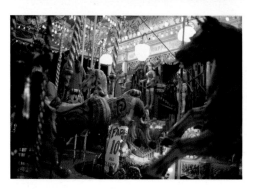

Orange colour – Figure 21.11

Cause: Daylight type colour slide film exposed to a subject lit by domestic type tungsten light bulbs.

Avoid: Shoot with a blue (80 A) filter over the lens. Daylight colour negative film gives a print with a similar cast, but this can be given considerable correction during either darkroom or digital printing.

Starting Photography

Out of focus – Figure 21.12

Cause: A fixed focus lens camera used too close to the subject. The green hedge, being further away, is sharper than the flower; but both remain closer than the camera's nearest subject distance.

Avoid: Don't exceed your camera's closest focus limit – often about 1 m.

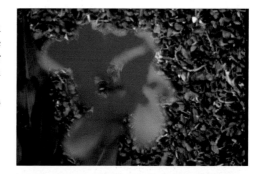

Red-eye – Figure 21.13

Cause: Flash on the camera lighting up the pink retina at the back of the eyes, normally shadowed and seen as black.

Avoid: Use a camera with a flash unit higher or further to one side of the lens. Or, preferably, bounce or diffuse its light. See page 63.

Pale print from over-exposed negative – Figure 21.14

Cause: Faulty light measuring system (batteries low?). Or film speed set far too low. The lens aperture was stuck fully open, or the shutter was sluggish.

Avoid: Check over your camera functions looking through the back of the (empty) camera body.

Print from underexposed negative – Figure 21.15

Cause: A simple camera loaded with slow film and used here in dim lighting. Or slow film mistakenly set by (or on) the camera at an ultra fast ISO rating.

Avoid: Keep to sunny conditions when you photograph with very basic equipment. If possible, check what ISO figure the camera is set for. (As this is typical of the best print possible off a nearly transparent negative you are unlikely to improve on the result.)

Yellow colour cast all over – Figure 21.16

Cause: Photographed under a yellow awning, or using bounced flash off a yellow ceiling, or a yellow filter left on.

Avoid: Recognize such lighting. Request lab to reprint giving maximum correction of cast. Shoot instead on black and white, or artificial light colour film. Or try using a filter – pale blue here.

Only the background is sharply focused – Figure 21.17

Cause: An autofocus camera has focused for the central zone of the picture (the more distant doors) or the AF mechanism is jammed. Perhaps a manual focusing lens was set for the wrong distance?

Avoid: Use AF lock (page 49) for off-centre subjects. With a manual lens always set the distance for your main subject – and don't move closer after focusing.

Wrong moment to shoot – Figure 21.18

Cause: Releasing the shutter just as someone or something unexpectedly barges into the picture.

Avoid: Try to anticipate what is about to happen between camera and subject. A compact camera has the advantage that through its viewfinder you still see some of the scene just outside your picture limits (see Figure 8.3). Make sure you have enough film left to allow several shots when people are swarming around you. (One or two 'mistakes' like this deserve a place in the family album.)

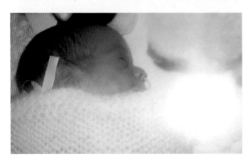

Large white spot – Figure 21.19

Cause: Flash direct from the camera reflected off the plastic window of this baby's incubator

Avoid: Do not shoot 'flat on' to windows – angle your viewpoint. Where possible shoot by natural daylight, loading fast film if necessary.

Entire picture, even static elements, blurred and smudged – Figure 21.20

Cause: Camera shake. In poor light with slow film an auto-exposure camera may have selected a slow (1/8 second or longer) shutter speed, at which setting the camera could not be hand-held sufficiently still. Perhaps the firing button was jabbed hard instead of squeezing gently when exposing?

Avoid: Load faster film when poor light is expected. Watch for 'shake' warning light with auto cameras – then improvise some firm support or use a tripod for shooting. With manual set cameras select the widest lens aperture, to allow use of the fastest possible shutter speed for the situation without underexposing.

Ring of light – Figure 21.21

Cause: Photographed directly towards the sun with a simple compact camera having a shiny rim to its lens.

Avoid: Anticipate light flare from these conditions. Adjust camera direction. Tilting it downwards or shifting slightly right here would allow the tree to shade sunlight. Fit a lens hood, or shade with your hand.

Bands of orange or red, showing up most clearly in dark areas – Figure 21.22

Cause: Light entering camera or cassette has fogged the film. Perhaps the back was opened, or there is a missing screw.

Avoid: Always fully rewind the film immediately after your final exposure, before anyone can open the camera. Never load your camera in strong sunlight.

Mis-framed picture – Figure 21.23

Cause: Inaccurate use of the viewfinder, e.g. using a compact camera quite close but ignoring its parallax correction guide lines, page 32.

Avoid: Follow your camera's instructions for near subjects. Always ensure your eye clearly sees all four corners of the rectangular frame line at one time, especially if you wear glasses.

Main subject too dark – Figure 21.24

Cause: The camera's overall light reading was influenced too much by the large, bright area of window in this picture.

Avoid: Read exposure from close to the figure, then apply the camera's AE lock. Alternatively use fill-in flash, or pick another background.

White dog appears yellow – Figure 21.25

Cause: Fault in printing. The large area of strong blue background has confused the lab's automatic printing equipment. It has intensified yellow to counteract what it measures as excess blue in the picture.

Avoid: Have a corrected reprint made.

Sprocket hole shapes, patches of light and dark – Figure 21.26

Cause: Fogged to light, probably during processing (see page 103). A less likely alternative is light leaking into the camera affecting film loosely coiled on the take-up spool.

Avoid: Complain to your lab. Test your camera by exposing another film under the same conditions.

21.27 Subject appears distorted in shape – Figure 21.27

Cause: Photographed with a short focal length (wide-angle) lens too close to the nearest part of the horse's head.

Avoid: Move further back. Then change to a longer focal length (or have the smaller image enlarged out of the centre of your negative). Compare with Figure 12.7.

Part Six Experimental and Constructed Images

Don't become too fixed in your ideas about what makes a technically good photograph. Successful pictures don't necessarily have to be blur-free, full of detail, and an accurate record of what was in front of your camera. In fact occasionally an 'error', like some of those on pages 104–8 produces the sort of image which sums up an event or expresses a subject rather better than the result you expected. You can then explore this approach further, in order to expand your picture-making skills. It's also great fun.

Few of the techniques in this part call for equipment beyond a camera offering a 'B' setting shutter, or a few attachments such as lens filters. On the other hand they are all suggestions for experiments, so you must be prepared to waste film on a trial-and-error basis.

Even professionals expect to shoot many frames for one good result. Take a range of versions of your subject, making notes of the settings used. Then, if neces-

Figure 22.1 Not on fire – the camera was just shifted part way through exposure.

sary, make further experimental shots based on your best results.

Remember too that even after the shooting and processing stages there is still plenty you can do to alter and reconstruct pictures. This can be done by joining prints, combining slides, and hand-colouring black and white prints. A wide range of manipulative possibilities also opens up if you can scan your pictures into a computer and so make use of special effects digital software.

22 Letting the image move

The painter Paul Klee once said that 'a line is a dot that has gone for a walk'. In photography as soon as you allow the image to move while it is exposing every dot highlight gets drawn out into a line. This image movement might be the result of shifting your camera during a long exposure, the subject being static and fixed (Figure 22.1 for example). Alternatively, your camera might be static and the subject moving, like Figures 22.3–5. Or thirdly, both camera and subject are on the move, Figure 22.7.

Figure 22.2 An abstract picture created from small lamps in a multi-coloured sign. The camera was kept moving for 8 seconds.

We are all used to experiencing blur as a symbol of movement, from close objects rushing past the car window, to the streaks drawn behind characters in comic strips. A photograph can exaggerate speed by showing the subject with lengthy blur trails, created by allowing considerable image movement during a long exposure time. Your subject can appear to have bumpy or smooth motion too, according to the shape of the lines – something you can control by jerking or gliding the camera with its shutter open. In extreme instances (Figure 22.2 for example) the nature of the subject gets lost and you create an abstract pattern of colour and light.

General technique

The best way to start experimenting is to shoot at night, picking scenes containing plenty of pinpoints of different coloured light. Street lights, illuminated signs; decorative lamps on buildings or at the seaside; and moving traffic during the rush hour are all good raw material. Try to pick a clear night with intensely black sky. You will need a camera allowing timed exposures up to several seconds and/or a 'B' setting. A tripod is also essential, together with a lockable cable release.

Load slow film and set a small lens aperture. If your camera offers aperture priority then choosing this mode should result in the slowest possible shutter setting without overexposing. If you have a manual camera try exposures around 10 seconds at ƒ16 for ISO 100 film, or be guided by what was used for pictures on these pages. Some cameras do not measure exposure when set to 'B'. In which case open the lens aperture fully until your camera indicates a timed exposure, then return the lens setting to ƒ16 and double the time for each change of ƒ-number as you go. For example, if opening the lens to ƒ2 makes the meter respond with 1/8 second then at ƒ16 you should give 8 seconds held open on 'B'.

Static subject, camera moved

One basic way of creating 'drawn' light patterns like Figure 22.2 is just to move around the street at night with the shutter open. In this shot eight small groups of different coloured bulbs in a sign were focused small in the frame. Then, as soon as the shutter locked open, the camera was panned upwards and downwards, swaying side-to-side to form the tangle of shapes.

Interesting results happen with a lit subject at night when you give part of a (long) exposure with the camera first still, and then moving. The 'still' part of the exposure records the general shape of your subject, avoiding total abstraction, and the moving part shifts all the highlights. In Figure 22.1, for example, the camera was loosely attached to a tripod. It was held firm for the first half of a 3 second exposure at ƒ22, and then panned left at 45° throughout the final 1½ seconds.

Static camera, subject moved

With night subjects like fairgrounds or busy highways long exposures with the camera kept absolutely still can record static parts of a scene clearly but elongate bright moving parts into light trails. The nearer a particular light (or the slower its movement) the wider its trail will appear. Figure 22.3 and Figure 22.4 show how two 5 second exposure pictures shot a minute or so apart record different patterns traced out by a fairground ride.

This 'drawing with light' can be developed further into 'writing with light' provided you have a steady hand. You will need to work outdoors at night, or in a darkened room with a black background. Secure the camera to a tripod and mark out on the ground the left- and right-hand limits of your picture area. Your 'performance' must not exceed these extremes. Focus on something such as a newspaper, illuminated by a hand torch, held midway between the markers. Set the shutter for 'B'.

To produce Figure 22.5 someone wearing dark clothes stood between the markers, facing the camera. Keeping on the move they 'wrote' in the air with a lighted

Figures 22.3–4 (Right) A fairground ride acts as a frantic drawing machine. Always try to include static elements too.

Figure 22.5 (Below) Writing in the air with a sparkler in the dark.

Experimental and Constructed Images

Figure 22.7 Panning gives a strong sense of movement. Only one girl's image was moving at just the right speed to record sharply. See also Figure 11.4.

Figure 22.6 Technique for camera panning. Follow the subject with a smooth camera movement. Fire the shutter half way through.

sparkler firework whilst the shutter remained open. A small handbag type torch makes a good light pen too, provided you keep it pointed towards the camera as you write. Torches with built-in colour filters allow the lines to change colour, or you can organize someone to use a series of filters over the camera lens.

Exposure varies according to the strength of light and speed of drawing. Test at about *f*16 for a total writing time of 10 seconds (ISO 100 film). Write at a consistent speed – slower lines thicken through overexposure, fast lines record thin. Words and numbers will appear the wrong way round to the camera so you should have the negative printed, or slide projected, through the *back* of the film.

Moving camera and moving subject

By means of panning the camera the image of a fast moving subject can be held steady on the film, but with all the *static* parts of the scene recorded blurred. This is best done at a shutter speed of about 1/30 second, and is therefore within the capabilities of quite simple cameras. As Figure 22.6 shows, you hand-hold the camera, pivoting your body so that its movement is in a smooth sweep. Then release the shutter halfway through the pan. If your camera has automatic exposure options set these to shutter priority mode.

Tips and Reminders

■ A compact camera has viewfinder advantages over an SLR camera for long exposure pictures. The eyepiece of an SLR blacks out while the shutter is open, so you must look over the top of the camera to monitor how much movement is being recorded.

■ With practice you can form blur lines which are sympathetic to the way you want to interpret your subject – a jerky pan for an old jalopy, or smooth gentle curves for a limousine.

■ Colour images of light blurs look particularly good as slides because of slide-film's extra contrast and brilliance. If results are in colour print form ensure they are printed sufficiently dark to give a black (not grey) background and strong colours.

Figure 22.8 Star tracks recorded at night during a 90 minute exposure.

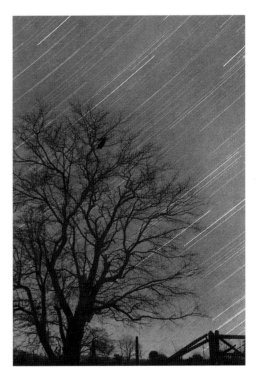

Static subject, static camera

Zooming is a way of making the image move and blur during exposure, while both your subject and the camera itself are completely stationary. You need a camera with a zoom lens, slow film, and a subject sufficiently dimly lit to need an exposure time of at least 3 seconds. Then, from beginning to end of the exposure time, you smoothly zoom the lens through its full focal length range. Figure 22.9, looking down on the lights of New York from the Empire State Building was shot in this way.

Whether you zoom from wide to long or the reverse makes little difference, but check out both ends of the range before shooting, to practise smooth lens handling and to preview the amount of blur. A firm tripod is essential. Since all blur lines radiate from the precise centre of the frame make this 'bullseye' contain something different from the rest, to justify such emphasis.

Star tracks

Stars in the night sky look quite static but only because they move too slowly for us to notice. The sky in Figure 22.8 was exposed for 1½ hours at ƒ16 on ISO 125 film. The camera was left on its tripod pointing generally towards the pole star (around which all other stars appear to rotate). Pick a clear moonless night, and shoot somewhere well clear of light-polluting roads and towns. Open country or a coastal area is ideal. Be sure to include some landmark, such as the tree shown here, to counterpoint the star tracks.

23 Exploring reflections

Some unusual and experimental pictures are possible without special know how or any out-of-the-ordinary gear. They involve straightforward photography of what you

Figure 22.9 City at night. The camera's lens was steadily zoomed during a 3 second exposure. The 'Christmas tree' shape resulted from a group of buildings more brightly lit than the rest, and imaged centre frame.

Experimental and Constructed Images

Figure 23.1 Distorted appearance due to refraction of light through the clear water of a swimming pool.

Figure 23.2 Reflection of the far bank in the smooth surface of a river. The result was turned upsidedown to make this picture.

can see in front of the camera, but by your careful choice of viewpoint and framing give a picture with strange optical appearances. Results include distorted shapes, images with detail broken up in unfamiliar ways, and combinations of two or more separate picture elements for dreamlike effects. All are based on photographing something either reflected or refracted. Everyday reflective surfaces include still water, glass windows and mirrors. Refraction alters the way things look when your subject is observed through patterned glass, clear or disturbed liquid, etc.

Using water

Pictures like Figure 23.1 are best shot looking down into the clear water of a swimming pool, preferably outdoors where light is plentiful. Using the long focus extreme of a zoom lens helps to fill up the frame. The appearance of this underwater swimmer changes every second due to the swirl of water altering refraction effects, as well as his own movements. So it is best to work at 1/250 second or faster (using shutter priority mode on an AE camera) and pick the right moment carefully. Autofocus is helpful here, provided it does not accidentally pick up on the pool's floor pattern some distance below the subject.

Still water creates an almost mirror surface. By including only the far bank and sky reflected in a river and presenting this *upside down* (Figure 23.2) an impressionistic landscape image is formed. Remember

that the reflection itself requires a lens focus setting different from the much nearer reflective surface. In a shot like this focusing on the tree's reflection and then setting a small lens aperture would have brought detail on the surface of the water into focus too. Specks of floating flotsam would break the dreamy illusion. This picture was therefore exposed at *f*2.8, taking great care to (manually) focus so that only tree and clouds were within the depth of field.

Using glass

Large glass-fronted buildings, including shops, are good locations for mixing one element (behind the glass) with another (reflected from its surface). Lighting is important here. People passing in the street may be sunlit and so dominate over figures inside the building. But later in the day the balance reverses as internal lighting comes on behind the glass.

In shots like Figure 23.3 things are happening on three planes. Some people are sitting directly inside behind the window; others are reflected grouped around a mon-ument on the opposite side of the road. The woman in the pink hat is seen direct, closest to the camera and also hiding what would otherwise be the photographer's own reflection in the glass. Working with effectively three images like this allows you to make use of interesting mixtures of scale, and here fills up what would be sparsely occupied scenes if shot individually.

Similar possibilities apply to mirrors hung on walls or buildings clad with a mirror finish – they all allow you to relate two or more quite separate elements together in the same picture. Remember to set a small aperture if reality and reflections are all to appear sharp. You will probably have to set focus (manually) for somewhere between the two. To prevent you and your camera appearing in the picture, shoot at a slight angle to the reflective surface. Where a square-on view is essential use a long focal length lens so you can shoot from well back and so appear as a small reflection, perhaps in some shadowed position.

24 Using lens attachments

Another way of experimenting with the appearance of subjects is to fit some special effects attachment or filter over the front of your camera lens. This has the advantage that you can create strange results – repeat

Figure 23.3 Lunchbreak at the annual meeting of a women's organization. A naturally formed montage of delegates inside, outside, and across in the park.

Experimental and Constructed Images

patterning, abstractions, off-beat colouring etc. – from almost any scene, rather than work with long exposures or reflective surfaces. Some attachments optically soften detail, or split up the image; others are coloured filters which tint all or part of your picture.

Typically a lens attachment is a circular or square piece of optical plastic sufficiently large to cover the lens. Circular types may screw into the lens rim if it has one, or they fit via a clip-on holder (Figure 24.5). You can also just hold it over the lens. For most types it is important to be able to rotate the attachment freely because this is the way you alter its effect on the image, to suit each particular shot. Using an SLR camera will allow you to exactly forecast the effect produced. However, with a compact camera first look directly at the subject through the attachment by eye, turning it to find the best effect and then transfer it without further rotation to the camera's lens.

Special effects attachments

Some optical attachments are made of clear plastic with faceted surfaces to give a multiple image of your subject. This way you can repeat whatever is composed centre frame into three or more separated but overlapping images, like Figure 24.1. Some work by having a parallel fluted pattern instead and

Figure 24.1 A single lamp-post against white sky, turned into overlapping shapes by a three-faceted prism lens attachment.

Figure 24.2 A reeded glass attachment, fluting set vertically here, repeats a single portrait profile.

Starting Photography

Figures 24.3–4 A starburst attachment over the lens spreads out isolated bright light sources. Right: The scene shot normally.

turn one narrow strip of image into a row of repeats. Strips may run vertically (Figure 24.2) or at any angle you choose to rotate the attachment. When you are making multiple image shots pick a subject with a strong, simple shape and plenty of plain background.

Another attachment, known as a *starburst* and made of etched or moulded clear plastic, spreads bright highlights in a scene into star-like patches with radiating 'spokes'. Much used on television, a starburst is good for glamorizing shots containing brilliant but well separated pin-point highlights – for example direct sunlight sparkling on water, disco spotlights, and tight groups of lamps in dark interiors or at night. As you rotate the attachment spokes rotate, so you can position them at the most

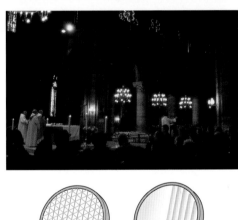

Figure 24.5 Lens attachments. A: Starburst. B: Fluted glass. C: Half-lens (focuses a nearby object in part of the picture). D: Five facet prism. E: Holder for filters.

Experimental and Constructed Images 117

Figure 24.6 Darkening blue sky. Left half no filter, right half orange filter.

interesting angle. Results from a softly lit scene however are disappointing as the star-burst just gives flat, slightly diffused images.

Almost all optical-effect attachments alter in their image changes according to lens focal length and aperture you set. An SLR camera with aperture preview button is the best way to make an exact check of image appearance at the *f*-number you will be using. There are dozens of different effects attachments made. They include types which just give soft focus around the edges of the picture. Others are bifocals containing a portion of close-up lens you can rotate to coincide with some small close object so it appears sharp when the camera's main lens

Figure 24.7 The effects of filtering when shooting in black and white.

Filter	Effect on image
Orange	Darkens blue sky Lightens yellows, reds
Dark green	Lightens green foliage Darkens blue sky, reds
Dark blue	Darkens reds, yellows Lightens blues

is focused on a more distant part of the background scene. This way a foreground flower may record with as much detail as a landscape filling the other half of a shot.

Filters

'Filters' are so called because they remove some of the light which would enter the lens. A simple grey 'neutral density' (ND) filter just dims the whole image, useful for avoiding overexposure when you have fast film loaded but want to use a slow shutter speed or set a wide lens aperture. A polarizing filter offers this same advantage but, like Polaroid sunglasses, also subdues reflections at some angles from surfaces such as glass or water. The filter can darken areas of blue sky at right angles to the direction of sunlight too. A pale *coloured* filter will 'warm up' or 'cool down' the general mood of a scene. Both these and ND filters are available as 'graduates' – meaning their colour or tone fades off in the lower half of the filter to tint or darken just sky and clouds in a landscape.

Stronger, overall colour filters have a special role in black and white photography, allowing you to alter how a particular subject colour translates into a darker or paler grey tone. The rule here is that a filter lightens the appearance of colours closest to itself (see colour wheel, page 24) and darkens opposite or 'complementary' colours. An orange or red filter for example darkens blue sky, so that white clouds in a landscape record more clearly, see Figure 24.6 above.

Starting Photography

In colour photography you may want to use a strong overall colour filter to compensate for some fluorescent or other artificial light source when using daylight balanced film – instead of hoping the lab can do corrections in printing. See Table 27.1, page 136. Some special effects colour filters, 'tobacco' hue for example, are made as graduates to tint as well as darken the sky area alone. They produce results suggesting dusk or dawn.

'Dual colour' filters are split into contrasting halves. Results like Figure 24.9 depend on your composing a picture with the horizon in a straight line, located about halfway across the frame. The smaller your lens aperture the more abrupt the division between the two colours appears. Most filters call for an increase in exposure. This is automatically taken into account though if your camera reads light through the lens and therefore the filter too. Otherwise override exposure by the maker's rating on the filter (×3 for example).

There are no set ways of using most lens attachments, so experimenting is

Figure 24.8 Traffic at night. Changing colours were created by a series of strongly tinted filters passed across the lens.

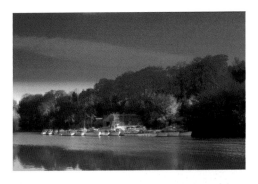

Figure 24.9 A dual colour filter, half deep red, half deep blue, gives garish results. The lower part of this picture is cropped.

always worthwhile. For example, deep colour filters intended for black and white work can produce strong effects in colour photography. Try jazzing up the light trails from a moving camera or moving traffic at night by holding a filter over the lens during part of a long exposure. For Figure 24.8 red, green and blue squares of filter were taped edge-to-edge to form one long continuous strip. Then, throughout a 30 second exposure of distant highway traffic, the strip was kept moving its full length several times across the lens.

Experimental and Constructed Images

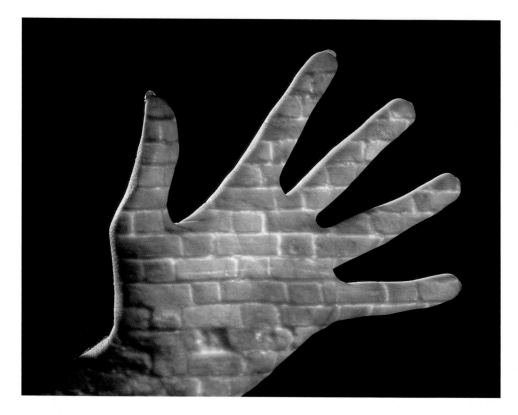

Figure 25.1 Colour slide projected onto an actual hand.

25 Combining pictures

Photography allows you to combine records of separate scenes or subjects taken at quite different moments in time, place and scale, into one picture.

This gives you the freedom to construct images which never existed in reality. Results can be bold and eye-catching like a poster, or haunting and strange, often making a statement in a visually more convincing way than something which is drawn. Constructed images may differ radically from normal vision – or at first glance look normal but contain an odd and disturbing feature, like Figure 25.7.

As far as equipment is concerned you should have a tripod and cable release. Some techniques call for access to a slide projector and a filter; for others your camera should have a shutter offering a 'B' setting.

One way of combining images is by projecting a slide onto a subject. Another

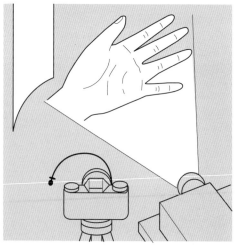

Figure 25.2 The set-up for the result above.

is to sandwich two slides together, or make two exposures on the same frame of film. Other methods include the basic cutting and sticking together of photographic prints, or the use of a computer and appropriate software (page 126).

Starting Photography

Combining by projection

Using a projector you can make a slide (or negative) image appear on the surface of any suitable light-toned object, then photograph the result exactly as it appears to the eye. Work in a blacked out room and if you are using daylight film have a bluish 80 A filter on the camera to correct for the orangey light from the projector. In Figure 25.1 a slide of brickwork is projecting onto a hand. By using a distant, black background no brickwork appears elsewhere. (Compare this shot with Figure 13.13 which explores a similar idea by very different means.) A matt white card reflector returned some diffused projector light-spill from the rear, to give some degree of form to the fingers and prevent them looking 'cut-out'. Correct exposure, measured off the hand alone, was ¼ second at *f*4.

Your image-receiving surface could be flat or curved – one or more eggs perhaps, paper cups, wooden blocks, or any object painted matt white for the purpose like the bottle used in Figures 25.3–4. Be careful not to make the result too complicated though –

if the image you project has a strong pattern then pick a receiving object simple in shape.

Strips of black card held about halfway between projector and receiving surface will restrict the image to where you want it to appear. Other lighting is needed to just suggest surroundings and the forms of your still life objects, provided you keep the light off the projected image. For the pictures below a desk lamp bounced light from a wall on the left. The relative brightness of this light and the projected slide is best judged by eye, but measure the exposure needed from close up to the projected part.

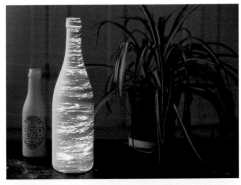

Figures 25.3–4 Slides projected onto a matt white painted bottle. Finely adjust strength and direction of light in the room.

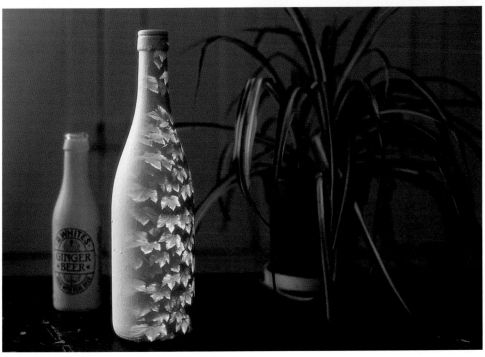

Combining by sandwiching

'Sandwiching' simply means placing two slide film images together in face contact within the same (glass) mount. Details of one appear in the lighter parts of the other. You can then project your result, or send it for a print or transfer to a photo-CD (instructing the lab to keep the sandwich together).

Be careful that the relative size of each image, as well as its positioning in the frame suits the other slide. You don't have the same flexibility here as when projecting a slide onto an object. Another point to watch is that each slide should be slightly pale – overexposed by about one stop – otherwise your sandwich will be too dark. It is worth keeping a selection of reject slides for this possible purpose.

Quite often one existing slide suggests another which needs taking to complete an idea. In this way you can also ensure that size, lighting, and placing are tailored convincingly. The sandwiched picture, Figure 25.6, for example, started as an experimental night shot of a distant town, the camera being tilted downward and wiggled for the second half of a four second exposure. The result seemed to suggest chaos and stress. Then another slide was planned and shot of a man with his hands to his head and silhouetted in front of white sky (Figure 25.5). This silhouette was slightly overexposed so that when sandwiched it was not impenetrably black and some of the light-trails could be seen 'penetrating' his head.

The seaside is an ideal location for shooting several picture components because of the large plain background offered by sea and sky. Figure 25.7 is a sandwich combining two 'throwaway' slides. One is a shot of the seashore with a blank,

Figure 25.5 Man against white sky – a component for the picture below.

Figure 25.6 'Chaos and Stress'. Sandwich of the slide left and camera-moved street lights.

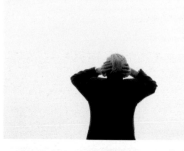

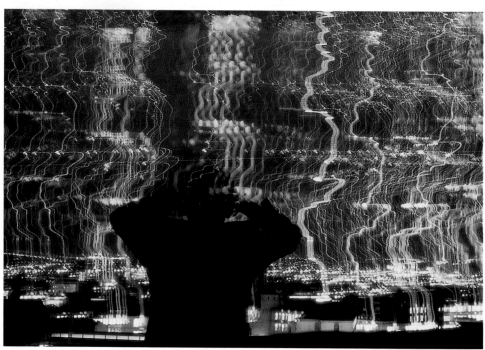

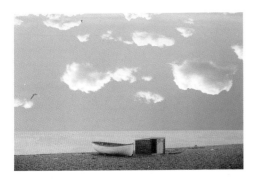

Figure 25.7 Surrealism at the seaside – via sandwiched slides.

(taking care not to shift the chair itself) so that the second half recorded it empty. Working indoors with dim light from a window and at smallest aperture, $f16$, the exposure required was four seconds. So, with the girl in place and keeping very still the shutter was held open on 'B' for two seconds. Then, keeping the cable release pressed and locked, the lens was covered with a black card while the girl left. Next, it was uncovered again for a further two seconds before the shutter was finally closed.

It is important to plan pictures like this in terms of where 'lights' and 'darks' will overlap. In Figure 25.8 the girl wore a plain dark dress and the chair was chosen for its lighter tones and patterned design which would therefore 'expose through' her clothing. The cardigan, face and hands had the

overcast sky. The other contains only blue sky and clouds, but sandwiching this film *upside down* creates a slightly unsettling, surreal effect.

Bear in mind that results similar to the combining of two pictures by sandwiching are now possible by digital means, using cloning or 'layering' software. See page 126.

Multiple exposures

Another way of mixing images together, involving only your camera, is to make several exposures onto one frame of film. You saw how with sandwiched slides the details of one picture appear most strongly in the *light* parts of the other. But multiple exposures give the opposite effect, one picture showing up most in the *dark* areas of the other, see Figure 25.8. You will find this fact important when you plan out your picture.

Making two or more exposures is easiest if your camera has a superimpose button. This disengages the wind-on mechanism so that the film stays still and only the shutter resets after each exposure. Superimpose ('multiple exposure') controls are provided on a number of compact and SLR cameras. On the other hand any camera with a 'B' shutter setting can be used for this work provided it accepts a cable release, preferably with a locking screw (page 37). You will need to work with slow film, probably indoors in order to make a time exposure necessary. A tripod is essential. Both Figures 25.8 and 25.10 were taken with a manual SLR camera, with the shutter set at 'B'.

For the picture, right, the girl sat in the chair for half the exposure, then got up

Figure 25.8 Double exposure – is she there or not?

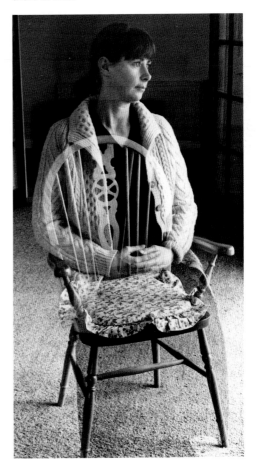

Experimental and Constructed Images

Figure 25.9 The wild wood. Three
exposures on one frame of film.

opposite effect – dominating over the shad-
owy part of the room behind.

The man (Figure 25.10) looking two
ways at once, is also the result of two super-
imposed exposures. If you cover up vertically
one half of the picture at a time you will see
that between exposures he has simply
moved his eyes. For the first exposure only
the left half of his face was illuminated (while
he looked that way) then that light was
switched out and another, illuminating the
right half, was switched on instead.

For this technique you need a
darkened room, or work outdoors at night.

Figure 25.10 (Left) Achieved by lighting
change and double exposure. See text.

Starting Photography

Have two lamps you can control from the camera, set up well to the left and right, or use a flashgun you fire manually on its 'open flash' button, holding it first at arm's length left, and then right. Only one half of the face must be seen at a time, leaving the other totally shadowed. Give the full measured exposure to each half of your picture since quite different parts of the head are illuminated at a time.

In Figure 25.9 exposure needed was 1/60 second at *f*11. But then the shutter was fired *three times* at this setting onto the same frame of film, rotating the camera a few degrees about a horizontal axis between each one.

Combining images digitally

Using a home computer of sufficient power (say 64 Mb of random access memory; and 3 Gb hard disk) your photographic images can be combined and manipulated on-screen. For example, Figure 25.11 shows the result of rearranging and simplifying the original 'straight' picture of birds on page 20. Comparing the two you can see that a large, confusing part of the aerial has been replaced with blue sky cloned from another part of the picture. The flying bird has also been cloned and shifted to a better position; a cloned adjacent patch of sky seamlessly covers where it had been.

The first step is to input ('capture') chosen negatives or slides into your computer system by converting them into digital data. An inexpensive way to achieve this is to get your photographic lab to transfer them all onto a Photo-CD, which you then insert into the computer's CD player. Alternatively, use a desk scanner which accepts your film

Tips and Reminders

■ Think up visual associations for the pictures you combine. For example, the way an eye resembles a daisy centre. A cracked mud pattern might be appropriately projected onto a bare white foot, or the faces of two partners superimposed (position their eyes in register).

■ Using a projector try projecting black and white negatives instead of slides onto objects. Similarly you can project 'constructed' slides, sandwiching tiny plant leaves or woven fabric within a glass slide mount.

■ Don't expect to get special effects like multiple exposure right with one attempt. For example, in a picture like Figure 25.9 shoot several versions, varying the degree of turn between each part exposure.

Figure 25.11 The picture below, shown straight on page 20, has been manipulated on a home computer to simplify its content and composition.

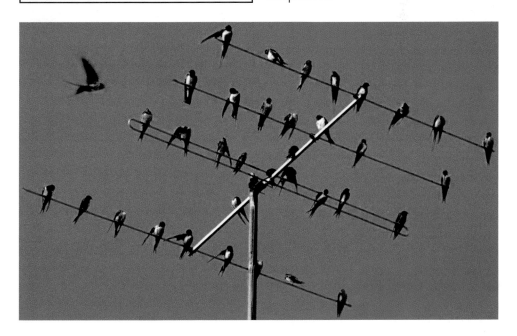

Figure 25.12 A home digital workstation. Films and prints here are input by scanning, or via bureau made Photo-CD. After on-screen changes pictures print out by inkjet.

in a holder, Figure 25.12. Otherwise you can work from photographic prints on paper via a flatbed scanner. If your shots were taken with a digital camera this may be connected directly into the computer to download its pictures, or the camera may contain a memory card which you remove and slot into a reading device.

The computer also needs an image manipulation software program such as *PhotoDeluxe* or *PhotoSuite*, which is initially installed from a CD. With pictures and software installed you can then bring the images up onto your monitor screen (negatives being electronically converted into positive form). Using the mouse, or better still a mousemat-size graphics tablet and pen, you may manipulate them with 'tools' offered on screen by your software program. Two or more images can be slid as 'layers', one on top of the other, to superimpose wholly, or in part, with great precision. You can combine the main subject in one shot with the background of another. Any chosen elements in a picture can be multi-cloned, changed in size or colour, reversed in tones or switched left-to-right, then returned to the shot. In fact it's tempting to overdo these and many other image distorting controls just for their novelty value. Programs have even greater usefulness for improving and 'fine-tuning' results in subtle ways. Retouching out any spots, disguising joins, or removing obtrusive items from backgrounds is made easy by vastly enlarging up the image on screen and working on it pixel-

by-pixel. Done well, changes are accepted as straight and natural pictures.

The final stage, when you are satisfied with what you have put together on the monitor screen, is to print it out onto paper. This requires a photo-quality digital printer such as a four or six-colour inkjet type. Your manipulated image can remain stored in digital form – on a computer floppy disk for example – for future prints.

Digital cameras and their memory cards are still expensive relative to the image quality and 'front end' features offered by film cameras. New technology is improving digital equipment all the time, but at present it is more practical to shoot on 35 mm or APS film, and have selected pictures put on a CD. Then, by means of appropriate photo-software you can edit and make excellent colour prints up to about A4 size without darkroom or chemicals.

The industry standard software program for professionally manipulating photographs is *PhotoShop*. This enables you to handle a vast range of tasks. However, its multi-faceted controls mean that it is quite complex to learn and demands a more powerful computer (over 100 Mb of RAM) to run efficiently. If you are aiming to teach yourself digital manipulation at home first build up experience with a lower cost, more limited software program. Later having practised enough to use this easily increase your computer memory and hard disk capacity and move up to advanced software.

26 Manipulating prints

There is still plenty of scope for physically experimenting with images after you get your prints back from the processing lab. If you are good at hand-work and have an eye for design there are various possibilities of montage – pictures constructed from different paper prints arranged so that they join, overlap, or blend with each other. Your aim may be simply an original form of pattern and decoration, or the assembly of a panorama otherwise impossible to shoot 'straight' without special equipment. You can construct a picture of a crowd of people or a fantastic landscape, create a caricature or a visual pun.

Similarly the hand colouring of monochrome prints opens up possibilities of colour pictures in which every individual hue is under your control. Realistic or bizarre, coloured in full or limited to just a suggestion here and there, you have a free hand. In fact there is little point in aping regular colour photography – hand colouring is best used for interpretive effect.

Assembled, montaged or coloured, once your hand-worked print is complete you can copy it – either using your camera

Figure 26.1 Four prints from the same negative make up a pattern montage.

Figure 26.2 With slice and reassembly you can redesign any building.

as shown on page 141 or through a high quality photocopying machine or scanner. Results will then be free of joins or irregular surface finish.

Montaging

Like slide sandwiching and multiple exposure, a print montage can combine elements or events which did not in fact occur together in real life. One person with eyes shut in a group can be pasted over with a cut-out print from another negative which is bad of everyone else. A strong foreground lead-in to a landscape can be combined with a distant main subject, when they were really hundreds of miles apart and shot on different days.

Experimental and Constructed Images

Another form of reconstruction is to carefully dissect a single print into a regular pattern of slices, concentric discs, squares, etc., and then reassemble them in some different way, like the church architecture shown in Figure 26.2. In Figure 26.1 four prints have been butt-mounted to create one pattern. Look at the bottom left hand quarter only and you will find that the subject is simply the inside of a shed door, including the shadow of the handle. It was constructed using two normal prints and two printed through the *back* of the negative.

The landscape, Figure 26.7, shows a more subtle form of repeat patterning – two butt-joined prints, one enlarged through the back of a negative and one from another negative, straight. Having the dog on only one half breaks up the symmetry of the final result, making you wonder if the scene is real or constructed. Pictures like this need to be planned out before they are shot. If possible make them pose a question or express some point of view. Figure 26.4, for example, says something about the fact that we work with hard edges to our pictures, unlike scenes observed by eye. A print of the man was pasted onto a seascape print, and the shadow by his feet painted in with watercolour.

Hand colouring

Hand-tinting monochrome prints allows you to choose to leave some parts uncoloured and suppressed, others picked out strongly like the girl's eyes in Figure 26.3, irrespective of original appearance. Have your print made on fibre based paper (if possible make the print yourself and sepia tone it, see page 178). The print should be fairly pale because underlying dark tones desaturate your colours. Choose paper which is matt, not glossy – the latter's extra gelatin top coat often gives uneven results. Remember too that big prints take longer to colour than small ones. Begin with a size you know you can finish.

Work with either transparent photographic dyes or ordinary water colours. Dyes give stronger hues and you can build them up by repeated application, but unlike watercolours they are hard to blend and mistakes cannot be washed off. (A dye

Figure 26.3 A hand-tinted black and white sepia toned enlargement. You need a set of photo-colouring dyes.

Starting Photography

Figure 26.4 Montage (courtesy Graham Smith).

remover pen will erase small colour areas.) Start off by slightly damping your whole print surface to swell the gelatin, and firmly attach it on all four sides to hardboard with gummed brown tape. Work on largest areas first, with a colour wash on cotton wool. Then colour in smaller parts using a brush, size 0–4, or a hand-colouring dye pen. Explore local colouring by computer too.

Experimental and Constructed Images

Figure 26.5 Panoramas are a quick, cheap way of making a big picture of a scene you cannot get in completely with one shot. Include plenty of overlap.

Panoramas

A panorama can consist of two, three or more prints joined up to form one uninterrupted picture. This is a very successful way of showing an architectural interior or a landscape when you do not have a sufficiently wide-angle lens. Building up a panorama also gives you an impressively large image from what were only quite small prints.

For the most accurate-looking result you must work carefully at the shooting stage. Expose each picture for a

panorama from exactly the same spot. Pick a viewpoint giving some kind of start and finish to your vista – perhaps trees at one end and a building at the other. Avoid showing objects close to you in the foreground and shoot with a normal or long focal length lens – otherwise it will be difficult to join up both the near and the far details in the prints. In any case try to overlap the contents of each frame by at least 30 per cent so you need only use the central zone of each shot.

Expose your series of pictures as quickly as possible in case figure movements or fluctuating lighting conditions upset your results. A camera with motor drive will allow you to keep your eye to the viewfinder. If the panorama features a prominent continuous line, such as the horizon, keep your camera dead level. Pointing the camera slightly upwards or downwards results in prints that only join up to show this line curved (Figure 26.6). Autoexposure cameras will make changes in settings if some frames forming a panorama contain larger dark areas than others. Individual prints then show continuous elements like sky as too dark or light, and they will not match up. So ensure that exposure remains unchanged by keeping to one manual setting or applying AE exposure lock.

Figure 26.6 (Left) Avoid tilting the camera or pictures only join up in a curve.

Starting Photography

Finally, lay out your panorama prints overlapping so that details and tone values join up as imperceptibly as possible. Tack them down onto card with masking tape. Then, with a sharp blade, cut through each print overlap – either in a straight line or following the shape of some vertical feature. Discard the cut off pieces and either tape together or butt mount the component parts of your panorama. If necessary trim or mask off the top and bottom as straight lines.

Figure 26.7 Constructed landscape. See page 128.

Figure 26.8 Mosaic type panorama. A contact sheet printed from twenty exposures on one 35 mm film. Always start photographing at top left and finish bottom right.

Joiners

Not every set of panorama prints needs to marry up imperceptibly into one image. Another approach is to be much looser, abandon strict accuracy and aim for a mosaic which just suggests general appearance. The painter David Hockney explored composite image making this way by 'spraying' a scene with dozens of shots, often taken from more than one viewpoint and distance. The resulting prints, which he called 'joiners' both overlap and leave gaps. They have a fragmented jigsaw effect which suggests the passage of time and movement around the scene, concentrating on one thing after another.

Figure 26.8 is a rough mosaic in the form of a single sheet of contact prints. It was made by contact (page 150) from a film of twenty consecutive exposures. The individual pictures, all shot from one position using a hand-held camera and 50 mm lens, collectively make up something approaching a fish-eye view (page 61). For this kind of result pre-plan how many exposures are needed per row. Don't overlap pictures – in fact compose trying to leave gaps where the black horizontal bars (rows of perforations) will stretch across the final picture. The way that inaccuracies in a mosaic such as this restructure the architecture gives it individuality and life, but try to pick a camera position giving a symmetrical view to help hold it all together as one picture.

Tips and Reminders

■ When preparing to stick one cut-out print on top of a background print thin down its edges as much as possible. Turn your cut-out print face down on a flat surface and chamfer the back of the paper all round with fine sandpaper.
■ To see a long narrow panorama in true perspective it should be viewed held in a *curve*, keeping the two ends the same distance from your eyes as the centre.
■ Some computer software programs allow you to input several negatives forming an overlap panorama, assemble these components on screen, then print out one seamlessly joined image.

Projects

Project 21 Produce pictures showing: (a) slow subjects – elderly people, milk floats, tortoises, fat animals, etc., apparently whizzing along; (b) fast subjects made to appear stationary or moving very slowly.

Project 22 Walk around a fairground or lighted traffic-filled street at night, holding the camera with its shutter open for 3–5 seconds (at *f*16, ISO 100 film). Include plenty of pinpoint lights. Keep the camera still for part of each exposure.

Project 23 Make a series of abstract images of the human figure. Consider the possibilities of focus, movement, blur, reflection, refraction, and shooting through various semi-transparent materials.

Project 24 Create 'physiogram' patterns. In a darkened room rest your camera on the floor facing upwards, focused for 1 m and set for *f*8 (ISO 100 film). Suspend a pen torch pointing downwards so that it hangs 1 m above the lens, on nylon cord firmly anchored to the ceiling. Make the torch swing freely in various directions within an area about 1 m square for 30 seconds with the shutter open.

Figure 26.9 From a project series on 'pattern'. A colour slide was contact printed onto black and white film in the darkroom, then the two films sandwiched together slightly out of register.

Project 25 By combining two or more images construct a photograph of a fantastic landscape.

Project 26 By means of a double exposure produce either a double profile portrait, or show the contents of a household appliance (crockery in a dishwasher for example) inside its closed opaque unit.

Project 27 Make an imaginative series of five pictures on one of the following themes. Either: (a) the tree as a dominant element in landscape; or (b) railway and/or road patterns as a visual design feature.

Project 28 Using three frames of film carefully shoot an accurate panorama showing part of the interior of your room. Then use all the rest of the film to shoot a loose 'joiner' of the whole room. Assemble the two results appropriately.

Project 29 Create an interpretive photographic sequence of 4–6 pictures illustrating your concept of either: (a) transformation; or (b) harmony.

Project 30 Shoot several interior scenes and landscapes, then use montage to combine the *foreground* of one with the *background* of another to give an inside/outside fantasy scene.

Project 31 Using a montage of prints illustrate one of the following themes: The mob; Stairs and entrances; Family ties; Streetwise; Ecology rules!

Experimental and Constructed Images

133

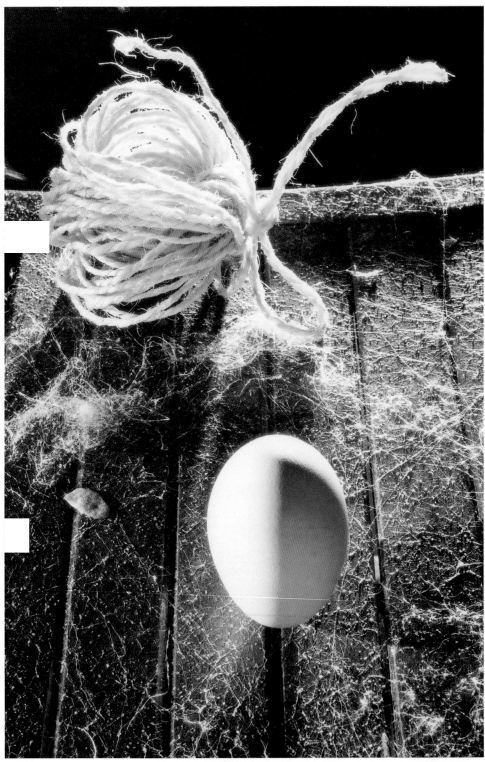

Figure 27.1 Working with light in the studio you can make pictures from simple oddments.

Starting Photography

Part Seven Using a Studio

A photographic studio is the rather grand term for any room you can clear enough space in to take pictures. Working in a studio should offer you full control over subject, camera position, lights and background, and is without doubt the best place to learn the basics of lighting and composition. A studio allows you time to experiment, especially with portraits or still life shots. You can keep essential bits and pieces on hand, and leave things set up. This is a great help in allowing you to shoot, check results, and if necessary retake the picture with improvements.

27 Layout and lighting

Your 'studio' may simply be an empty spare bedroom, or better still a garage, outhouse or barn. It should be blacked out so that all lighting is under your control. In the studio

Figure 27.2 A room cleared to form a temporary studio. The table with curved card background is used for still lifes.

shown in Figure 27.2 a large room has been cleared. Walls and ceiling are matt white and the floor grey, to avoid reflecting colour onto every subject. White surfaces are also important for 'bouncing' light when required. The window has a removable blind and the glass behind is covered with tracing paper. If daylight is needed for lighting it is therefore soft and diffused.

You don't need a lot of lighting units. Photographic lamps are of two main kinds – spotlights and floodlights (as described overleaf). They need to be mounted on height-adjustable floor stands and have tilting heads. The 'boom' stand below is an ideal way to position a lamp high up to backlight a figure or illuminate the background. You also need a stool for portraits and one or two reflector boards and diffusers. These can be made from white card or tracing paper stretched over a simple frame. Have a table to support small still life subjects at a convenient height. You will also need lots of useful small items – sticky tape, string, blocks of wood to prop things up with, modelling clay, wire and drawing pins.

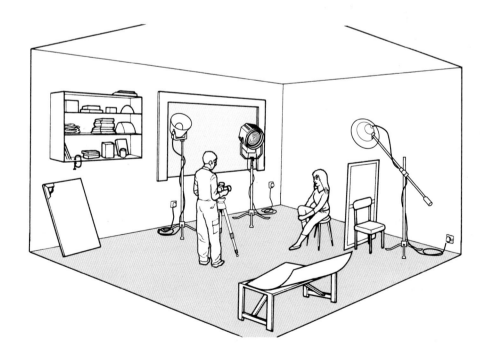

(A) (B)

Figure 27.3 Basic studio lamps. A: floodlight giving soft, even lighting. B: spotlight giving hard lighting like direct sunlight. Its lamp focuses for narrow or wide beam.

Lighting equipment

Floodlights are the general name for lighting units which give even illumination, and cause solid objects to cast shadows with soft edges. The effect is similar to hazy cloud conditions outdoors. Typically a floodlight has a 500 watt diffused glass bulb surrounded by a large open reflector. A traditional desk lamp produces similar effects, although being much dimmer is really only usable for still life subjects.

A typical *spotlight* uses a small clear glass 500 watt lamp in a lamphouse with a moulded lens at the front. A lever shifts the lamp, making the unit give out light in either a narrow or broad beam. Different attachments help you to shade off

Figure 27.4 Attachments for spotlights A: Snoot and B: Barndoors limit the light beam, shade camera from spilt illumination. C: Holder for coloured acetate filters.

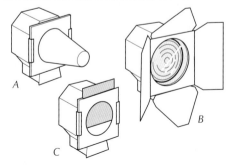

parts of the light. Spotlighting is harsh, causing sharp edged shadows like direct sunlight, especially when set to broad beam. The nearest domestic substitute for a photographic spotlight is a bulb having an integral reflector, or you could use a slide projector.

Unless you only work in black and white, however, you must ensure that the light from all your lighting units matches in colour. 100 watt lamps, for example, give yellower (as well as dimmer) light than 500 watt lamps, and so are best avoided for colour photography. Then, having matched up your illumination, you can fit a camera lens filter if necessary (see Table 27.1) to suit the colour film you are using.

Table 27.1 Camera filters for colour-balancing the lighting.

	Filter	Light source	Filter	
Using Daylight type films	No filter	Flash or col. matching tubes	85B	Using Art. light type films
	CC 40M	Warm white fluor. tubes	81EF	
	80A	500 W lamps (3200 K)	No filter	
		100 W domestic lamps	82B	

Another approach is to use flash in your studio, linking several flash units together. You can then shoot on unfiltered daylight type colour film, since flash is the same colour as sunlight. Flash heads for studio work often have built-in modelling lamps so that you can forecast how and where subject shadows and highlights will appear.

Controlling lighting

Exploring lighting, given the freedom offered by a studio, is interesting and creative – but be prepared to learn one step at a time. Firstly, if you are shooting in colour, match up the colour balance of your film with the colour of your lighting as closely as possible. Table 27.1 shows the code number of the blue conversion filter needed over the camera lens with daylight colour film (print or slide) using 500 W lamps. A few colour films,

136

Figures 27.5–6 Lighting direction. Surface appearances change dramatically when you alter the position of the lamp.

mostly slide, are balanced for artificial light and so need different filtering, or none at all.

Start off with a still life subject because it is easier to take your time experimenting with this than when shooting a portrait. Set up your camera on a tripod and compose the subject. You can then keep returning to check appearance through the camera viewfinder for every change of lighting, knowing that nothing else has altered.

Figures 27.7–8 Contrast control. A spotlight used alone and (right) with a large white card added on the right. Shadows become paler, without additional shadows forming.

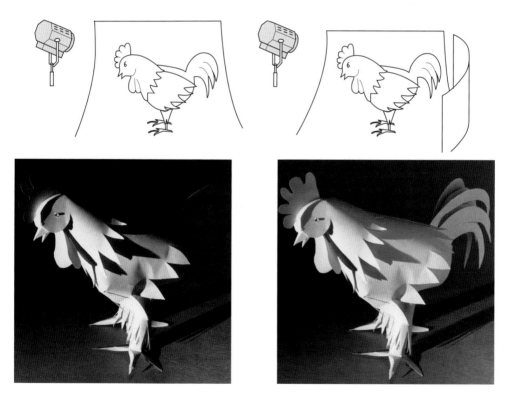

A and B

Figures 27.9–13 How different lighting set-ups affect texture, detail and form.

Starting Photography

Direction

Keep to one light source at first. The aim of most studio lighting is to give a fairly natural appearance as if lit by the sun. This means having one predominant source of light and shadows, positioned high rather than low down. Set up your light source (a spotlight, for example) somewhere above camera height and to one side of the subject. Adjust it to give the best lighting direction for showing up form, texture, shape, etc. – whatever you consider most important to stress. Figures 27.5–6 illustrate how simply changing direction picks out or flattens different parts of a three-dimensional subject.

Contrast

Be careful about contrast (the difference in brightness between lit and shadowed parts) at this point. Outdoors in daylight the sky always gives some illumination to shadows; but in an otherwise darkened studio direct light from a single lamp can leave very black shadows indeed. You may want to 'fill in' shadows with just enough illumination to record a little detail, using a large white card reflector as shown in Figure 27.8. This throws back very diffused light, and since it does not produce a second set of clearly defined shadows you still preserve that 'one light source', natural look.

The five studio shots, facing page, show how mixed changes of lighting can alter subject appearance, especially texture. The drawing shows where the (single) light source was positioned for each version. In (A) the spotlight was positioned at the rear of the stone slab, a little above lens height. Its direct light exaggerates texture but gives such contrast that the film both overexposes highlights and underexposes shadows. Version (B) uses a reflector board close to the camera to return diffused light into the shadows. In (C) the spotlight is now to one side, changing the direction of the (harsh) shadows. For (D) the spotlight was turned away from the leaf altogether, and illuminates a large white card. The result is diffused ('soft') light, still directed from the side but now free of sharp edge shadows and even less contrasty than B. In (E) the spotlight is now positioned close to and directly above the camera, and used direct. Like

Figure 27.14 Lighting from below looks unnatural – has a dramatic 'theatrical' air.

Figure 27.15 A range of methods of reducing light contrast in the studio, without creating a second shadow.

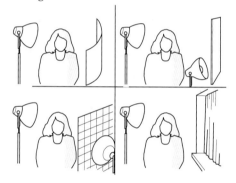

Figure 27.16 Soft, directional light, created here by illuminating the left-hand studio wall, gives natural, daylight-looking effects.

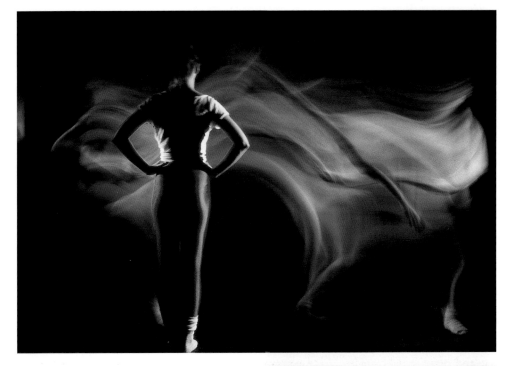

Figures 27.17–18 Double side lighting and a long exposure produced each of these expressionist dance images. See facing text.

flash on the camera everything receives light but it is like a drawing without shading, suppressing texture and form.

Arguably (B) gives the best compromise between drama and detail, although as a beginner you will often be tempted by (A) because it looks good in the studio. Always remember that your eye can cope with greater contrast than film will successfully record.

Portraits

Soft, directional lighting (meaning diffused light from one side) like (D) is often a good basis for portrait lighting too. For the result in Figure 27.16 you can turn one or more lamps to illuminate a large part of the studio wall on the left. Then bring up a reflector board close on the right of the camera as fill-in.

Like viewpoint and framing there are no absolute 'rights' or 'wrongs' of organized lighting. You must decide which subject features you want to emphasize or suppress, and the general mood you need to set. You can dramatize and dominate the subject matter with your lighting, or keep the light simple and subsidiary so that subject features alone make your shot. Notice the total change of feeling you can achieve when a face is lit unnaturally, from directly below (Figure 27.14).

Experiment until you can forecast and control how the final picture will look. Remember what you learnt by observing natural lighting outdoors. Think of a spotlight as direct sunlight and a flood like slightly hazy sun. The difference is that you can set their position instantly instead of

Starting Photography

waiting for different times of day. As you get more experienced it becomes helpful to use more than one lighting unit at a time. Don't allow this to interfere with your main lighting though, destroying its 'natural light' basis of causing only one set of shadows. The second lamp might for example separately illuminate the background behind a portrait or still life. This allows you to make the background lighter, or graduated in tone, or coloured (by filtering the light source).

Lighting and movement

The lighting control you have in the studio can help with many of the experimental approaches to depicting movement described in Part Six. Figure movements during a long exposure for example can be turned into abstract patterns in accurately directed ways. For Figure 27.17 and Figure 27.18 two dancers, in pale reflective clothing, posed some distance in front of a black background. The lighting was two spotlights – positioned left and right at right angles to the camera viewpoint, and screened off from both the background and lens. Within the 'slot' of light so formed one dancer stood completely still while the other moved to the music throughout a five second exposure. Including a static element in your picture gives counterpoint to all the action going on elsewhere. See also Figure 22.1 and Figures 22.3–4.

Lighting for copying

Photographic copying means accurately recording two-dimensional subjects such as artwork, photo-prints, montages and paste-ups, slides, and so on. You can turn prints into slides, slides into prints, or colour into black and white. The essential technique is to light as evenly as possible, and have the camera set up square-on. Drawings, pictures and clips from papers are best taped against black cardboard, attached to the wall, and lit by two floodlights positioned about 30° to the surface. Keep each flood well back for even illumination. Check lighting with a pencil (Figure 27.19) held at right angles to the original. The two shadows should be equally dark, and together form one straight line.

To copy a slide you can improvise by laying it horizontally on opal plastic, masked along all four edges with wide strips of black card. Illuminate the plastic from underneath using a floodlight (bounced off white card to avoid heat damage). Support the camera square-on and directly above, fitted with close-up extension tubes or bellows to allow a same-size image. Alternatively use a slide copying attachment (Figure 27.20) added to an SLR fitted with tubes or bellows. The slide slips into the far end of the attachment, in front of a light diffuser.

Figure 27.19 Set up for copying paste-up photoprints, drawings and other flat work.

Figure 27.20 Slide copying S: Slide. D: Light diffuser. Adjustable length tube fits on front of camera lens and extension ring.

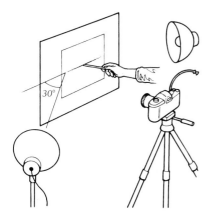

Part Eight Film Processing and Printing (B&W)

Doing your own film processing and printing gives you much more control over your results. You probably won't save money, but mastering the skills is enjoyable and will allow you to produce prints just the way *you* want them to look. This grows more important the further you progress in your photography – aiming for your own style of pictures or perhaps tackling specialized subjects beyond the range of the average commercial laboratory.

By far the best way to start is to process black and white film and make black and white prints (by contact and by enlargement). This will get you familiar with handling chemicals and setting up and working in a darkroom. Later you can progress to the extra challenge of judging colour test prints and working in the near darkness of a colour printing darkroom.

28 Processing a 35mm film

Processing black and white negatives is in many ways like cooking – you use liquids, and have to control time and temperature quite carefully. You also need some basic equipment. The ten most important items are shown below in Figure 28.1:

(1) is a 35 mm film-end retrieving tool used to extract the first inch or so of film if wound fully into the cassette, so it can be prepared for tank loading (Figure 28.2).

(2) is a light-tight plastic tank containing a reel. You push or wind your film into the spiral groove of the reel in the dark;

Figure 28.1 Basic equipment for processing film (see text above).

the whole length is held only along its edges, with each turn slightly separated from the next so that processing solutions act evenly over its entire surface. Each solution is poured in through a light-proof hole in the tank lid. You block off the hole and invert the tank at set intervals to agitate the solutions; some tanks have a plastic rod to rotate the reel for the same purpose.

(3) Bottles containing developer and fixing solutions. Start off by using the developer recommended on your film's packing slip. A standard fine-grain developer such as Ilford ID11 (made up from powder) is a good choice. You can also buy most developers in liquid concentrate form which are quicker to prepare. Made-up developer can be stored for weeks in a stoppered container. The acid hardener fixing solution is simpler and cheaper, and is also known by its main constituent 'hypo' (sodium thiosulphate). Unused fixer keeps indefinitely. Never let developer and fixer mix, because they will neutralize each other.

(4) A plastic measuring graduate holding sufficient solution to fill your tank. Also have (5) a plastic funnel for re-bottling solutions, and (6) a photographic thermometer clearly scaled from about 13°C (55°F) to 24°C (75°F). Other items are (7) thin plastic gloves for handling chemicals (see page 177); a minute timer (8); a flexible plastic tube (9) for ducting wash water down into your tank through the lid hole; and (10) plastic pegs to attach to the top and bottom of your processed film when it is finally hung up to dry on a nylon cord.

Figure 28.2 Left: Retrieving and trimming the film end, in normal lighting. Right: Loading into the film reel, in darkness.

Loading the tank

Before you use a tank for the first time practise loading with a scrap film or an unwanted (and uncut) length of negatives. Do this first in the light, then with your eyes closed, then in a darkened room. It's important not to force and buckle the film during loading, or you may get results as shown on page 145. The shaped tongue must be cut off the front end of the film to give a square shape for loading. If necessary, use a retrieving tool to slip into the cassette without fogging film (Figure 28.2A). Having pulled out the tip you can then do your trimming in the light.

The stage after this – winding a whole exposed film into the reel – only takes a few minutes but must be done in total darkness. If you don't have a darkroom use a large cupboard. It is also possible to untuck one side of your bed, pushing your hands in *deep* under the blankets in-between the sheets. Alternatively, buy a light-proof 'changing bag', Figure 28.3,which pushes onto your arms. Feed film in direct from the cassette (as shown in Figure 28.2) or use a cassette or bottle opener to take off one end and withdraw the spool of film. The actual way the film slides into the reel grooves depends upon your particular make of tank. Some are cranked in, others just

pushed. As soon as the whole film is loaded place the reel in the empty tank and fit on the lid. You can then do all your processing in ordinary lighting.

Using the solutions

The various stages and typical times of processing are shown in Figure 28.4. Developer solution, waiting in the graduate at the recommended temperature (normally 20°C) is poured into the tank and the clock started. The time required depends upon the developer and type of black and white film you are

Figure 28.3 A changing bag, top, or just using your bed saves having a darkened room.

Film Processing and Printing (B&W) 143

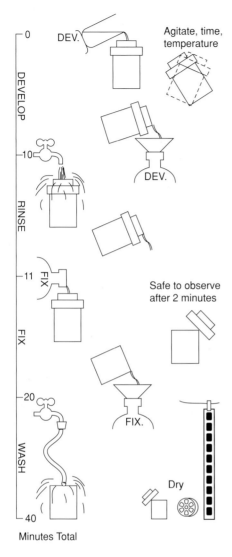

Figure 28.4 Film processing, stage by stage.

tank to overflowing with water and immediately empty it again. This helps to remove developer from the film (alternatively use 'stop bath' solution which halts development faster).

Now fixer solution is poured into the tank and initially agitated. Fixer temperature is less critical than developer – room temperature is adequate. The fixer turns creamy silver halides unaffected by development into colourless compounds which can later be washed out of the film. Your film needs about 10 minutes in the fixer, but after 1–2 minutes most of the film's milkiness has cleared and you can remove the tank top without having light affect your results. When the film has finished its fixing time, the solution is returned to its bottle.

Next a twenty-minute wash in cold water removes all remaining unwanted chemicals and you can remove the processed film from the reel and carefully hang it up to dry, with a peg attached to each end. A few drops of photographic 'wetting agent' in the final wash water helps the film to dry evenly. Always hold film by its edges only. Once it has fully dried cut it into convenient strips of five or six negatives and immediately protect these in sleeves made for the purpose (see Figure 28.5).

Film processing faults

Don't put the fixer in first – this will destroy all your pictures! Check temperatures before and during development, and be careful with

Figure 28.5 Sleeved pages hold strips of processed 35 mm negatives and fit into a ring binder.

processing. You must regularly agitate the solution to avoid streaky development, typically by gently inverting the tank several times during the first 30 seconds, and then for 5 seconds every half minute. At the end of development time you pour the solution out through the light-tight tank top. It is either poured away (if one-shot only) or returned to its bottle for re-use.

Although you cannot yet look, inside the tank the creamy surface of your film now carries a black image corresponding to where it received light in the camera. For the next step, which is rinse, you fill the

Starting Photography

Figures 28.6–8 Processing faults. Top: Dark, crescent-shaped kink marks. Centre: Undeveloped clear patch, where this part of the film remained in contact with another. Bottom: All negatives throughout the film show part of the picture pale. Cause is probably insufficient developer in the tank.

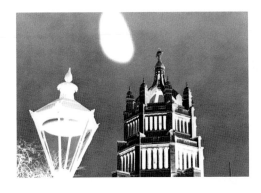

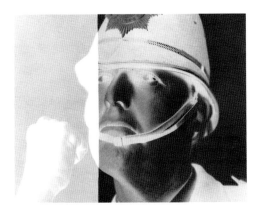

timing, otherwise it is easy to under- or overdevelop (see Figures 28.9–28.17). Avoid putting finger marks or splashes of any kind on your film – remember too that it is easily damaged by scratches, dust, hairs, etc., when drying.

If your film is clear with no images check to see if edge printing is present (see page 103). If the information is there you have either processed an unused film or the camera was faulty – shutter not opening, or film not winding on. If the edge data is *not* present the fault is almost certainly processing. Perhaps the developer was totally exhausted, or solutions used in the wrong order?

Film which is still creamy has not been fully fixed; further fixing time, or change to fresh fixer will probably result in good negatives. Patches of uneven tone usually means uneven development. Perhaps adjacent coils of film touched each other in the reel? Dark crescent shaped marks (Figure 28.6) and kinks or creases in the film itself are due to rough handling. The film was most likely buckled after removal from its cassette, when you were trying to load the reel in the dark.

Most of the time, however, faults are concerned with negatives that are a bit too dark ('dense') or too pale ('thin'). At first it is difficult to tell whether, say, a thin negative is due to underexposure or insufficient development. Of course, if every picture on your film looks thin the fault was probably development – although it could also be the ISO rating having been incorrectly set on the camera.

As Figures 28.9–17 show though, an *underexposed* negative is characteristically transparent and empty of detail in subject shadow areas, such as the girl's hair. A correctly exposed but *underdeveloped* negative (top centre) shows more detail here, but looks generally weak and grey ('flat'). A dense negative due only to overexposure records the subject's lightest parts as so solid that finer details are destroyed. Notice how shadows have ample detail though. *Overdevelopment* instead gives a negative that is contrasty and 'bright' – dense in highlights but carrying little more shadow detail than a correctly developed film. See also page 52.

Film Processing and Printing (B&W)

Figures 28.9–17　The effects of over- and underexposure and development. For key see facing page.

Starting Photography

Underexposed and under-developed (Try printing grade 4, very hard)	Correctly exposed and under-developed (Print grade 3, hard)	Overexposed and under-developed (Print grade 3, hard)
Underexposed and normally developed (Print grade 2, normal)	Correctly exposed and normally developed (Print grade 2, normal)	Overexposed and normally developed (Print grade 2, normal)
Underexposed and over-developed (Print grade 0, very soft)	Correctly exposed and over-developed (Print grade 1, soft)	Overexposed and over-developed (Try printing grade 1 or 2)

29 Contact printing

Film processing does not really require a darkroom, but before you can print or enlarge your negatives you will have to organize yourself some kind of blacked-out room to work in. This might have to be the family bathroom, quickly adapted for the evening (see Figure 29.2). Maybe you can convert a spare room, or perhaps you are lucky enough to have use of a communal darkroom designed for the purpose at a school or club, as shown in Figure 29.1.

The darkroom

The most important features to consider when you are planning a darkroom are: black-out; ventilation; water supply and electricity.

Excluding the light

Existing windows have to be blocked off – either temporarily using thick black plastic

Figure 29.2 Darkroom in adapted bathroom (for key to contents see Figure 29.1).

sheeting or paper, or more permanently with hardboard. Alternatively buy a fabric roller blind blackout. As long as you have kept out unwanted white light the walls of the room can be quite pale toned – a matt white finish helps to reflect around the coloured illumination from your safelight, designed not to affect the photographic paper.

Figure 29.1 Purpose built school darkroom. D: Developer. R: Rinse. F: Fixer. W: Wash. S: Safelight. T: Towel. V: Ventilator. C: Clock with large second hand. LT: Light trap.

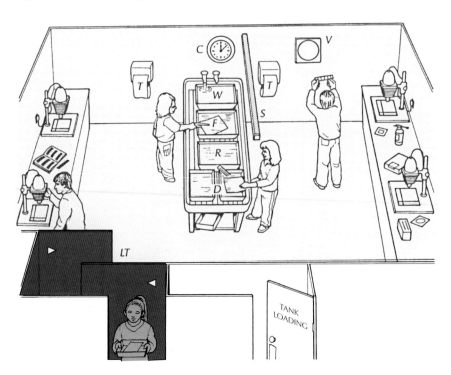

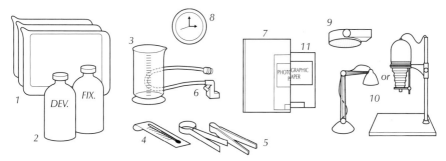

Figure 29.3 Basic equipment for contact printing. For each numbered item here see text.

work, even though you intend to return within a few hours. See also page 176.

Equipment for contact printing

Print processing

Most of the items necessary for contact printing are shown above, Figure 29.3. You need at least three plastic trays (1) big enough for your prints. 12 in × 10 in is a good size. One is for developer, one for rinsing and washing, and the other for fixing. Print developer (2) is similar to, but much faster-acting than, negative developer. It comes as a concentrated solution, diluted just before use and discarded after your printing session. The fixer is a less concentrated form of negative fixer, and can be re-used.

You also need the measuring graduate used for films, and a photographic tray thermometer (blue spirit or LCD with red display). The thermometer stays in the developer tray to tell you if the solution is too warm or cold. (5) Plastic tongs – one for developer, the other only for fixer – allow you to keep your hands out of solutions. A washing hose (6) connects the cold water tap to the rinse tray and turns it into a print washing device. Have a clock to time minutes during processing and (if you have no enlarger timer) seconds during exposure.

Suitable orange lighting is permissible in the printing darkroom, as black and white paper is not sensitive to this colour. You can buy a bench or hanging safelight (9) which contains a 25 watt bulb behind dyed glass, or use a fluorescent strip light with a special coloured sleeve. The safelight is positioned near the developer tray (Figure 29.1) but no closer than specified, usually 1 m (3 ft).

Ventilation

Working alone for an hour in the darkroom you may not find the air too stuffy, but for groups working for longer times you need a light-tight air extractor fan (V). A communal darkroom also needs a light trap (LT) instead of a door. This helps the circulation of air and makes it easy for people to enter or leave without disturbing others. Wall surfaces inside the light trap are painted matt black, to reduce reflections.

Water supply

In the bathroom use the bath to wash prints, and the hand basin to rinse your hands, etc., free of chemicals. The permanent darkroom has a large flat bottomed PVC sink to hold trays for processing solutions, and a tank or tray for print washing. Always separate the wet stages of darkroom work from 'dry' work such as handling the enlarger and packets of paper, etc. In the larger darkroom each can take place on different sides of the room.

Electricity

Take special care over your electricity supply, needed for the enlarger and safelight, because electricity and water can be a lethal combination. Never let wires or switches come into contact with water or wet hands. Take your supply from a three-pin socket, and include a circuit breaker of the type sold for garden tools. Metal parts of your enlarger or safelight should be connected to the earth wire ('grounded'). This is especially important in any board-over-the-bath bench arrangement. Take out any temporary wiring as soon as you have finished

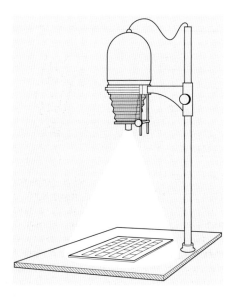

Figure 29.4 Using an enlarger to give a patch of light for exposing a contact print.

Exposing equipment

To expose your contact print you need an even patch of white light which will shine through the negatives laid out on the paper. You could use a reading lamp fitted with a 15 watt bulb, but as an enlarger will be needed later (page 154) for making enlargements this can conveniently provide your contact printing light. All you have to do at this stage is raise it to a height where it gives a large enough patch of light for your print as shown in Figure 29.4.

The negative strips can be held down in tight contact with the light sensitive printing paper during exposure by a sheet of thick glass, Figure 29.3. Better still buy a proper contact printing frame – glass with thin plastic grooves on its underside to hold the film, and hinged to a baseboard.

The light-sensitive paper

Most black and white photographic paper is known as bromide paper (due to the silver bromide used in its light-sensitive emulsion). It comes in different sizes, surfaces, and types of base and grades of contrast. 10 in × 8 in just accommodates seven strips of five 35 mm negatives. Perhaps you decide to start off with a packet this size of glossy, resin-coated (RC), multigrade paper.

You will also need a set of simple enlarger filters to adjust the contrast of the paper, see page 155.

Printing a contact sheet

It is best to make a contact print from every film you shoot. This way you have a visual file of all your pictures, from which to choose the ones to enlarge. Prepare the solutions in their trays and bring the developer to its recommended temperature. Now you can change the lighting in your darkroom to safelighting and open your packet of paper. Position one sheet, glossy side upwards, under the switched off enlarger and re-close the packet. Lay out your negatives in rows on the paper with their emulsion (dull) side downwards. Have all the edge numbers running the same way – it is irritating later to discover one row of pictures upside down. Then cover over the negatives with the glass.

Insert a grade 2 (normal contrast) filter into the enlarger lamphouse. Then, with the enlarger near the top of its column and the lens two f settings 'stopped down' from widest aperture, give a trial exposure of about 20 seconds. Remove the glass and put your negatives carefully to one side. As shown in Figure 29.5, slide the exposed sheet of paper smoothly under the surface of the developer. Note the time on the clock and rock the tray gently to keep the paper fully submerged. Magically the shapes of the frames on your film appear on the paper, then the pictures themselves – growing darker and stronger all the time. But keep one eye on the clock and remove the print when its recommended development time is up (typically 1 minute at 20°C for RC paper).

Maintain the same time in the developer no matter how fast or slowly the print darkens – in printing you alter results by *exposure*, and always keep development consistent. The print next has a quick rinse and goes face down into the fixer tray. Full fixing takes about 5 minutes although after 1 minute or so you can switch on normal lighting. In the example right (Figure 29.7) the exposure given is correct for most pictures on the sheet. If results were too *dark* you would give a shorter exposure time or reduce the lens aperture; if too pale increase exposure time or widen the aperture.

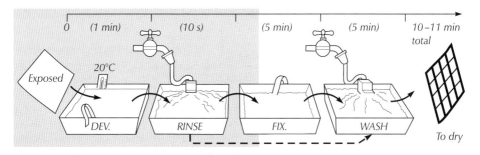

0 *(1 min)* *(10 s)* *(5 min)* *(5 min)* *10–11 min total*

Exposed 20°C DEV. RINSE FIX. WASH *To dry*

Figure 29.5 Print processing, RC paper. (Rinse tray does double duty as wash.)

Prints can be allowed to accumulate in the fixer – for up to half an hour if necessary – before you put them to wash as a batch. Washing also takes about 5 minutes but keep separating the prints now and again, and prevent any floating face upwards to the surface where washing will be ineffective. After washing, sponge off surplus water from the front and back surfaces and dry your print by pegging it on a line or laying it out on photo blotting paper. RC plastic paper dries quickly but the process can be hastened with warmed air from a hair dryer.

Often you find that when exposure is correct for some pictures on the sheet it is too much or too little for others, because your negatives vary. This has happened in Figure 29.7 where the four frames at the bottom left are underexposed. You could make two sets of contacts, one exposed for dark pictures, one for light. But better still use a shaped card (Figure 29.8) to give 50 per cent extra exposure time to this corner of the sheet. Figure 29.9 shows the improvement. Note too that an ordinary wooden ruler is about the same width as 35 mm film. You can cover up individual rows or ends of rows of pictures by laying rulers on top of the glass, and then remove them according to the exposures required.

Colour negatives can be contact printed to give black and white results in just the same way as monochrome negatives, but often need about 2–3 times the exposure. (See also photograms, page 163.)

Figure 29.6 Stop down the lens for the first trial exposure.

Figure 29.7 The result – correct for most, but not all, pictures.

Negatives emulsion side down

Figure 29.8 Shading to correct unevenness in the set of contact prints.

Figure 29.9 The corrected reprint. Compare the bottom left frames with Figure 29.7.

Drying prints

The simplest way to dry your washed prints is to first wipe off surplus water with a sponge or a flat (window-cleaning type) squeegee. Then peg them on a line, or lay them face up either on clean photo blotting paper or a fibreglass drying screen or muslin stretched on a frame (see Figure 29.10). Special hot-air dryers are made which accept RC black and white paper and all colour papers. They give you dry results in a few seconds, but even when left at room temperature these plastic papers dry within about 15 minutes.

If you have made black and white prints on fibre base paper, which is more like drawing paper, peg them up in pairs back-to-back to avoid curling. Never attempt to put fibre paper through an RC dryer. A few dryer/glazers are designed for fibre based printing papers. Don't try glazing RC papers of any kind – the face of your prints will become stuck to the equipment! Glossy RC paper air dries with a shiny finish.

When dry number your contact sheet on the back with the same reference number you put on your set of negatives. Check carefully to see which images are sharp enough to enlarge, what people's expressions look like, whether the composition works, and so on. Using grease pencil on the print surface, mark up your best shots, showing possible cropping. As you will probably be checking these contacts in the darkroom, don't do pencil marks in a colour which makes them invisible under safelighting. If you have several very similar images in your contacts double-check the edge number to ensure you put the right negative into the enlarger.

Figure 29.10 Drying prints by (A) muslin rack, (B) line and peg, or (C) hot air RC dryer.

Starting Photography

Figure 29.11 Contact sheet with shots chosen for enlarging framed up in wax crayon.

30 Enlarging

Making an enlargement reveals details and gives an impression of 'depth' to your pictures which is lost in a small print. During enlarging too you can decide to exclude parts of the negative in order to improve composition; darken or lighten chosen local areas of the picture; and juggle with contrast and density so that (within limits) you can compensate for negatives which are slightly dark or pale. It is even possible to construct pictures with the enlarger, by combining parts of different negatives into one print.

The 35 mm enlarger

Up to now the enlarger has just been a handy source of light for contact printing, but before making enlargements you need to understand it in more detail. Basically an enlarger is like a slide projector, although it has a much less powerful lamp and is attached to a vertical stand. Inside, to ensure that your negative is evenly illuminated, the light first passes down through large condenser lenses, or a plastic diffusing screen. The negative itself is held flat, its dull (emulsion) side downwards, between two halves of a carrier having a rectangular cut-out the size of one film frame. The negative carrier pushes into a slot in the enlarger just below the condensers or diffuser.

Below the negative is a lens (typically 50 mm focal length) which you can move up or down to focus a sharp image on the enlarger baseboard. Adjustable bellows prevent the escape of any light between carrier and lens. An enlarging lens needs no shutter but has an adjustable aperture, usually scaled in *f*-numbers. Changing from one *f*-number to another doubles or halves the brightness of the image. (As you can feel and hear the position of each setting by a 'click' it is unnecessary to keep peering at numbers.) Your enlarger may contain a filter drawer in the lamphouse, as Figure 30.1 shows, to accept contrast-changing filters for variable contrast ('multigrade') paper. Alternatively a filter holder can be attached to the lens. The way you use filters is explained on the facing page.

The whole enlarger head can be moved up or down a firm metal column and

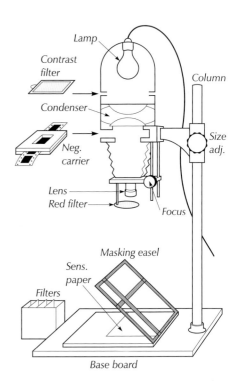

Figure 30.1 Parts of a (condenser) enlarger.

locked at any height to control the size of enlargement. On the baseboard you will need a masking easel, which has a white base surface and a hinged frame with adjustable metal strips. You can move the easel around to compose your enlargement, adjusting the strips to give a picture of the chosen size and proportions. During exposure the bromide paper is held down flat and correctly positioned under the strips on all four sides. The strips also prevent light reaching the paper and so give your enlargement neat white borders. Avoid holding paper down by glass – this upsets sharpness and may introduce dust specks and scratch marks.

If possible have an enlarging exposure timer – a clock switch which plugs in between enlarger and power supply. You set the estimated number of seconds needed, press a button, and the lamp switches on for exactly this time. Another useful aid is a focusing magnifier, a unit to magnify a small part of the image. You place this on the

masking easel and look through it whilst focusing the enlarger.

The printing paper

For enlarging you use the same type of light-sensitive paper as for contact printing. In other words it can have a plastic RC base and so be a fast processing type, Figure 29.5. Or you might prefer a fibre base paper (better for mounting and retouching, but slower to process and dry). The surface may be glossy, or semi-matt (again better for later hand-work on the print).

Contrast

You can control the contrast of your enlarge-

ment – normal, hard, soft, etc. – in two ways. Either buy packets of grade 1, soft; grade 2, normal; grade 3, hard, etc., or instead use one packet of variable contrast 'multigrade' paper and buy a range of filters to tint the enlarger light for different grade effects. Using graded papers means you must buy several packets at once and possibly run out of a particular grade. 'Multigrade' paper is therefore more economic, once you have bought your filters. In addition you can make prints which differ in contrast between one chosen part and another, see page 161.

Making a test print

Start by picking a negative which has plenty of detail and a good range of tones. As shown below, set the masking frame for your size of paper. Position the negative dull side downwards so that the shot you want to enlarge fills the cut-out part of the carrier. Check that there is no dust on the film surface (a

Figure 30.2 Enlarging. Top sequence: making exposure test strip, see result overleaf. Bottom row: making final enlargement, shown page 157.

TEST

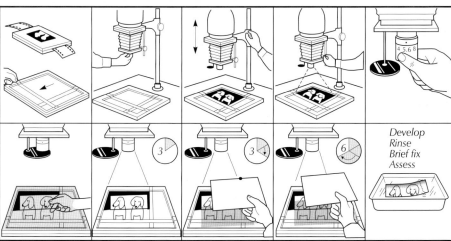

Develop
Rinse
Brief fix
Assess

PRINT

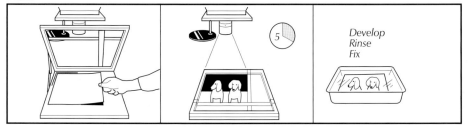

Develop
Rinse
Fix

Figure 30.3 Positioning the test strip.

can of compressed air is useful here) and insert your negative into the enlarger. Fit a filter for grade 2, normal contrast, if you are using multigrade paper. Open the lens aper-

ture fully. Switch on the enlarger and change the darkroom from ordinary light to safelighting. You can now visually focus the projected image on the white easel surface, making further adjustment to enlarger height if necessary until the picture is

Figure 30.4 Processed series of test exposures
– the right-hand version gives most
information.

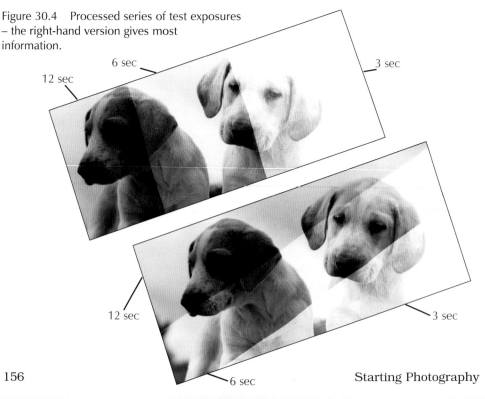

Starting Photography

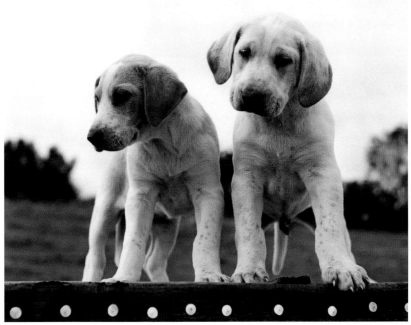

Figure 30.5 The final enlargement.

exactly the size you want, and sharp. Close down the lens aperture by about two clicks (three clicks if the negative is pale, or one if rather dense). Switch off the enlarger.

Cut or tear part of a sheet of your printing paper to form a test strip, and lay it face upwards on the easel where it will receive an important part of the image (the puppies' heads in Figure 30.3). Now, by shading with a piece of card, you are going to give the paper three different exposure times, in strips as shown in Figure 30.2. Carefully decide the most informative way for each strip of exposure to run. Don't arrange them like the left-hand test strip in Figure 30.4, which only shows you how the longest exposure affects one puppy and the shortest exposure the other. Making each band run longways instead allows you to discover how much each exposure time affects both the dogs.

To get this result the whole test piece of paper was first given 3 seconds. Then, holding thick card an inch or so above it, two-thirds of the paper received 3 seconds more. Finally, the card was shifted to give the final third another 6 seconds. The combined effect was therefore to give strips of 3, 6 and 12 seconds. By holding the card quite still a noticeable line of tone change records on the print, which helps you pick out the different exposure bands when you judge results.

The test strip is processed in the same way as the contact sheet on page 151. You can then switch on normal lighting to decide which is the best exposure (if all three strips are too pale make a further test using longer exposure times, or a wider lens aperture if you prefer). An exposure time of about 5 seconds was judged correct for the puppies' picture. So next a whole sheet was given this exposure, and when processed produced the result as shown in Figure 30.5.

Controls in printing

If you look along the middle row of pictures on pages 158–9 you see what happens when a normal contrast negative is printed onto different contrast grades of paper. On grade 1 paper (or multigrade paper printed through a grade 1 filter) you get more greys between pure black and white than when using grade 3 paper (or a grade 3 filter on multigrade paper). Grade 1 is your best choice when you are printing a contrasty negative like the one in the bottom row. Similarly you might use grade 3 for a flat,

Figures 30.6–17 Low, normal, and contrasty negatives printed onto:

(a) grade 1 (soft) paper

low contrast negative. In other words *contrast grade compensates for negative contrast*. Although not shown here, you can buy other graded papers or (especially) use further filters for multigrade paper, to give more extreme grades 0 or 4.

 To get the best out of a set of negatives expect to use at least three different contrast grades, or filters. Even with the most accurate film processing the range of

subjects recorded on any one film means that differences in lighting and subjects themselves are bound to result in negatives of differing contrasts. The usual way to decide which grade to use is by simply examining the contrast of the image projected on the white surface of your masking easel, and comparing it with how previous negatives have printed.

(b) grade 2 (normal) paper

(c) grade 3 (hard) paper

Don't expect miracles, however, when your film exposing technique has been faulty. If you look back again to page 146 you will see a very pale and flat negative caused by underexposure and underdevelopment, and another dark negative caused by overexposure and overdevelopment. These are really too lacking in shadow or highlight details respectively to be correctable by any contrast grade in printing.

Another reason for grades is to intentionally distort contrast. This may just be to give extra 'punch' and emphasis. The wood texture picture on page 21 for example was printed using grade 4 to give extra strength. Figure 13.13 too is not strictly a 'correct' print relative to the actual subject – tones have been increased in contrast and the image kept light – but both help to emphasize shape and pattern to the full.

Film Processing and Printing (B&W)

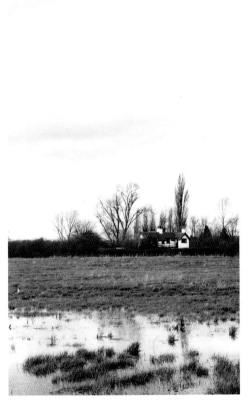

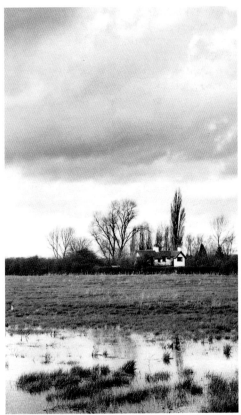

Figure 30.18 A 'straight' print shows washed out sky although the land detail is reasonably correct.

Figure 30.20 The same negative printed with an additional 12 seconds given to the sky (totalling 22 seconds here) prints in missing detail.

Printing-in, and shading

Since a longer exposure gives a darker print it is possible to give extra exposure time to just part of the paper where you want to darken your picture. You can use this 'printing-in' technique to bring up detail in a pale

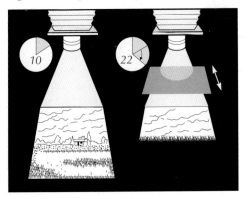

sky, like Figure 30.20 above. Of course, such details have to be present in the negative in the first place but often cloud information is quite dense on the film and sky records as white paper when you give your whole print correct exposure for ground details. Figure 30.18, above, had 10 seconds all over. Figure 30.20 on the right had the same but then the sky alone was exposed for a further 12 seconds while an opaque card prevented light reaching the landscape part.

Unlike the making of test strips, you do not normally want a sharp edge line to show where change of exposure has taken place. So, while you are printing-in, blur the line by keeping the card continuously on the

Figure 30.19 Printing-in sky detail.

Starting Photography

move and holding it nearer to the lens than to your paper. If you use multigrade paper it's also possible to change filters between the main and printed-in parts of the exposure. In this way landscape ground information can be printed grade 2 contrast, but dense, low contrast sky detail printed in grade 4.

Printing-in an entire sky is a useful technique but you will even more often want to darken some relatively small, isolated part of a picture – the over-lit side of a face perhaps, or the window part of a room interior. The best way to do this is to give your print-

Figure 30.21 Shading with a 'dodger', and (right) printing-in using a hole in card.

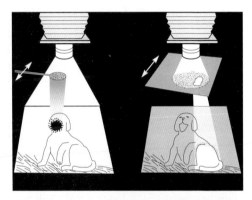

ing-in exposure with a card carrying a hole about the size of a small coin. For the opposite effect – making an isolated central area *paler* – use a small disc of card taped to a thin but rigid piece of wire. You can then push this 'dodger' into the enlarger light beam a few inches above the paper during part of the main exposure, to keep back light from the area that prints too dark.

The enlargement, Figure 30.22 (below left), was given a straight, overall exposure of 14 seconds. The result looks correct over most of the image, but the dog's mouth is too dark and its hindquarters too light. The second version, Figure 30.23 (below right), also received 14 seconds but during this time a disc-on-wire dodger was pushed into the light beam about 2–3 inches above the paper, and allowed to cast a shadow over the open mouth for 3 seconds. Then, when 14 seconds was completed, a card with a hole in it about the same size as the disc was used to give extra exposure to the dog's hindquarters only, for another 5 seconds. In each instance the dodger and the printing-in card were kept on the move.

Figure 30.22 (Below left) Straight print.

Figure 30.23 (Below) Corrected print.

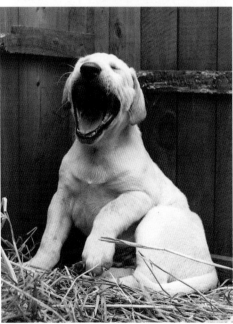

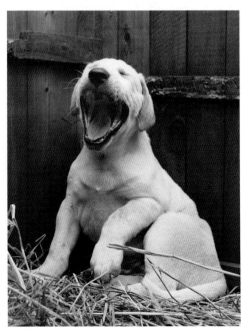

Figure 30.24 Print from unsharp negative.

Figure 30.25 Unsharp print from sharp negative.

Figure 30.26 Hair and debris on negative.

Figure 30.27 Damp fingermarks, solution splashes.

Print faults to avoid

If your printing paper still just looks white after processing or carries a ghost-like pale image, you may have processed an unexposed sheet, or exposed it upside down, or put it in the fixer first ... or it may simply be grossly underexposed. Perhaps your developer is exhausted, contaminated, or much too diluted?

If the print goes dark all over including its white borders the whole sheet was fogged to light – maybe the safelight is too bright, or someone has opened the printing paper packet in room lighting? If borders remain white the fault is probably gross overexposure, or light reaching the easel other than through the enlarger lens.

A yellowish all-over stain suggests that your print was developed for a very long period (possibly in exhausted developer) or has not yet fixed properly. Yellow or purplish patches are due to uneven fixing – for example, when prints are left face up and allowed to float to the surface of the fix solution.

Your print may show smears or blobs of darker or lighter tone (Figure 30.27) not present on the negative. The most likely cause is odd spots of water or developer getting onto the paper before processing. Perhaps your 'dry' bench was splashed with liquid, or you handled dry paper with wet fingers? White specks, or hairs and other clear-cut squiggle shapes like Figure 30.26 are often magnified debris on the negative – although sometimes due to dirt on the enlarger lamphouse condenser or diffuser which only appears clearly at a small lens aperture.

If your enlargement is not quite sharp check closely to see if the grain pattern of the negative has printed sharply; if it has (Figure 30.24) then the image shot in the camera was unsharp. But if the grain is also unsharp your enlarging lens is improperly focused. Sometimes a print from a perfect negative reveals a double image – either overall or just some part you have printed-in. This is because you jogged the enlarger or paper part-way through exposure.

Starting Photography

Constructed prints

Double printing

Shading and printing-in also allow you to combine parts of several negatives into one picture. For Figure 30.29, the mouth negative was first enlarged and exposed, shading the child's tongue and bottom left quarter the whole time. Then the negative was changed and the unexposed parts of the paper exposed to the train shot, this time shading the top and right-hand side of the paper.

Photograms

'Photograms' are pictures created from the shadows of objects placed directly on or above the paper. For Figure 30.30 the enlarger was set as if for contact printing, but instead of negatives, chocolate buttons were just scattered on the surface of the paper. Then, after giving half the exposure time needed for a good black, all the buttons were shifted around and the same time repeated. Figure 30.28 goes further, using three pressed leaves in a pile on the paper, two of which were removed in turn after 3

Figure 30.29 One print from two negatives.

and 6 seconds of a 9 second exposure. After processing, this negative print was contact printed face down under glass onto another sheet of paper to give a *positive* result.

Figure 30.28 Print from photogram of leaves.

Figure 30.30 Chocolate button photogram.

Part Nine Presenting and Assessing your Work

The final stage of photography is to present your results in the most effective possible way. If you made your own prints they must first be dried and finished; but even if you have received back work from a processing and printing lab several decisions still have to be made.

Shots need to be edited down to your very best; cropped finally to strongest composition, and then framed as individual pictures or laid out as a sequence in an album or wall display. Slides can similarly be edited and prepared for projection. At the same time negatives, slides and contact prints deserve protective storage and a good filing system, so that you can locate them again when required.

Now you have the opportunity to review what has been achieved and assess your progress in picture making since starting photography. But how should you criticize the work ... and also learn to listen to the criticism of others?

31 Finishing off

Final cropping
This is the final stage in deciding how each picture should be cropped. What began as the original framing up of a subject in the viewfinder (Figure 1.3) concludes here by your deciding whether any last trims will strengthen the composition. Don't allow the height-to-width proportions of photographic paper to dictate results. Standard size enlargements from a processing lab for example show the full content of each negative – and however careful you were in originally framing, individual pictures are often improved now by cropping to a squarer or more rectangular shape. Placing L-shaped cards on the print surface, Figure 31.1, is the best way to preview any such trim. Then

Figure 31.2 Print taped along one edge to card and covered by a cut-out window mat.

put a tiny pencil dot into each new corner to guide you in either cropping the print itself before mounting, or preparing a 'window mat' cut out the correct size to lay on top. See Figure 31.2.

Mounts and mounting
If your finished print is to be shown mounted with a border choose this carefully because pictures are strongly affected by the tone or colour of their immediate surround. Compare the two identical black and white prints, Figures 31.4–5. On a *white* mount dark parts such as the shadows form a strong comb-shape, whereas on a *black* mount the pools of

Figure 31.1 Using L-shaped cards to decide trim.

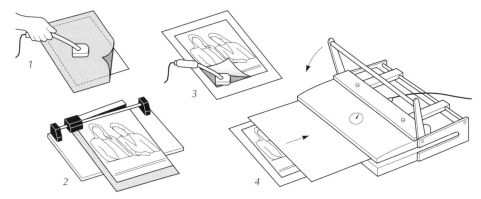

Figure 31.3 Dry mounting. 1: Tacking mounting tissue onto the back of the print. 2: Trimming print plus tissue. 3: Tacking onto mount. 4: Inserting into heated press.

sunlight become more emphasized. Even a thin white border left from the masking easel can change the picture by enclosing and separating it from a dark mount – just as a black edge-line drawn on it would do the same on the white mount.

Don't overdo coloured mounts or they may easily dominate your pictures. Colour prints usually look best against a mid-grey, or a muted colour surround in harmony with the picture. If the dominant colour scheme of the shot is, say, green, try a grey-green mount. Always use archival quality photographic display board – other card may contain chemicals which in time will stain your picture.

A window mat form of presentation is relatively simple and effective. You attach your (untrimmed) print to the mount *along one edge only* with high quality adhesive tape and then secure another card with a correctly measured cut-out 'window' on top. Use a firm, really sharp blade when cutting

Figures 31.4–5 How final picture appearance is influenced by a light or dark mount.

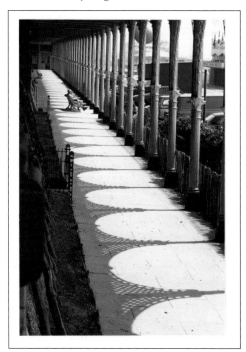

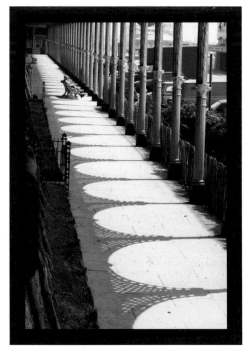

the window – make sure corners are left clean and free from bits.

If instead you simply want to mount direct onto board, trim the print first and coat the back with a spray-on or paint-on photo-adhesive; or use wide (up to 16 inch) double-sided self-adhesive sheeting. Then position your picture accurately on a mounting board, allowing the same width of surround at the top and sides. Some spray adhesives are designed to allow reposition-ing after mounting.

For the cleanest, flattest most pro-fessional looking mounted result it is difficult to beat *dry-mounting*. However, to do this job properly you need access to a dry-mounting press and an electric tacking iron. As shown in Figure 31.3, there are four main steps. (1) Cover the back of your print with an oversize sheet of heat-sensitive mounting tissue.

Figure 32.1 Simple, time-based story sequence.

Briefly touch the centre of the tissue with the heated iron, to tack them together. (2) Trim print and tissue to the exact size you need. (3) Position your print accurately on the mount, then carefully lifting each print corner tack the tissue to the board. Keep one hand on the print centre to keep it steady. (4) The mount-ing press must be set to the recommended temperature for your mounting tissue. This may be between 66°C and 95°C, according to type. Cover your print and board with a sheet of non-stick silicon release paper, insert the whole sandwich into the heated press and close it for about 15 seconds.

Spotting
Sometimes otherwise perfect enlargements show one or more tiny white dust spots. The simplest approach is to spot these in with black watercolour applied almost dry on the tip of a size 0 sable brush. You can also buy spotting dye in grey and sienna as well as neutral black.

Alternatively use a retouching pen which has a brush tip and contains its own dye (pens come in different shades of grey). Checking through a magnifier, stipple tiny grey specks into the white area until it disappears. Grey is successful for tiny spots on colour prints too, but multicolour sets of pens are also made for this purpose.

An entirely different approach, able to invisibly repair a badly marked print or slide (including 'red-eye') is to scan it into a computer system and then use retouching software. On the monitor screen the area you are working on can be greatly enlarged, and exact colour cloned from an area nearby. You then print out the result through any high resolution digital printer.

32 Presenting pictures in sets

Print sequences and photo-essays

If you have shot some form of narrative picture sequence you must decide the minimum number of prints needed to tell your story. Perhaps the series of pictures was planned right from the start, set up and photographed like scenes from a movie. Sometimes though it evolves from part of a heavily photographed event or outing, which becomes a narrative story once you begin to sort out the prints.

The sequence shown in Figure 32.1 is of the evolutionary kind – often the only way of making a documentary type story (one which relates to actual events). In this instance all the dog pictures were taken first and edited down to seven, then picture number 6 was shot specially to fill a gap in the story. You can help continuity by trimming all your prints to the same shape and size. Then present them in rows on one mount (as here) so that they read like a cartoon strip, or run them one to a page in a small album or a handmade book.

If you want to caption such pictures, be sparing in what you write. As a

Figure 32.2 Part of a documentary series on a British country town. Differing print sizes help to give variety.

photographer it is often best to let your pictures speak for themselves, even though some viewers may differ slightly in the story they read from the sequence. People don't like to have ideas rammed into their heads; unless you can write brilliant copy you will probably only be repeating what can be seen anyway and this can seem precious or patronizing.

Sets of pictures may share a theme but, because they are not based on a narrative to be read in a set order, allow you much greater freedom of layout. Follow some of the layout ideas on the pages of picture magazines and display your work more as a 'photo-essay', presenting half a dozen prints on an exhibition board or page of a large format album. As Figure 32.2 shows, you can make all the picture proportions different in a documentary series, to give variety and best suit each individual composition. L-shaped cards are again useful here.

Don't be tempted to slip one or two dull or weak pictures into a photo-essay just because their subject content ought to be included. Every shot should be good enough to stand on its own; if necessary take some more pictures. Similarly if one print is a bit too small or large relative to others be prepared to print it again at a different size. When laying out your set take care over the way you relate one print to another – the lines and shapes they contain should flow together well, not conflict and confuse.

Albums and storage files

Smaller family albums give you less scope for layout ideas but they are a quick, convenient way to sort out your best shots. Most albums are geared to enprint sizes, two or three to a page. The type which have a cling-film overlay to each page allow you to insert, re-position or remove prints at any time without adhesive or mounting equipment. A

pocket file, Figure 32.3, is also a handy way of carrying around small prints.

Unframed enlargements on individual board mounts are most safely stored in

Figure 32.3 Some ways of showing work. A: Clingfilm album. B: Glass frame. C: Pocket file. D: Photo-CD. E: Print box.

boxes made of archival material. You can keep to one standard mount size and buy or make a box which opens into two halves so that anyone viewing your pictures can move them from one half to the other.

Don't overlook the importance of filing negatives and contact prints efficiently too – otherwise you may spend hours

Figure 32.4 Left: Spot the slide mount top right (image upside down) when loading projector.
Right: Clear plastic hanging sheets have individual pouches for slides, can be numbered for filing.

searching for an important shot you want enlarged. A ring file with loose-leaf sleeved sheets each accepting up to 36 negatives is ideal. If you make a contact sheet off all your pictures punch each one and file it next to its set of negatives (see page 144). Photo-CDs come with a set of thumbnail reference prints on the box.

Slides

Processed slides are normally returned to you in plastic, glassless mounts. For maximum protection from fingermarks and scratches it is advisable to transfer your best slides into glass mounts. If you have your own projector these selected shots can be stored in a magazine, ready for use. Each slide should have a large spot stuck on its mount at the bottom left when you hold the picture correct way up, exactly as it should look on the screen. Then it is always loaded into the projector with this spot *top right* facing the lamp.

When projecting slides pick a matt white surface for your screen (even a slightly tinted wall will distort colours). Ensure that the room has a full blackout too. Slight presence of light will dull colours and turn blacks into flat greys. To store a large slide collection keep them in pocketed clear plastic sheets (Figure 32.4) which can be numbered and hung in any standard filing cabinet.

33 Evaluating your results

Is your photography improving, and if so on what basis can you tell? It's important to develop some way of assessing the success of picture making. One very practical approach is to put prints up on the wall at home for a while and see if you can keep on enjoying them – perhaps seeing something new each time you come back to look. Another way is to discuss your pictures with other people – both photographers and non photographers. By this route you may also discover if and why others reach different interpretations of the same photograph, and how these vary from what you aimed to express.

Tips and Reminders

■ To trim prints cleanly and with square corners, use a rotary trimmer able to cut up to 1/16th inch board. A bevel edged 45° cutter and metal ruler are the best tools for mat windows.

■ Avoid ordinary household glues or sticky tape for mounting. Use photographic products of archival quality. When spray mounting keep the room well ventilated, or work outside.

■ When spotting use half an empty (glass) slide mount as a mini-palette to dilute and test tone and colour. Position this on the print surface where you can look through the glass and forecast whether the spotting will match the part to be filled-in.

Labs scan filed images onto Photo-CDs (up to 100 per disc) for about the same cost as the original processing and printing.

Discussion is easiest if you are a member of a group, club, or class, putting up several people's latest work and then getting everyone to contribute comments. At worst it allows you to see your own pictures afresh and also discover what others have been doing. At best you can get down to learning why pictures are taken and the reaction and influence they can exert on others.

But how do you criticize photographs, deciding what is 'good' and what 'bad'? There are at least three aspects to consider, each varying in its importance according to the stage you have reached and the type of photography you undertake.

Technical quality

This has greatest importance when you are a beginner, needing to gain experience in the use of equipment and processes. It involves questions of whether exposure and focusing were correct. Could the print have better colour; be darker or less contrasty; and is there too much grain? As well as improving your technical ability this form of criticism is especially valid in photography used for accurate record-making. It is mostly concerned with *facts* (the negative is either sharp or unsharp, grainy or grain free). But if overdone the danger is that you apply the same rules to every picture, irrespective of subject and approach. Some photographs more concerned with expression *should* be dark and grey or light and contrasty, to strengthen and carry through the particular image.

Communication of ideas

Here results are judged mainly in terms of the approach you have used to express your ideas. This means establishing (or imagining) the purpose of the picture – factual, persuasive, etc. – and then deciding whether your result succeeds in this visual intention. Maybe it is concerned with expressing the relationship between two people. Perhaps the picture is making a broader comment on society in general ... or captures the peak of some action or event. Again, most of the interest may be in what can be read *into* a picture – Figure 16.9 or 17.2, for example.

Formal structuring

Another concern is how effectively the 'building blocks' of picture making have been used. Your photograph's overwhelming strength may lie in its design – compositional aspects such as framing, use of perspective, colour, pattern, tone values and so on. Relative to these imaginatively used elements the precise nature of the subject itself might take second place, as in Figure 2.4. On the other hand you may have chosen to allow the subject to remain a key element but made much stronger (in dramatic appeal for example) through the way you planned and constructed your picture.

Developing a critique

Whatever approach to criticism you adopt (and of course several can be used at once) your photograph is a sort of catalyst. On the one hand you the photographer with your own attitudes and interests, and the physical problems you remember overcoming to get this result. In the middle the photograph itself, which may or may not put over facts and ideas. On the receiving end the viewer with his or her interests and background experience, the way they feel at that particular moment and the physical conditions under which your photographs are seen.

Discussing *photography* as well as *photographs* is very much a part of studying the subject. What things can photography do well, and what can painting or drawing do better? How many ways might a particular theme or type of subject be approached? Look at the work of other photographers, in exhibitions and collections of their work printed in books.

Photography is essentially a medium, like writing or speaking, for expressing ideas and communicating information. In the hands of an artist it provides an outlet for personal feelings and offers almost as much freedom as drawing or painting. Used by a scientist it can report and measure in a detailed, factual way. Thanks to modern technology everyone can now take photographs which 'come out' – giving unfettered opportunities to develop visual skills and so make pictures with an individual, personal style.

Appendices

Appendix A Rollfilm and sheet-film cameras

The great majority of modern cameras use 35 mm or APS film, but other cameras are made to accept larger picture format rollfilm or individual sheet films. You will also find many older, second-hand cameras needing films of this kind.

Unlike 35 mm material in its light-tight cassette, *rollfilm* comes on an open spool attached to lightproof 'backing paper' (Figure A.2). Film and backing paper are rolled up tightly together so that light cannot reach the sensitive surface during loading. Inside the camera they wind up tightly onto an identical take-up spool after exposure, ready for unloading. No rewinding is therefore required.

The main rollfilm still in general use is 120 size, which allows pictures 6 cm (2¼ in) wide. Rollfilm cameras (often termed *medium format* cameras) may give twelve pictures 6 × 6 cm to a film; others give ten pictures 6 × 7 cm or sixteen 6 × 4.5 cm.

Figure A.1 Rollfilm twin lens reflex camera. S: Shutter speed control. R: Release for shutter. A: Aperture control. V: Viewing and focusing screen. M: Mirror (fixed). E: Exposure counter at back of camera. F: Focusing control. L: Light-sensitive film.

Figure A.2 How the start of a 120 rollfilm is attached inside its light-proof backing paper.

Negatives this size need less enlargement than 35 mm film so you can make big prints which are relatively grain free.

A few large format cameras use individual sheets of film, typically 4 × 5 in. Each sheet has first to be loaded into a film holder in the dark (see facing page). Using *sheet film* allows you to process each exposure individually; and the still larger negative gives even finer grain and detail.

Twin lens reflex cameras

Some rollfilm cameras are designed as twin lens reflexes. As Figure A.1 shows, the camera body has two lenses – one for viewing and focusing, the other for shooting. The upper or 'viewing' lens reflects off a fixed mirror and forms an image on a ground-glass screen on top of the camera. The lower lens is the one which takes the photograph, and is fitted with a shutter and a diaphragm within the lens. To use a TLR camera you load it with a rollfilm, set shutter speed and *f*-number according to the light and then look down onto the focusing screen to see what you are photographing.

Turning the focusing knob moves both lenses backwards and forwards, so that when your subject is sharply imaged on the ground glass the taking lens is also correctly positioned to give a sharp image on the film inside the camera. Pressing the release fires the bladed shutter, exposing the picture. The image on the focusing screen does not disappear at the moment of shooting like a single lens reflex. It is easy to shoot from low

Starting Photography

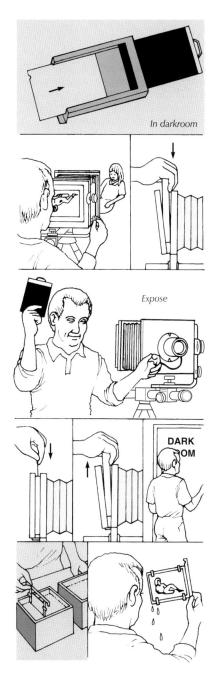

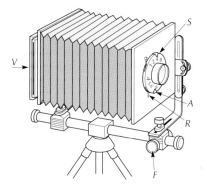

Figure A.4 Monorail 4 × 5 in camera. V: Viewing and focusing screen. S: Shutter speed dial. A: Aperture setting control. R: Shutter release. F: Focus controls.

length. The picture on the focusing screen appears reversed left to right – irritating when trying to follow a moving subject.

View cameras

These sheet film cameras, Figure A.4, look large and professional but are basically of simple construction. They are designed always to be used on a tripod. The front panel carries a lens with a diaphragm and a shutter; the back has a full size 4 × 5 in ground-glass focusing screen. Focusing controls allow the two panels to be moved towards or away from each other along a rail, and flexible square-shaped bellows between the panels keep out the light. Other knobs allow sliding or swinging of the front and back panels. These are known as 'camera movements' and used to help control depth of field or shape distortion.

The large focusing screen is especially helpful for carefully composing still-life subjects in the studio, although you must get used to checking an image which is seen upside down. The long bellows make it possible to focus very close subjects. However, these cameras are large, slow and cumbersome to use. The step-by-step sequence in Figure A.3 shows how you start off in the darkroom where each sheet of film is loaded into a special holder. When the film holder is slipped into the camera it replaces the focusing screen, taking up the same position. A panel or 'darkslide' in the holder is then removed to reveal the emulsion side of the

Figure A.3 How a picture is exposed with a 4 x 5 in camera, using a sheet film holder.

viewpoints and still see to focus. However, since viewing and taking lenses are separate, the camera suffers parallax error (page 32) especially in close-up work. It is also bulky, and you lack the ability to change lens focal

film to the (light-tight) inside of the camera. Then, after the exposure has been made using the shutter on the lens, the darkslide must be replaced. The entire film holder is then withdrawn from the camera and taken to the darkroom where the film is removed and processed.

Limitations for beginners

Far fewer medium- and large-format cameras are made than 35 mm types. They are mainly aimed at professional photographers, and include single lens reflex and direct viewfinder types. Kits of this kind are expensive – with the exception of one or two basic twin-lens reflexes intended for beginners. You must also remember that these cameras are bulkier to carry around, and mostly lack features such as built-in exposure meters and autofocus common to smaller cameras. You will need more costly enlarging equipment too, able to accept the larger negatives.

Appendix B Using a hand-held meter

Modern small format cameras have a light meter built into the camera to measure the subject and calculate exposure. But you will not find this feature in older cameras, or in most cameras taking larger formats (Appendix A). You then have to buy a separate, hand-held exposure meter. Used properly this will measure your subject and read out the appropriate combination of *f*-number and shutter speed to set for the film you are using.

A small hand-meter simplifies the making of local readings of highlight and shadow parts as it is easier to bring near to the subject than moving the whole camera. In fact you can measure exposure without taking out the camera (an advantage for candid work). However, since the meter does not measure light through the camera lens you must be prepared to adjust the exposure settings it suggests when shooting close-ups, see facing page.

A traditional hand-meter, Figure B.1, has a light-sensitive cell at the front to measure the light reflected from your subject. You first set the ISO rating of your film in a window on a large dial, point the meter, note the number shown under a moving

needle, and set this against an arrow on the dial. Suitable combinations of lens aperture and shutter setting, all of which will result in correct exposure, then appear lined up in the upper part of the dial. You choose the one giving the depth of field or movement blur effects you need, and set the camera accordingly.

Different ways of making readings

Any hand-meter pointed generally at your subject from the camera position will give an exposure reading based on the assumption that the subject has roughly equal areas of light and dark. Some hand-meters have a white plastic diffuser, which slides over the cell. You then hold the meter at the subject, its cell facing the camera, when taking your reading. This 'incident light' single measurement scrambles all the light reaching parts of the subject seen by the camera, ignoring light or dark unimportant background.

A very accurate way of working is to take two undiffused readings, pointing the

Figure B.1 Measuring, reading off and setting exposure.

Figures B.2–3 Making highlight and shadow readings. Left: direct from subject itself. Right: from substitute hands in direct light and shadow. (Meter calculator was then set midway between 3 and 6.)

meter direct at the darkest important shadowed area, and then at the brightest important highlight area. You then split the difference between the two. For example, for Figure B.2 readings were taken about 15 cm (6 inches) from the lightest and then the darkest parts of the man's head. The dial was set to midway between the two readings – in this case 4½ – and the camera settings needed then read off.

When a subject cannot be approached so closely try taking readings from nearby substitutes under the same lighting. For example, in Figure B.3 the photographer is reading off the matching skin of his or her own hands – first turned towards, then away from the same lighting received by the face. In landscapes you can read off the grass at your feet for grass on a distant hill – provided both are under the same lighting conditions. Remember though, when taking any form of reading, not to accidentally measure your shadow or that of the meter.

Exposure increase for close-ups

When you are shooting subjects very closeup (using extension rings or bellows to get a sharp image), the image is less bright than with distant subjects – even though lighting and *f*-number remain the same. Inside the camera the effect is like being in a darkened room with a slide projector being moved away from the screen (the film). As you focus the camera lens for an ever-closer subject the image becomes bigger but also *dimmer*.

If your camera measures exposure through the lens itself this change is taken into account by the metering system; but when using a separate meter you must increase the exposure it reads out. In practice the increase starts to become significant when you focus on a subject closer than about five times the focal length of the lens you are using, growing greater as you focus on subjects closer still, e.g. something 250 mm from a 50 mm lens needs only 1½ times the normal exposure; at 170 mm it requires twice, and at 100 mm four times the exposure the hand meter shows. To calculate exposure increase multiply the exposure shown on the meter by $(M + 1)^2$. Where M is magnification, meaning height of image divided by height of subject.

For example, photographing a 30 mm high postage stamp so that it appears 12 mm high on the film. As magnification is 0.4 you must multiply exposure by 1.4^2 which is 2. You can increase exposure either by giving a slower shutter speed, or by opening up the aperture – one *f*-number for a ×2 increase, one and a half for ×3, and so on.

Appendix C Batteries

Practically every modern camera relies on some form of battery to power its auto exposure or focus systems, film wind-on, flash etc. When a camera fails to operate, or functions in a sluggish way the cause can almost always be pinned down to exhausted battery condition or poor contacts.

There are four main battery types. Relatively low cost *alkaline* batteries are

common for powering small wind-on motors, flash and general camera circuitry. They are not rechargeable but have a good shelf life and are virtually leak proof. Tiny *silver oxide* batteries are often used for camera or hand meters, and for light emitting diode viewfinder displays. They provide constant voltage over a long life. *Nickel cadmium* ('Ni-Cad') batteries are rechargeable, and together with their recharging gear are more expensive than other battery types. They are most often used in accessory flashguns. One problem with Ni-Cad is 'memory fatigue', meaning that a battery will not charge to full capacity as it gets older, and therefore needs recharging more often. *Lithium* type batteries are increasingly used in modern equipment designed for this power source. They have a long powered-up storage life but to avoid any danger of leaking always remove a lithium battery from your equipment immediately it is exhausted.

In general remember that batteries are affected by temperature. Low temperatures slow down their chemical reaction, resulting in erratic or sluggish camera operation. On the other hand batteries stored bagged in a refrigerator have a greatly extended shelf life. Make sure batteries are inserted with the polarity (+ or –) marked on their contacts matching the terminals in your equipment.

Safety points

Keep batteries away from young children – some tablet types look like sweets. Never allow anyone to try opening a battery or throw it on a fire. Do not attempt to recharge batteries other than nickel types marked as suitable, and always recharge through the recommended transformer.

It is good practice to remove the batteries from photographic equipment you will not be using for some months. Changing non-rechargeable batteries once a year is also advisable – especially before going to a location where the correct replacements might be difficult to buy.

Appendix D Health and safety in photography

The equipment and processes used in photography are not particularly hazardous, provided you take one or two (mostly common sense) precautions. For example, the use of electrical equipment in the studio, or within the darkroom in the presence of water and dim lighting clearly requires care. Similarly, when you are using photographic chemicals it is best to adopt working habits which pay due regard to your health.

Electrical equipment

Remember that studio spotlights and floodlights produce heat as well as light. The *bottom* of the lamp head is always cooler than the *top*, so only grip the bottom when tilting the light. Never drape any diffusing or filtering material you may be using over a lamp head. Instead, arrange to support it a foot or so in front of the lamp (even just hold it there when you take the picture). Keep lamps and curtains well apart for similar reasons, and don't leave lamps on in an empty room.

Each lighting unit needs a plug fitted with an appropriate fuse. Lamp wattage divided by the supply voltage tells you how many amperes are drawn. Fit a fuse rated just slightly above this figure, e.g. use a 5 A fuse if the lamp draws four or less amperes. Just fitting a 13 A fuse in every plug reduces your protection. All lighting equipment should be earthed ('grounded') through a third wire.

Watch out, with items like lamps which you move about, that the cable does not fray where it enters the lamp head, and that the connections at each end have not worked loose. Never try to remove a bulb from its socket whilst it is still hot, and make sure your lighting unit is disconnected before fitting a new lamp. Be careful not to have the power cable stretched between socket and lamp head so you can trip over it, or have the unit set up in a way that makes it unstable and top heavy.

Most flashguns have two circuits – a trigger circuit to the shutter which uses a very low and harmless current, and an internal higher powered circuit to the flash tube. Never try opening up the internal electrics to repair your unit. Even though battery operated it may be storing enough electricity to give you a powerful shock.

In the darkroom, where water is

present, it is even more important to have your electrical equipment – enlarger, safe-light, ventilator – properly fused and earthed (see page 149). Avoid having sockets or switches where someone might grasp them with a wet hand – near the sink, for example. If possible have all switches fitted to the ceiling and operated by non-conductive pull-cords. Avoid running wiring under, or close to, sinks, metal drying cabinets, etc. Your power supply outlets should be at bench top height, never at floor level in case of flooding.

Care with chemicals

Handle photographic chemicals with the same care as other chemicals used around the home. Always read any warning on the label, especially if you are unfamiliar with what you are about to use. If any contents are hazardous the container will have first aid measures labelled.

Avoid splashing chemicals into your eyes or onto your skin, particularly skin that is dry and chapped. A few people may have an adverse reaction to chemicals such as developers, resulting in skin irritation. Waterproof gloves are then essential when film processing or printing. It is always a good idea to wear simple eye protectors and gloves (rubber or plastic) when preparing chemicals, especially if you are dissolving chemicals in powdered form. Never use a punctured glove though – it can give your hand prolonged contact with trapped liquid chemical.

Wearing gloves can be uncomfort-able and impractical if you are working for long sessions, constantly moving from wet to dry bench operations, as in printing. At least keep your hands out of solutions by using tongs or paddles to move chemical-covered prints.

Always try to mix chemicals where the ventilation is good and there is running water nearby to dilute any splashes. If you spill any chemical clean it up as soon as possible. Spilt solution soon evaporates, leaving behind a chemical dust that blows about. This is easily inhaled or accumulates in odd corners of your darkroom.

Don't have food or drink in any room where chemicals are used. Make sure all your storage containers are accurately labelled, and *never store chemicals in food or drink containers*. Someone else may assume they are for consumption. For similar reasons keep all photographic chemicals out of the reach of children. Don't store chemicals, or solutions, in a refrigerator or freezer.

Appendix E Chemically treating B&W prints

Even after you have made a black and white bromide print, there are still several ways you can alter the image by chemical means. You can decide to make your picture lighter in tone; or bleach away parts to white paper; or tone it so that the neutral black image turns into a colour. All these chemical treatments are carried out in trays, working under ordinary room lighting.

Start off with a fully fixed and washed print. If it has already dried re-soak it in water for 2–3 minutes, then blot it or wipe off surplus liquid. Working on a damp

Figure E.1 Erasing the background from a print with iodine bleach.

Figure E.2 Routine for sepia toning prints.

print helps to allow the chemicals to act evenly.

Reducing (lightening) the image

Farmer's reducer is a mixture of potassium ferri-cyanide and hypo (see formula, page 179). This forms a yellow solution which you apply on a cotton wool swab to over-dark parts of the picture. Then immediately hold your print under a cold water tap to halt the reduction. Examine the effect carefully. Repeat the process – just a little at a time – until the part of the print (or the entire image) is sufficiently lightened. If you go too far there is no way you can bring back the image again. Finally re-fix and wash the whole print.

Farmer's reducer has its most rapid effect on the palest tones in an image, so it is excellent for the overall 'brightening up' of pictures with veiled-over (grey) highlights. Don't expect to rescue a really dark print this way however – if overdone the reducer leaves a yellowish stain and brownish-black tones. Farmer's reducer can also be used to lighten very dense, low contrast negatives; i.e. overexposed and underdeveloped. At the same time it greatly exaggerates the graininess of the image.

Bleaching to white with iodine

By using an iodine bleacher you can erase chosen parts of your print right down to white paper, without leaving any final stain. It is ideal for removing an unwanted background to a subject, leaving it with a 'cutout', appearance. Two separate solutions are needed – the bleacher itself, and a tray of print-strength fixer.

As Figure E.1 shows, paint over the unwanted area of your print with a swab of cotton wool (changing to a watercolour brush when working close to the edges of fine detail). A strong brown stain immediately appears, with the black image fast vanishing beneath it. Wait until the unwanted parts have lost all their black silver, then rinse the whole print in water for at least 30 seconds. Next put it in the fixer solution for 5 minutes or so until the brown stain has completely disappeared, leaving clean white paper. Finally, wash the print for the same time recommended for your printing paper after regular fixing.

Sepia toning

Changing the print image from black into sepia is the simplest and most popular toning process. It gives a rich sepia or chocolate colour, like a nineteenth-century photograph. Sepia toning is also advisable before hand colouring (see page 128).

You need two separate solutions, bleacher and toner. Slide the print into the tray of bleacher, face up, and rock it for a minute or so until the once black image is bleached to a pale straw colour. You then rinse it under the cold water tap and place it in a tray of toner solution. The picture reappears in a sepia colour within a few seconds, but needs 2–3 minutes to reach full richness and depth. You finish off by washing and drying in exactly the same way as when making the print in the first instance.

The image now consists of brownish silver sulphide instead of the usual black metallic silver. This is very permanent – you cannot return a sepia print to black. Remember too that with toners of this kind bleaching is essential before the black image

can become sepia. You can therefore *selectively* bleach, say, just the background to your main subject by carefully applying bleacher on a brush or swab. Only this area then becomes sepia in the toner, leaving the main image black.

Another alternative is to dilute the bleacher with an equal volume of water to slow its action. You then immerse the whole print but remove it before darkest greys and shadows have lost their black appearance. After completing the toning stage of the process as normal your picture consists of a mixture of sepia and black. Results have deeper brown-black shadows than given by full toning. And if you don't like the result just re-bleach your print to affect the remaining black parts and tone the print again to get a fully sepia image.

You can also buy kits of multi-toner chemicals, typically consisting of a bleacher and a range of toners, each of which will result in a different colour image. A kit with yellow, magenta and blue toners permits you to mix them in varying proportions (blue and yellow to get green, for example) and so form a wide choice of image hues. Most results are rather garish; some are not very permanent and alter with time.

Chemicals required

Farmer's reducer and most toners can be bought as packs of ready-weighed powders and liquids from manufacturers such as Tetenal. This is the most convenient and, in the long run, cheapest way of working. To make up your own solutions, however, prepare them from the following chemicals. Follow the handling precautions described on page 177.

Iodine bleacher

Warm water	400 ml
Potassium iodide	8 g
Iodine	2 g
Water up to	500 ml

Farmer's reducer

(a) Potassium ferricyanide	5 g
Water	500 ml
(b) Sodium thiosulphate (hypo crystals)	80 g
Warm water	500 ml

Mix equal quantities of (a) and (b) just before use (does not keep as a single solution).

Sepia toning

Bleach in:

Potassium ferricyanide	20 g
Potassium bromide	20 g
Water up to	1 litre

Tone in:

Sodium sulphide	20 g
Water up to	1 litre

The sulphide in this formula gives off a 'bad eggs' smell, especially when diluted. Use it in a well-ventilated area, away from films and papers.

Glossary

AE Automatic exposure metering, i.e. the camera measures the light and sets shutter and aperture (either or both).

AE lock (AE-L) Locks an automatic exposure setting in the camera's memory.

AF Auto-focus.

AF lock (AF-L) Locks an *autofocus* lens in its present focus setting.

Angle of view The extent of the view taken in by the lens. It varies with focal length for any particular format size. The angle made at the lens across the image diagonal.

Aperture (of lens) Size of the lens opening through which light passes. The relative aperture is calibrated in *f*-numbers, being the diameter of the beam of light allowed to pass through the lens, divided into its focal length. Widest relative apertures therefore have lowest *f*-numbers. All lenses set to the same *f*-number give images of a (distant) scene at equal brightness.

Aperture preview Button on some SLR cameras to close the lens to the *aperture* set for photography. Allows you to visually check *depth of field* in the viewfinder.

APS Advanced Photographic System. Easy-load cameras and film cartridges 30 per cent smaller than 35 mm. See page 42.

Autofocus (AF) System by which the lens automatically focuses the image of a selected part of your subject.

Av Aperture value. *AE* camera metering mode by which you choose aperture, and the metering system sets shutter speed. (Also called aperture priority.)

ASA Stands for (obsolete) American Standards Association. The initials were once used for a film speed rating system. Now replaced by ISO.

'B' Setting Brief or Bulb. On this setting the camera shutter stays open for as long as the release button remains depressed.

Bracketing (exposure) Taking several pictures of your subject at different exposure times or aperture settings. E.g. half and double as well as the estimated correct exposure.

Bromide paper Light-sensitive photographic paper for enlarging or contact printing. Carries a predominantly silver bromide emulsion. Must be handled in appropriate (usually amber or orange) safelighting.

Burning-in Giving additional exposure time to one selected area, during printing.

Camera obscura A dark chamber to which light is admitted through a small hole, producing an inverted image of the scene outside, opposite the hole.

Cassette Light-tight container for 35 mm camera film. See page 40.

CCD Charge-Coupled Device. Electronic light-sensitive surface, digital replacement for film.

CD-ROM Compact disc with read-only memory.

Close-ups Photographs in which the picture area is filled with a relatively small part of the subject (e.g. a single head). Usually photographed from close to the subject but may be shot from further away using a long focal length lens.

Close-up attachments Accessories which enable the camera to focus subjects which are closer than the nearest distance the lens normally allows.

Contact printing Printing with light, the object (typically a negative) being in direct contact with the light-sensitive material.

Colour balance A colour photograph which closely resembles the original subject appearance is said to have 'correct' colour balance. Mis-matching film type and lighting (wrong colour temperature) gives a cast most apparent in grey tones and pale tints.

Colour temperature A means of describing the colour content of a 'white' light source. Based on the temperature (absolute scale, expressed in kelvins) to which a black metallic body would have to be heated to match the light. E.g. Household lamp 2800 K, Photoflood 3400 K.

Complementary colours Opposite or 'negative' colours to the primary colours of light (blue, green and red). Each is made up from the full spectrum less the primary colour, e.g. the complementary of red is blue plus green = cyan.

Contrast The difference (ratio) between the darkest and brightest parts. In a scene this depends on lighting, and the reflecting properties of objects. In a photograph there is also the effect of exposure level, degree of development, printing paper, etc.

Cropping Cutting out unwanted (edge) parts of a picture, typically at the printing or mounting stage.

Daylight colour film Colour film balanced for use with flash, daylight, or daylight-matching strip tubes (5500 K).

DIN Stands for Deutche Industrie Norm (German Industrial Standard). DIN numbers denoted a film's relative sensitivity to light. Halving or doubling speed is shown by decrease or increase of the DIN number by *three*. Now incorporated in ISO and distinguished by degree symbol.

Depth of field Distance between nearest and farthest parts of the subject sharply imaged at the same time. Greatest with small lens apertures (high *f*-number) distant scenes, and shortest focal length lenses.

Developer Chemicals, normally in solution, able to convert the invisible (latent) image on exposed

photographic material into visible form.

Developing agents Chemicals (typically Phenidone, Metol and hydroquinone) able to change light-struck silver halides into black metallic silver.

Digital image Stream of electronic data, forms visible image on computer monitor.

Diffuse lighting Scattered illumination, the visual result of which is gentle modelling of the subject with mild or non-existent shadows.

Dodging Local shading in enlarging, usually by means of a piece of opaque material on a thin wire. Has the opposite effect of *burning-in*.

DX coding Coding printed onto film cassette denoting speed, length, etc. Read by sensors in the film compartment of most 35 mm cameras.

Emulsion Suspension of minute silver halide crystals in gelatine which, coated on film or paper, forms the light-sensitive material used in traditional (non-digital) photography.

Enlarger Optical projector to give enlarged (or reduced) images which can then be exposed on to light-sensitive paper or film. See page 154.

Enlarging easel (masking frame) Flat board with adjustable flaps used on the enlarger baseboard to position and hold paper flat during exposure.

Exposed A light-sensitive material which has received exposure to an image. Usually relates to the stage after exposure and before processing.

Exposure Submitting photographic material to the action of light, usually by means of a camera or enlarger.

Exposure-compensation dial Camera control overriding film speed (e.g. DX) setting, + or −.

Exposure latitude The amount by which a photographic emulsion may be under- or over-exposed, yet still give an acceptable image when processed.

Exposure meter Instrument which measures light intensities falling on, or reflected off the subject, and indicates or sets corresponding camera settings (shutter and aperture).

Extension tubes Rings or short tubes mounted between camera body and lens to space the lens further away from the film and so allow the sharp focusing of very close subjects.

ƒ-numbers See **Aperture**.

Fill-in Illumination to lighten shadows, reducing contrast.

Film speed Measure of sensitivity of film to light. Usually expressed as an ISO figure.

Filter, lens Sheet of (usually dyed) gelatin or glass. Used over the camera or enlarger lens mainly to reduce the light (neutral density grey filter) or to absorb particular wavelengths from the light beam.

Fixer Chemical (basically a solution of sodium thiosulphate plus potassium metabisulphite as acidifier). Used after development to make soluble those parts of a photographic image unaffected by the developer. Photographs can thereafter be handled in normal lighting.

Fixed focus Camera lens set for a fixed subject distance. Non-adjustable.

Fixing agent Chemical able to change silver halide into colourless soluble salts.

Flare Scattered light which dilutes the image, lowering contrast and seeming to reduce sharpness. Mostly occurs when the subject is back-lit.

Flash contacts Electrical contacts, normally within the mechanism of the camera shutter, which come together at the appropriate moment to trigger the flash unit. Older shutters may be fitted with X and M contact sockets. Use X for electronic flash.

Flash (Electronic) Equipment which gives a brief, brilliant flash of light by discharging an electronic capacitor through a small gas-filled tube. Given time to recharge, a unit gives many thousands of flashes, usually triggered by *contacts* within the camera shutter.

Flash factor See **Guide number**.

'Flat' images Images which are low in tonal contrast, appearing grey and muddy.

Floodlamp Studio lighting unit consisting of a large reflector containing a photolamp or other pearl glass lamp. Gives diffuse lighting.

Focal length In a simple lens the distance (typically in millimetres) between the lens and the position of a sharp image for a subject a great distance away. A 'normal' lens has a focal length approximately equivalent to the *diagonal* of the picture format it covers, i.e. 50 mm for 36 × 24 mm.

Focal plane The plane – normally flat and at right-angles to the lens axis – on which a sharp image is formed. In the camera the emulsion surface of the film must be in the focal plane at the moment of exposure to record a focused image.

Focus priority (trap focus) *Autofocus* camera mode by which you cannot release the shutter until the lens has sharply focused your subject.

Focusing Changing the lens-to-image (or lens-to-subject) distance, until a sharp image is formed.

Fog Allowing random light to reach light-sensitive material, as in opening the camera back accidentally or leaving a packet of paper open. Also caused by bad storage or contaminated or over-prolonged development (chemical fog).

Form An object's three-dimensionallity. Height, breadth and depth.

Format Height and width dimensions of the picture area.

Glossy paper Photographic paper which can give prints with a shiny, glossy surface.

Grade, of paper Classification of black and white photographic papers by the gradation they offer

between black and white. Soft (Grade 1) paper gives a wider range of grey tones than Hard (Grade 3). See also Variable contrast paper.

Grain Irregularly shaped, microscopically small clumps of black silver making up the processed photographic silver halide image. Detectable on enlargement, particularly if the film emulsion was fast (ISO 1000 or over) and overdeveloped. Hard grade paper also emphasises film grain.

Guide number (flash factor) Figure denoting the relative power of a flash source. The GN is the light-to-subject distance (usually in metres) multiplied by the *f*-number for correct exposure. E.g. GN of 16 = 2 m at *f*8 or 1 m at *f*16. (Unless *film speed* is quoted, factor refers to ISO 100 film.)

'Hard' images Image with harsh tonal contrasts – mostly blacks and whites with few intermediate grey tones.

'Hard' light sources Harsh source of illumination, giving strong clear-cut shadows. Tends to dramatize form and texture.

Hyperfocal distance Nearest subject rendered sharp when the lens is focused for infinity. Focused for the hyperfocal distance and without change of *f*-number, depth of field extends from half this distance to infinity.

Hypo Abbreviation of hyposulphate of soda, an incorrect early name for sodium thiosulphate. Popular name for fixing bath.

Incident light attachment Diffusing disc or dome (usually of white plastic) placed over the cell of a hand-held exposure meter to make readings *towards the light source*. Calculator dial is then used in normal way. Gives results similar to reading off an 'average' subject or grey card.

Infinity A distance so great that light from a given point reaches the camera as virtually parallel rays. In practice, distances of about 1000 times the focal length or over. Written on lens focusing mounts as 'inf' or a symbol like an 8 on its side.

Infinity lock Control which sets (autofocus) lens for distant subjects only. Useful if shooting through windows.

Inkjet printer Digital printer, forms images using a very fine jet of one or more inks.

Inverse square law 'When a surface is illuminated by a point source of light the intensity of light at the surface is inversely proportional to the square of its distance from the source.' In other words if you double the lamp distance light spreads over a larger area and illumination drops to $1/2 \times 1/2 = 1/4$ of its previous value. Forms the basis of flash Guide Numbers and close-up exposure increases. Does not apply to large diffuse sources or in practice the (extremely distant) sun.

ISO International Standards Organization. In the ISO film speed system halving or doubling of speed is denoted by halving or doubling number. Also incorporates *DIN* figure, e.g. ISO 400/27° film is twice as sensitive as ISO 200/24°.

K (Kelvin) Measurement unit of lighting and *colour temperature.*

Large format cameras Normally refers to cameras taking negatives larger than 120 rollfilm size.

Latent image The invisible image contained by the photographic material after exposure but before development. Stored protected from light, damp and chemical fumes a latent image can persist for years.

Long focal length lens Lens with focal length longer than considered 'normal' for picture format. Gives larger detail, narrower angle of view. Almost all such lenses are *telephoto* types.

Macro lens Lens intended for close-up photography, able to focus well forward from its infinity position for subjects a few inches away, gives highest quality image at such distances.

Macrophotography Photography at very close subject range.

Masking frame See **Enlarging easel.**

Mat or overmat Card with cut-out opening, placed over print to isolate finished picture.

Monochrome image Single coloured. Usually implies black image, but also applies to one which is toned, i.e. sepia.

Montage An image constructed by combining what were originally several separate images.

Multigrade Multi-contrast printing paper. See **Variable contrast.**

Negative image Image in which blacks, whites and tones are reversed, relative to the original subject. Colour negatives have subject colours represented by their *complementaries.*

'Normal' lens The lens regarded as standard for the picture format, i.e. having a *focal length* approximately equal to its diagonal.

Overdevelopment Giving too long, or too much agitation in the developer, or having too high a temperature, or developer too concentrated. This results in excessive density, and exaggerated grain structure in the developed material.

Overexposure Exposing photographic material to too much light because the image is too bright, or exposure time too long. Results in excessive density in the final image.

Panning Rotating or swinging the camera about a vertical axis.

Panchromatic Photographic materials sensitive to all visible colours, recording them in various shades of grey. Should be processed in total darkness or an exceedingly dark safelight. All general purpose films are of this kind.

Parallax error Viewpoint difference between the picture seen in the viewfinder and as seen by the camera lens. See page 32.

Photo CD CD format for storing photographs as

digital files. Disc typically holds up to 100 images, stored in various levels of resolution.

Photographic lamps Generalized term now often applied to both 3200 K studio lamps (floods and spots) and the brighter, short life 3400 K photoflood lamps.

Polarizer Grey-looking polarizing filter, able to darken blue sky at right angles to sunlight, and suppress reflections from (non-metallic) surfaces at angles of about 30°.

Polycontrast See **Variable contrast**.

Printing in See **Burning in**.

'Pushing' Slang term for *uprating* film speed.

Rapid fixer Fixing bath using ammonium thiosulphate or thiocyanate instead of the normal sodium thiosulphate. Enables fixing time to be greatly reduced, but is more expensive.

Reciprocity law failure Normally the effect of dim light, or small lens aperture, can be counteracted by giving a long exposure time. But this reciprocal relationship (half the brightness = double the exposure time) increasingly breaks down with exposure times beyond one second. The film then behaves as if having a lower speed rating. Colour films may also show incorrect balance.

'Red-eye' The iris of each eye in portraits shows red instead of black. Caused by using flash directed from close to the lens.

Reflex camera Camera with viewfinder system using a mirror and focusing screen.

Refraction Change of direction of a ray of light passing obliquely from one transparent medium into another of different density e.g. from air into glass. The basic reason why lenses bend light rays and so form images.

Resin coated (RC) bromide paper Bromide paper having a water-repellent plastic base. RC papers require less washing, dry more rapidly and generally process faster than fibre base papers.

Reversal film Film which can be processed to give a positive image direct. Colour slide films are of this type. Some black and white films can be reversal processed.

Rollfilm Photographic film, usually 6.2 cm wide (known as 120) attached to a numbered backing paper and rolled on a flanged spool.

Safelight Darkroom light source filtered to illuminate only in a colour to which photographic material is insensitive. The correct colour varies with type of emulsion, e.g. orange for bromide papers.

Selective focusing Using a shallow depth of field (i.e. by means of a wide lens aperture) and focusing so that only one selected zone of the subject is sharply recorded.

Shading, in printing Preventing the image light from acting on a selected area of the picture for a time during the exposure.

Sheet film Film supplied as individual sheets; usually 10 or 25 to a box.

Shutter Mechanical device to control the time the light is allowed to act on the film. Usually consists of metal blades within the lens, or two blinds passing one after another just in front of the film, the exposure occurring in the gap between them (focal plane shutter).

Silver halides Light-sensitive compounds of silver with the halogens (iodine, bromide, etc.). Normally white or creamy yellow in colour. Used as the main sensitive constituent of photographic emulsions

Single lens reflex (SLR) Camera in which the viewfinder image is formed by the picture-taking lens.

Soft focus Image in which outlines are slightly spread or diffused.

'Soft' light sources See **Diffuse lighting**

Spotlight A compact filament lamp, reflector and lens forming one light unit. Gives hard direct illumination, variable from narrow to broad beam.

Stop-bath Stage in processing which arrests the action of the previous solution (e.g. a weak solution of acetic acid used between development and fixation).

Subject The person, scene, situation, etc. being photographed. (Tends to be used interchangeably with object.)

'T' setting Setting found on some large format camera shutters for time exposures. Pressing the release opens the shutter, which then remains open until pressed for a second time.

Telephoto lens Long focus lens of compact design (lens is physically closer to the film than its focal length).

Test strip One of a series of test exposures on a piece of printing paper, then processed to see which gives the most satisfactory result.

Texture Surface qualities such as roughness, smoothness, hairiness, etc.

Through-the-lens (TTL) metering Measuring exposure by a meter built into the camera body, which measures the intensity of light passing through the picture-taking lens.

Time exposure General term for a long duration exposure.

Tones, tone values Areas of uniform density in a positive or negative image which can be distinguished from darker or lighter parts.

Translucent Transmitting but at the same time also diffusing light, e.g. tracing paper.

Transparency Positive image film.

Tungsten lamps Lamps which generate light when electric current is passed through a fine tungsten wire. Household lamps, photofloods, studio lamps, etc., are all of this type.

Tungsten light film (also known as 'Type B' or

'Artificial light'). Colour film balanced for use with 3200 K studio lighting.

Tv. Time value. *AE* camera metering mode by which you choose shutter speed and the metering system sets aperture. (Also called shutter priority.)

Twin lens reflex Camera with two linked lenses – one forming an image onto film, the other giving an image on a focusing screen. See page 172.

Uprating Shooting film at more than the manufacturer's suggested speed rating, e.g. exposing 400 ISO film as if 800 ISO. The film is then given extra development.

Underdevelopment Giving too short a developing time; using too low a temperature, too great a dilution or old or exhausted solutions. This results in insufficient density being built up.

Underexposure Exposing photographic material to too little light, because the image is too dim or exposure time too short. Results in insufficient density and shadow detail in the final image.

Variable contrast (multigrade) paper Black and white printing paper which changes its contrast characteristics with the colour of the exposing light. Controlled by enlarger filters typically ranging from yellow to purple.

Viewpoint The position from which camera, and photographer, view the subject.

Wetting agent Chemical (e.g. weak detergent) which reduces the surface tension of water. Facilitates even action of developer or final wash water.

Wide-angle lens Lens with a focal length much shorter than the diagonal of the format for which it is designed to be used. Gives a wide angle of view and considerable depth of field.

Zoom lens A lens which offers continuous variation of focal length over a set range, maintaining the same focus setting.

How they were taken

Additional technical details on the pictures in this book. Unless otherwise stated all photographs were exposed on 400 ISO black and white, 64 ISO colour slide, or 100 ISO colour neg. 35 mm film.

P.6 1/250 sec at *f*8. Exposure read mainly off a sunlit part of hill, left of picture.

P.7 1/60 sec at *f*16.

P.9 Exposure reading, 1/250 sec at *f*11, averaged from face and sunlit chest.

P.10 Fig 2.2 1/60 sec at *f*8. Fig 2.3 1/60 sec at *f*22.

P.11 Backlighting calls for a lens hood, or shading the lens with your free hand. Otherwise scattered light flares into dark areas turning them grey. 1/250 sec at *f*8.

P.12 Fig 3.1 Wide angle lens. Focus set for far end of platform, 1/30 sec at *f*16.

P.13 Fig 3.3 1/125 sec at *f*8. Exposure based on a general overall light reading since highlights and shadows are about equal in area here.

P.14 Although backlit, some light filled-in from a white wall behind the camera. Exposure measured off shaded skin tones.

P.15 Fig 3.6 Exposure measured from lit walls halfway along sides, 1/60 sec at *f*2.8. Fig 3.7 Overcast. Average of reading off bushes and reading off hand (for cat). 1/125 sec at *f*16.

P.16 1/125 sec at *f*5.6. See text page 19.

P.17 1/125 sec at *f*5.6. Exposure measured solely from the lit green foliage.

P.18 All five pictures shot at *f*5.6.

P.20 Shot using a handheld 200 mm lens. 1/500 sec at *f*5.6.

P.21 Brilliant sunlight, but some reflected back from a concrete yard below. 1/250 sec at *f*11, old 6 x 6cm rollfilm camera.

P.22 Fig 5.3 Exposure read close to the yellow flowers, as key picture elements. 1/125 sec at *f*5.6. Fig 5.4 A candid shot with a simple compact camera.

P.23 Fig 5.5 Shot from a distance, using a 100 mm lens and avoiding tilting the camera upwards. 1/125 sec at *f*5.6.

P.24 Fig 6.1 Wide angle 28 mm lens. 1/125 sec at *f*11.

P.25 Fig 6.3 1/250 sec at *f*11. Overall exposure reading; normal lens. Fig 6.4 6 x 6cm camera 1/10 sec at *f*22. Exposure read from close-up to water alone.

P.26 Fig 6.5 Daylight colour film, no filter. 1 sec at *f*2. Fig 6.6 1/250 sec at *f*11. General exposure reading.

P.41 Fig 9.4 Lit by daylight from a large (rear) window, plus large white reflector boards around the camera. 1 sec at *f*22.

P.42 Fig 9.6 Sole lighting source was rugby practice pitch floodlighting. Exposure read off back of hand (to match faces). Picture enlarged from 50 per cent of the 35 mm negative area.

P.44 Fig 10.6 Image shot with Kodak DC200 camera, downloaded direct to computer, cropped, then printed by Epson 700 inkjet printer.

P.45 Fig 11.1 1/250 sec at *f*8. Exposure read off photographer's hand.

P.46 Fig 11.2 1/8 sec at *f*11, resting the camera on the ice rink barrier. Overall exposure reading.

P.47 Fig 11.4 ISO 125 film, 1/60 sec at *f*16. See also page 112.

P.48 Figs 12.1–2 Shot with an SLR, picking widest aperture to localise depth of field. 1/125 sec at *f*2.8, hand held.

P.49 Fig 12.4 One shot taken using 1/500 sec at *f*4, the other 1/30 sec at *f*16 (to maintain the same exposure).

P.51 Fig 12.6 Wide angle lens, using its depth of field scale. By focusing for 4 metres sharpness extended from 1.5 metres to infinity. Fig 12.7 Normal lens. Depth of field also becomes shallower the closer your subject, as here.

P.55 Fig 13.11 Taken with a 6 x 6cm TLR camera (page 172) from ground level, to avoid a complicated background. 1/60 sec at *f*11.

P.56 Fig 13.13 Exposure measured from close-up, filling the picture with shadow area. 1/125 sec at *f*8. Printed light on very hard grade paper.

P.59 Fig 14.4 Hand held camera. 1/250 sec at *f*8. Exposure read off lit parts at the base of the monument.

P.60 Fig 14.5 1/30 sec at *f*4, pressing the camera against a wall.

P.61 Fig 14.7 1/125 sec at *f*11. The subject himself here held the camera only about 5 cm from his open mouth.

P.63 Fig 15.3 Although the flash window was covered with a loop of tracing paper this must not also cover the light sensor in any way.

P.64 Fig 15.4 Built-in flash direct from the camera. Fig 15.5 Separate, tilting head flashgun mounted on SLR camera. Flash Guide No. 32 (metres). Bouncing light calls for a more powerful flash than offered by most built-in units.

P.65 Fig 15.6 Flashgun window angled upwards to reflect off ceiling above camera. Shadows are further reduced by fill-in re-reflected back up from the white bath.

P.66 Fig 15.8 Flash switched off, overall exposure reading. 1/60 sec at *f*8. Fig 15.9 Flash on camera, reduced to quarter power by tracing paper. 1/30 sec at *f*11. Gives natural looking shadow fill. Fig 15.10 Full direct flash. 1/125

sec at $f16$. Fig 15.11 Existing light measured from settee corner. 6 secs at $f8$, being best compromise between inside and outside. Fig 15.12 Accessory flashgun fired manually three times during 4 sec exposure at $f8$. (Shutter locked open on B and lens covered by black card during the periods flash was recharging.)

P.67 Fig 15.14 Compact camera, set to fill-flash mode. Daylight shaded parts are easily overfilled (lower half here) may need printing-in.

P.69 Fig 16.1 Shot with a 6 x 6 cm TLR camera at floor level. 1/60 sec at $f4$. See also text page 71.

P.70 Fig 16.2 Compact auto-focus camera. Hazy sunlight. Fig 16.3 Exposure 1/60 sec at $f4$, measured off the face outside (through a window in the door).

P.71 Fig 16.4 Bounced light from add-on flashgun. Boys were leaning over a white tablecloth. Semi-auto camera set to $f5.6$. 85 mm lens.

P.72 Fig 16.5 Simple basic compact camera, no adjustable settings.

P.73 Fig 16.6 Exposure read off the back of the photographer's hand 1/125 sec at $f4$. Fig 16.7 Picture was cropped long and low to remove distracting skyline above the hedge.

P.74 Fig 16.8 Shot from a distance using a 135 mm lens to 'cramp up' the patterns. Exposure, measured off the stones, 1/250 sec at $f8$. Fig 16.9 Taken with an autofocus camera, used from the hip without looking through the viewfinder.

P.76 Figure 17.5 Shot from a distance using a 100 mm lens. 1/250 sec at $f5.6$.

P.78 Figure 17.8 A 135 mm lens was used so it could be shot from a distance, without tilting the camera and so converging vertical lines.

P.79 Fig 17.11 Shooting from up the beach with a 100 mm lens helped to bunch breaking wave with pier detail. 1/250 sec at $f11$, ISO 800 film.

P.80 Figs 17.12–13 Pictures with slightly converging lines can also be corrected by tilting the enlarger easel, or scanning them into a computer and applying shape-adjusting software.

P.81 Fig 17.14 General meter reading, but then covered by further 'bracketed' shots given increased and decreased exposure. 28 mm lens. Fig 17.15 50 mm lens, ¼ sec at $f4$.

P.82 Fig 17.16 1 sec at $f5.6$, 50 mm lens. Fig 17.17 Based on what exposure time the camera first gave automatically, further frames were shot at $f5.6$ and $f4$, same exposure duration. 28 mm lens.

P.83 Exposure read from girl's face and pullover only: 1/60 sec at $f11$. The horse has moved slightly, which helps give liveliness.

P.84 Fig 18.2 General reading 1/250 sec at $f4$. 50 mm lens. Fig 18.3 1/125 sec at $f8$. 100 mm lens.

P.85 Fig 18.4 1/250 sec at $f4$. Fig 18.5 1/125 sec at $f11$. General reading. Lens zoomed to Tele.

P.86 Fig 18.6 80 mm lens 1/250 sec at $f4$. Fig 18.7 50 mm lens. $f8$. Bounced flash indoors,

P.87 Fig 19.1 28 mm lens. Exposure measured for sunlit grassland. 1/250 sec at $f8$.

P.88 Fig 19.2 1/125 sec at $f8$. Fig 19.3 1/125 sec at $f11$.

P.90 Fig 19.9 Exposure read off sunlit grass nearby. 1/60 sec at $f11$.

P.91 Fig 19.11 1/125 sec at $f8$, using a Kodak No.12 yellow filter. Other shots were taken at half aperture differences either way. Fig 19.10 28 mm lens, 1/125 sec at $f16$.

P.93 Fig 19.16 Choice of moment in time is critical here, to catch waves in a good position relative to sky detail. 1/250 sec at $f5.6$.

P.94 Fig 20.1 Exposure measured by a general reading (keeping out of direct sunlight). 50 mm lens, no extension tube. 1/125 sec at $f4$.

P.97 Fig 20.8 Light here was measured off snow alone, then several shots taken at twice, then three and four times the exposure shown. This picture 1/125 sec at $f5.6$.

P.99 Fig 2.13 1/60 sec at $f16$ using ISO 200 film.

P.100 Fig 20.14 Weak existing light from window, left. ¼ sec at $f11$. Tripod.

P.101 Fig 20.15 Backlit winter tree, shadowed hill beyond. Exposure read from close to sunlit face of tree. 135 mm lens. 1/125 sec at $f5.6$.

P.115 Fig 23.3 1/125 sec at $f16$, the lens focused on the women just behind the glass.

P.118 Fig 24.6 1/125 sec at $f11$ left hand picture, 1/125 sec at $f8$ other version.

P.119 Fig 24.8 30 secs at $f8$, slide film. Fig 24.9 With most dual-colour filters each half cuts down light by the same amount. Here the exposure factor was ×3.

P.120 Fig 25.1 Exposure measured entirely from the projected image on the hand. ¼ sec at $f4$. The wrist was firmly supported.

P.121 Figs 25.3–4 Two strips of black card hung vertically half way between projector and bottle limited the slide image to bottle shape alone. 1 sec at $f5.6$.

P.124 Fig 25.9 Exposure measured off the ground. The horizontal axis tilt between part-exposures is made easier with a tilting head tripod.

P.140 Figs 27.17–18 Exposure read for the lit (side) of the dancer's body, then *twice* the amount indicated given. 5 secs at $f16$.

Index

Index